The End of Art Theory
Criticism & Postmodernity

The End of Art Theory

Criticism and Postmodernity

VICTOR BURGIN

HUMANITIES PRESS INTERNATIONAL, INC.
ATLANTIC HIGHLANDS, NJ

First published in 1986 in the United States of America by
HUMANITIES PRESS INTERNATIONAL, INC.,
Atlantic Highlands, NJ 07716
Reprinted 1987

Library of Congress Cataloging-in-Publication Data
Burgin, Victor.
The end of art theory.
(Communication and culture)
Bibliography: P.
Includes index.
1. Arts, Modern—20th century. 2. Postmodernism.
I. Title II. Series: Communications and culture
(Atlantic Highlands, N.J.)
NX456.5.P66B87 1986 709'.04'001 86-2986
ISBN 0-391-03431-6
ISBN 0-391-03430-8 (pbk.)

Printed in Hong Kong

Contents

List of Illustrations

Acknowledgements

The author and publishers wish to thank the following who have kindly given permission for the use of copyright material:
The Ancient Art and Architecture Collection for print *Hermaphroditus disclosed by Pan*. Fresco from the House of the Dioscuri, Pompeii, first century.
Produzioni Europee Associate SRL for still from their motion picture *Fellini's Casanova*, 1976.
The Metropolitan Museum of Art, New York for reproduction of *Broken Eggs*, 1756, by Jean-Baptiste Greuze.
MCA Publishing for still from *Vertigo*, 1958, by Alfred Hitchcock. Copyright © by Universal Pictures, a Division of Universal City Studios, Inc. Courtesy of MCA Publishing Rights, a Division of MCA Inc.
The National Gallery for reproduction of *The Judgement of Paris*, 1632–35, by Peter Paul Rubens.
Tate Gallery Publications Department for reproduction of *Ophelia*, 1851, by John Everett Millais.
The Wallace Collection for reproduction of *The Judgement of Paris*, 1745, by François Boucher.

Every effort has been made to trace all the copyright-holders, but if any have been inadvertently overlooked the publishers will be pleased to make the necessary arrangement at the first opportunity.

Preface

The essays collected here were written between 1976 and 1985; some have been published previously, two appear in print for the first time. The nature of these writings, the form of my production as an 'essay writer', is determined by my other main forms of work: as an artist, exhibiting work in galleries and museums; and as a lecturer, teaching 'theory' to, mainly, under-graduates. Issuing from a position which faces onto both academy and gallery, these essays are simultaneously polemical, practical, and pedagogical in intent: one of their functions has been to intervene in ongoing cultural-political debates; another has been to allow me to work out the historical and theoretical framework of my own art practice; finally, the essays are intended to be useful to students and teachers in the field of 'visual representations' in general, and the 'visual arts' in particular. It is this intention which has dictated a procedure of writing which 'interrupts itself' to provide thumb-nail sketches of basic theoretical concepts, and examples of their application.

At the end of the first essay in this book I remark that the division of labour between 'theorists' and 'practitioners' is prob-lematical for a truly *critical* cultural initiative, and I touch on this again towards the end of the final essay. In recent years post-structuralism's deconstruction of metalinguistic hierarchies has in effect gone further, to result, particularly in the field of literary criticism, in a form of writing which abandons all

pretence to theoretical distance from its objects, revelling in its own inescapable condition as *writing*. I have not, for the most part, adopted this strategy of writing in my essays as I doubt that (undergraduate) students would find it helpful; it is in the gallery, through the use of the 'mixed system' of photograph and text, that I have tried to articulate the concerns of theory *otherwise*.

'Modernism in the *Work* of Art' was first given as a paper at the 1976 Edinburgh Film Festival 'Avant-garde Event'. It was first published, in expanded form, in *20th Century Studies*, 15–16 December 1976.

'The Absence of Presence: Conceptualism and Post-modernisms' was written for the exhibition catalogue, *1965 to 1972 – when attitudes became form*, Kettle's Yard Gallery, Cambridge University, 1984. It is based on a talk given at the John Hansard Gallery, Southampton University, 1982.

'Seeing Sense' was written for *Artforum*, New York, February 1980.

'Re-reading *Camera Lucida*' was published in *Creative Camera*, 215, November 1982. It was first given as a lecture at the Polytechnic of Central London.

'Tea with Madeleine' is from *Wedge*, 6, New York, Winter 1984. The 'left-hand' discourse was first presented as a talk at a seminar on *Desire* at the Institute of Contemporary Arts, London, November 1983, and subsequently published (as 'Man-Desire-Image') in *Desire*, ICA documents series, 1984. I consider the absent 'third column' here to be my gallery work from around this period (see *Between*, ICA and the Camden Press, 1986).

'Diderot, Barthes, *Vertigo*' was first presented, in a shorter version, at the symposium *Film and Photography* – organised jointly by the Department of English, Department of Art History, and the Film Studies Program – at the University of California, Santa Barbara, May 1984.

'The End of Art Theory' is based on various informal talks given, during 1984–5, to art students at: California Institute of the Arts, Valencia; University of California, Los Angeles; Cranbrook Academy, Detroit; Cooper Union, New York; Goldsmiths' College, London; Camberwell School of Art, London.

I have not revised the essays for publication here. On occasions I repeat myself. As the *contexts* differ, however, I hope this may be excused. The inconsistent spelling of 'fantasy' (*phantasy*, in the earlier essays) may be disregarded. I once felt it necessary to signal a psychoanalytic framework for the concept by adopting the spelling in the *Standard Edition* of Freud. I later conformed to common practice (see Laplanche and Pontalis, *The Language of Psycho-Analysis*, Hogarth, 1973, pp. 314–15, 318,n.β).

<div align="right">VICTOR BURGIN</div>

Modernism in the *Work* of Art[1]

Mukarovsky, in 1934,[2] saw among the pitfalls awaiting the art theorist with no grasp of semiology, 'the temptation to treat the work of art as a purely formal construction'. Today, nevertheless, the tendency to apply semiotic theory to visual art in the direction of a 'poetics' has flowed into an easy confluence with the existing mainstream of 'Modernist' criticism, focused on the internal life of the autonomous object. Mukarovsky's requirement that theory should 'grasp the development of art as an immanent movement which also has a constant dialectical relation to the development of the other domains of culture', remains unfulfilled.

It is worth looking again at Modernism in its relation to other visual art in the modern period in order to return it to its own position in the history of art *practice*, its place in the social production of meaning. It is worth considering whether Russian Formalism, the object of much interest in recent aesthetic theory, may be assimilated to Modernism as simply as has occasionally been implied; and whether to abandon the Modernist programme would indeed be to revert to 'representationalism', losing the ground won by visual art in the modern period (as is often assumed). The term 'Modernism' here is to be understood by reference to Clement Greenberg's writings as it is these which, *de facto*, constitute the locus of present Modernism in the visual arts.

I

A siege condition for culture is described in Clement Green-
berg's 1939 essay 'Avant-Garde and Kitsch'.[3] He argues:
Western culture is in crisis; before the modern period such crises
of established values led to artistic academicism, a petrification
of culture. In this present crisis, however, the unprecedented
phenomenon of the avant-garde promises to 'keep culture
moving'[4] by raising art to 'the expression of an absolute in which
all relativities and contradictions would be either resolved or
beside the point',[5] this it will accomplish by eschewing the world
of 'ideological confusion and violence'.[6] Contemporaneously
with the emergence of the avant-garde: 'the new urban masses
set up a pressure on society to provide them with a kind of
culture fit for their own consumption . . . a new commodity was
devised: ersatz culture, kitsch, destined for those . . . insensible
to the values of genuine culture'.[7] In kitsch, 'there is no disconti-
nuity between art and life'.[8] Whereas the values of avant-garde
art are a reflection of values 'projected' by the 'cultivated'
observer, the values of kitsch are 'included' in the art object, to
be instantly available for 'unreflective enjoyment' – 'Picasso
paints *cause*, Repin paints *effect*'.[9] Because kitsch is so unde-
manding, it is the most in demand; a demand to which Hitler
and Stalin alike must accede, regardless of their personal tastes.
Dictators, of political necessity, must flatter the masses by
'bringing all culture down to their level'.[10] The cultural level of
the masses cannot be raised within existing, capitalist, modes of
production; only a socialist solution to the problems of
production could grant the majority the leisure necessary to the
appreciation of avant-garde art. However, the exigencies of 1939
demand that socialism be appealed to not for a new culture but,
'*simply* for the preservation of whatever living culture we have
right now'.[11]

At the most immediate level, Greenberg's essay is to be read
as a protest at the growth of totalitarian philistinism prior to the
Second World War. However, that he considers the threat to
'true' culture to be mass culture in general is clear from his
indiscriminate use of the term 'kitsch'. An example of what
today we might call kitsch is given by Tocqueville. He describes

arriving in New York by the East River and being 'surprised to perceive along the shore, at some distance from the city, a number of little palaces of white marble, several of which were of classical architecture'. He continues, 'When I went the next day to inspect more closely one which had particularly attracted my notice, I found that the walls were of whitewashed brick, and its columns of painted wood'.[12]

There is more here than that absence of 'truth to materials' deplored by Morris and, after him, the Bauhaus. It is a defining attribute of kitsch that its styles should be derivative of established 'high' culture. In kitsch, the content most likely to succeed is presented in the form most likely to inspire respect, thus Greenberg refers to 'the faked article' and 'debased and academicised simulacra'. Greenberg is therefore correct in applying the term 'kitsch' to the official art of Russia, Germany, and Italy in the 1930s, where sentimental and propagandistic contents were pretentiously, presented in conventionally 'artistic' dress. However, he also speaks of 'that thing to which the Germans give the wonderful name of *Kitsch*: popular, commercial art and literature with their chromeotype, magazine covers, illustrations, ads, slick and pulp fiction, comics, Tin Pan Alley music, tap dancing. Hollywood movies, etc., etc.' Here, all manifestations of mass culture whatsoever are damned by association with kitsch as 'ersatz culture' in a clean sweep so broad that all that remains as 'genuine culture', 'true culture', 'superior culture', is 'art and literature of a high order'.[13]

Greenberg gives no indication of the nature of 'genuine' culture that is not a truistic assertion; there is, however, a clear echo in his essay of that definition of culture as 'the best of what has been thought and written'. As Raymond Williams has described,[14] it was the impact of industry and democracy in the nineteenth century which gave rise to a conception of culture as something separate from and 'above' society. The ideas of 'culture in opposition' variously expressed by such members of the Victorian intelligentsia as Arnold, Morris and Ruskin, were formed through their practical criticism of the social realities of their day. By degrees, however, the notion of culture as a repository of ideal values became a means not of criticising the world, but of evading it. What is nowhere apparent in Greenberg's

essay is that, at the time he was writing, the notion of 'high' culture, given *a priori*, had been very widely repudiated in art practice both in America and in Europe. The sense of popular cultural identity which had emerged in the US during the 1920s was confirmed with the creation, in 1935, of the Federal Art Project section of the Works Progress Administration (renamed Works Project Administration in 1939). Established as part of the New Deal, at the time when ten million Americans were unemployed, the WPA/FAP set out to employ artists *as* artists in the full-scale production of a democratic mass culture.[15] Holger Cahill, National Director of the WPA/FAP, wrote in 1939:

> During the past seventy-five years there developed in this country a tremendous traffic in aesthetic fragments torn from their social background, but trailing clouds of aristocratic glories. Fully four-fifths of our art patronage has been devoted to it. [He complains] people who would lay down their lives for political democracy would scarcely raise a finger for democracy in the arts. They say that . . . you cannot get away from aristocracy in matters of aesthetic selection . . . that art is too rare and fine to be shared with the masses.[16]

With WPA, a previously élite group of culture producers oriented itself to mass society. Again in 1939, the year that 'Avant-Garde and Kitsch' appeared, the painter Stuart Davis made this defence of abstract art:

> In addition to its effect on the design of clothes, autos, architecture, magazine and advertising layout, five-and-ten-cent-store utensils, and all industrial products, abstract painting has given concrete artistic formulation to the new lights, speeds, and spaces which are uniquely real in our time. That is why I say that abstract art is a progressive social force.

Davis is contemptuous of American social realism ('the chicken yard, the pussy cat, the farmer's wife, the artist's model'), but his critique is not made in the name of timeless cultural values:

I call the expression of domestic naturalism static. The expression remains static even in the class-struggle variety of domestic naturalism, because although the ideological theme affirms a changing society, the ideographic presentation proves a complete inability to visualise the reality of change.[17]

The dominant tendency within the WPA/FAP was documentary and didactic. The Federal Theatre staged documentary plays, 'Living Newspapers', in which the specific sources of the facts they presented were scrupulously footnoted. As part of the Federal Writers' Project the American Guide Series was produced, a combination of road guide and local history: 'a majestic roll call of national failure, a terrible and yet engaging corrective to the success stories that dominate our literature'.[18] 'Informant narratives' were commissioned, autobiographical accounts by 'ordinary' people. Such projects overlapped those of other WPA departments, notably the Farm Security Administration (FSA) programme of economic agitation on behalf of Southern tenant farmers, for which teams of writers and photographers were employed.

In America in the inter-war years 'art' approached a dismantling of the differentiation between 'high' and 'low' culture *in practice*; in ideology, however, this fact was not recognised. The documentary movement took place within clearly demarcated institutional spaces (Ben Shahn, for example, made photographs for the FSA and paintings, on the basis of the photographs, for the FAP); to adopt Benjamin's terminology,[19] US artists supplied the existing apparatus of production. European artists had already attempted to change it, and in so doing had attacked those distinctions between 'high' art and 'mass' art which had a technological base. After the First World War, avant-garde visual art practice in Europe became divided between that in which the notion of élite culture remained implicit, and that in which it was explicitly rejected. A characteristic response of artists opposed to what they saw as the class character of 'high' culture was to abandon those modes of artistic production historically most closely associated with it. Not surprisingly, this response was the most programmatic in Russia during the immediate post-revolutionary period where, by 1920, the *Lef*

group of ex-Futurists and Formalists had rejected the aesthetic-
ising tendencies of 'laboratory art' (for example, Malevich,
Gabo) in which the object was proclaimed as an end in itself,
and had outlined the objectives of 'production art'.

Alexei Gan
wrote in 'Constructivism' (1922): 'Painting, sculpture, theatre,
these are the material forms of the bourgeois capitalist aesthetic
culture which satisfies the 'spiritual' demands of the consumer
of a disorganised social order . . . (the constructivist) must be a
Marxist-educated man who has once and for all outlived art and
really advanced on industrial materials'.[20] Mayakovsky wrote:
'One of the slogans, one of the great achievements of *Lef* – the
de-aestheticisation of the productional arts, Constructivism. A
poetic supplement: agit-art and economic agitation: the
advertisement'.[21]

While some *Lef* artists (for example, Tatlin, Popova) entered
industry as designers, others embraced 'mass media'. Such an
engagement had begun during the massive propaganda and
education effort of the civil war period (1917–21): 'The
traditional book was, one might say, divided into separate pages,
enlarged a hundred-fold, painted in brighter colours and hung
up in the streets as posters. Unlike the American poster ours
was not planned to be taken in at a single glance from the
window of a passing car, it was meant to be read and digested
at close range'.[22] With the return of 'private enterprise' under
Lenin's New Economic Policy (1921), such propaganda efforts
were carried into the economic sphere. In an attempt to attract
people to state shops and goods, the *Agitreklama* group was
formed (supervised by Mayakovsky and including Rodchenko)
to produce both political and commercial posters.[23] By the late
1920s there emerged, amongst those concerned to find a way
between aestheticism and utilitarianism, a demand for an 'art of
fact'. The attack on traditional technologies and formats was
reiterated:

To the easel painting, which supposedly functions as 'a mirror
of reality', *Lef* opposes the photograph – a more accurate,
rapid, and objective means of fixing fact. To the easel painting
– claimed to be a permanent source of agit – *Lef* opposes the
placard, which is topical, designed and adapted for the street,

the newspaper and the demonstration, and which hits the emotions with the sureness of artillery fire. In literature, to *belles lettres* and the related claim to 'reflection' *Lef* opposes reportage – 'factography' – which breaks with literary traditions and moves entirely into the field of publicism to serve the newspaper and the journal.[24]

The artistic developments within Russia which culminated in the call for 'factography' may be seen as quite continuous with the tendencies of Futurism, and coherent with Mayakovsky's prerevolutionary demand that the classics be 'cast from the steamboat of modernity'. They are therefore not to be simplistically interpreted as an attempt to accommodate political pressure. Moreover, the factographic tendency emerged independently in various international centres during the same period. As noted above, in America documentary was to become the dominant aesthetic mode of the 1930s, and there is a *Lef* sentiment, albeit a less than *Lef* conviction, in these words of the supervisor of a Chicago WPA programme: 'The poster, serving the public, is readily understandable to the man on the street. While it may go through phases in its healthy growth, it is free from the many isms that infest the allied arts . . . The poster performs the same service as the newspaper, the radio, and the movies, and is as powerful an organ of information, at the same time providing an enjoyable visual experience.'[25] In the 1920s, however, it was in Germany that the move towards an art of fact was, outside of Russia, the most pronounced. It was in Germany also that the use of photography in this move was to become the most technically developed.

Tocqueville had remarked. 'In aristocratic countries a few great pictures are produced; in democratic countries a vast number of insignificant ones'.[26] Cheaply available, photography had early fulfilled the need for large numbers of 'insignificant' pictures – family portraits, view postcards, and so on. Photography became more significantly a 'mass medium' however, with the rapid expansion of photo-journalism in Germany, where photographically illustrated magazines were first developed, and where they had become an established success by the early 1920s.[27]

Technological developments in Germany allowed the transition from 'press photography' to 'photo-journalism': the Ermanox and the Leica cameras both appeared on the market, in small numbers, in 1924 and 1925 respectively. The Leica, a technological by-product of the film industry, incorporated technical features adapted from ciné-cameras to create a small camera, quick and easy to use, the most prominent of its advantages being its replacement of the single-exposure photographic plate by multi-exposure roll film (movie film). The Ermanox, although a plate camera which had to be used with a tripod, coupled an extraordinarily 'fast' lens (1.8, against the Leica's 3.5) with a very sensitive panchromatic plate (a relatively small one, 4½ × 6 cm), making it possible to photograph subjects in 'available light' (for example, by ordinary electric light) without the use of flash. Such new tools, used by photographers like Salomon, Man and Eisenstaedt, helped establish the idea, prevalent in the 1920s, of the camera as the representative instrument of the age.[28]

It was the phenomenological surface of industrial society to which the camera seemed to offer unprecedented access, and it is this which was celebrated in the earliest photomontages of avant-garde. Moholy-Nagy:

> In the photographic camera we have the most reliable aid to the beginning of objective vision. Everyone will be compelled to see that which is optically true, is explicable in its own terms before he can arrive at any subjective position. This will abolish that pictorial and imaginative association pattern which has remained unsuperseded for centuries and which has been stamped upon our vision by great individual painters.[29]

Vertov too had insisted on the *differences* between the world seen by the eye and the (more actual) world capable of being presented by the camera: 'The position of our bodies at the moment of observation, the number of features perceived by us in one or another visual phenomenon in one second of time is not at all binding on the film camera'.[30] Early attempts to formulate a theory of montage in the cinema had carried implications for still photography which ran counter to the conventional wisdom

in which it was held to be a 'transparent' medium of representation. For example, Kuleshov's experiments with Mozhukin, in which the same shot of the actor's impassive face was successfully juxtaposed with shots of a variety of objective situations, rebuffed the naturalist idea of photographic portraits as 'mirrors of the soul' – the audience read a different expression in the face for each successive juxtaposition. Further experiments with the actor Polonsky confirmed, in Kuleshov's words, 'this property of montage to override the actor's performance'.[31]

Kuleshov's experiments took place between 1916 and 1917. It is unlikely that they were known to the Berlin Dadaists whose work with montage began about the same time, nevertheless, there was a general, international, interest in 'filmic' construction then. Hausmann speaks of, 'the application of the photograph and printed texts which, together transform themselves into static film'.[32] Lissitsky wrote in 'The typography of typography' (1923), 'Printed words are seen and not heard . . . A sequence of pages is a cinématographic book'.[33] Szymon Bojko has cited the graphic artist S. Telingater attempting, in 1923, 'a bioscopic book', a 'ciné book' which could be read and viewed simultaneously – one in which the sequence of pages and pictures would be reminiscent of moving picture frames'.[34] Stott reports: 'Archibald MacLeish called his prose-poem accompanying FSA photographs in *Land of the Free* (1938) a "Sound Track"'.[35]

The 'layout' of the photomagazine had gone some way towards fulfilling Brecht's demand for 'something set up, something *constructed*' in photography; in the transition in Germany from *Dada* to *Tendenzkunst*, photomontage went further. Hausmann:

Photomontage allows the elaboration of the most dialectical formulas, by virtue of its oppositions of scale and structure. . . . Its domain of application is above all that of political propaganda and commercial publicity. The clarity neccessarily demanded of political or commercial slogans increasingly influences its means of counterposing the most arresting contrasts, expelling whims of intuition.[36]

John Heartfield's work for *AIZ* was almost entirely responsible for liberating photomontage from the formulas of cubism,

futurism, and 'cinématic' construction. It is probable that he
learned from the surrealists (Aragon judged that Heartfield,
'superseded the best in that which was attempted in modern art,
with the cubists, in that lost way of mystery in the everyday').[37]
Heartfield turned the affectivity that surrealist images derive
from their unresolved status in respect of fantasy and reality
upon the cognition of an actual material condition of the world.
The factographic tendency in art did not survive the 1930s in
any strong way. In 1932 the central committee of the CPSU
dissolved all existing writers' and artists' associations in order to
establish a single union of Soviet writers and analogous bodies
for the other arts. It was at this time that the notion of Socialist
Realism as such appears, and from this time that the Stalin/
Zhdanov line was rigorously enforced. In 1933 Hitler became
Chancellor of the German Reich. The Communist party was
banned and *AIZ* published its last Berlin issue in February, its
editors escaping to Prague, Heartfield among them, to continue
publishing as *Volks-Illustrierte* until 1936.

The various WPA arts projects were all eroded during the war
years or before (the WPA was officially liquidated in 1943) due
to practical exigencies brought about by the war itself, but due
also to repeated attacks by an increasingly conservative coalition
in Congress. (Appropriations for the Federal Theatre Project,
for example, were abruptly cut off as the result of a House
Committee on unAmerican Activities report in January 1939
that, 'a rather large number of employees on the Federal Theatre
project are either members of the Communist Party or are
sympathetic to the Communist Party'.[38])

II

Anyone aware of the 'factographic' visual art practice of the
interwar years in Eastern and Western Europe and America,
must be struck by the way Greenberg writes as if it had never
taken place. Quite simply, within Greenberg's scheme of things,
there is no *place* for it. In 'Avant-Garde and Kitsch' it is stated
that, beleaguered by mass culture, the ranks of art are to be re-
formed around 'those values only to be found in art'. That such

values exist, and that they are purely formal, is taken as self-evident. Thus the proper programme of artistic endeavour is simply established: 'Content is to be dissolved so completely into form that the work of art or literature cannot be reduced in whole or in part to anything not itself, . . . subject matter or content becomes something to be avoided like a plague'.[39]

In this, Greenberg's Modernism bears a close resemblance to the formalism of Roger Fry and Clive Bell. Fry attempted to extract from the work of Cézanne basic principles which could, retrospectively, be discovered in all previous painting. His interpretation of Cézanne was formed from his knowledge of the Cubists, of whom he said (1912): 'The logical extreme of such a method would undoubtedly be the attempt to give up all resemblance to natural form, and to create a purely abstract language of form − a visual music'.[40] In the same year, Bell wrote: 'To appreciate a work of art we need bring with us nothing but a sense of form and colour and a knowledge of three-dimensional space' (adding the qualification, 'the representation of three-dimensional space is neither irrelevant nor essential to all art, . . . every other sort of representation is irrelevant'). And he goes on to complain of those who, 'treat created form as though it were imitated form, a picture as though it were a photograph'.[41]

Formalism is typically defined in opposition to realism. In classic realism there is assumed an unmediated presentation of the referent through the sign (unmediated that is save for 'noise' in the physical channel of communication − problems of technique exercised in the interests of conformity to some prevailing model of reality). Realism is primarily 'about' content and major debates within realism concern subject matter alone (witness the recurring 'crisis of content' in nineteenth century painting).

With the hindsight granted us by Saussure we can today see that classic realism rests on a mistaken concept of signification: the sign is assumed to be 'transparent', allowing unproblematical access to the referent (effectively the same error is committed in naïve expression theory). Cubism we can see as constituting a radical critique of realism, a practice compatible with a recognition of the disjunction of signifier and signified within the sign. Post-Cubist Western formalism however did not develop as a

scientific aesthetics based upon a critique of the sign, but rather as a normative aesthetics based upon a notion of territoriality. Greenberg's formalism is in direct line of descent from the attempt by Bell and Fry to 'free' art from concerns not 'peculiarly its own'. With Bell, recourse is made to a Kantian ontology (a *noumenal* world 'behind' mere appearances) in order to justify abstraction, whereas Greenberg (albeit a self-avowed Kantian: 'I conceive of Kant as the first real Modernist') claims that the Modernist art object denotes nothing other than itself: 'Thus would each art be rendered "pure", and in its "purity" find the guarantee of its standards of quality as well as of its independence'.[42]

As both support an immanent analysis of art, Greenberg's ideas and those of the Russian Formalists have of late tended to be associated as similar; but there are some important differences. Attacking Symbolism, the Formalists rejected the Symbolist idea of form in which form the perceivable, was conceived in opposition to content, the intelligible. They extended the notion of form to cover all aspects of a work. Todorov:

> The Symbolists tended to divide the literary product into form (i.e. sound), which was vital and content (i.e. ideas), which was external to art. The Formalist approach was completely opposed to this aesthetic appreciation of 'pure form'. They no longer saw form as opposed to some other internal element of a work of art (normally its content) and began to conceive it as the totality of the work's various components . . . This makes it essential to realise that the form of a work is not its only formal element: its content may equally well be formal.[43]

Russian Formalism therefore differs substantively in this from the formalism of Bell and Fry, and from Greenberg's Modernism, in which all considerations of content are arbitrarily banished in a quasi-legal ruling.

Russian Formalism again differs importantly from Modernism in its attitude to 'tradition'. Greenberg: 'Lacking the past of art and the need and compulsion to maintain its standards of excellence, Modernist art would lack both substance and justific-

ation'.[44] This statement could serve as a prescription for academicism; in 'Avant-Garde and Kitsch' he had written, 'avant-garde culture is a superior sort of Alexandrianism. But there is one important difference: the avant-garde moves, while Alexandrianism stands still. And this, precisely, is what justifies the avant-garde's methods and makes them necessary'. As 'movement' is the central concept in Greenberg's legitimation of Modernism it is worth considering it at some greater length.

A familiar model of movement is used; the dominant version of art historical motion, it is the one we might call the 'problem/solution' model: any given 'generation' of artists attempts to solve the problems they inherited from the previous generation; the solutions they provide are only partial ones; so, in turn, their failures provide 'problems' for the succeeding generation. An early version of this model was provided by Vasari: Giotto was more successful at rendering three-dimensional space than had been Cimabue; Masaccio represented an improvement over Giotto . . . and so on, the whole effort culminating in Michaelangelo and Raphael. This Renaissance model has been taken over into the Modern period. The basic components the historian has to deal with are 'movements' in art (produced by 'generations' of artists) and the relationship between these movements is causal. This version lends the illusion of purposive movement to what might equally well be described as a contingent succession of collapses, bringing conservation and continuity out of impermanence and waste, and providing the basis for what Edgar Wind (again, speaking of the Renaissance) called, 'a proud art which is no-one's servant, posing all its problems from within'.

Greenberg retrospectively imposes a picture of over-all 'progress' upon the Modern period:

> Manet's became the first Modernist pictures by virtue of the frankness with which they declared the flat surfaces on which they were painted. The Impressionists, in Manet's wake, abjured underpainting and glazes, to leave the eye under no doubt as to the fact that the colours used were made of paint which came from tubes or pots. Cézanne sacrificed verisimiilitude, or correctness, in order to fit his drawing and design more explicitly to the rectangular shape of the canvas.

The putative goal of this progress, and there must be a goal
if progress is to be assessed, was, 'the stressing of the ineluctable
flatness of the surface that remained . . . Because flatness was
the only condition painting shared with no other art, Modernist
painting oriented itself to flatness as it did to nothing else'. But
further, as:

> Modernist art continues the past without gap or break [it
> therefore follows] . . . Leonardo, Raphael, Titian, Rubens,
> Rembrandt or Watteau. What Modernism has shown is that,
> though the past did appreciate these masters justly, it often
> gave wrong or irrelevant reasons for doing so.[45]

The re-reading of old works in new contexts can refresh both
the work and the context, but such a hermeneutics is not to
be confused with history. Greenberg's account of art history is
innocent of any reference to political, economic, sociological,
or technological determinants contemporary with, and possibly
operative within, the 'purely aesthetic' decisions he describes.
He projects into the past a set of unargued assumptions and
their reflection is returned unmodified in all but one respect,
their status has been inverted – no longer mere assertions they
are now indisputable facts supported by 'history'.

The Russian Formalists did not subscribe to a view of linear
descent in art, but rather saw history as a succession of disconti-
nuities, 'sideways leaps', represented in Shklovsky's image of the
'knight's move'. According to Shklovsky, 'in the liquidation of
one literary school by another, the inheritance is passed down,
not from father to son, but from uncle to nephew'.[46] This concep-
tion accommodates the incorporation into art of previously
peripheral, or popular, art forms. ('New forms in art are created
by the canonization of peripheral forms. Pushkin stems from the
peripheral genre of the album, the novel from horror stories,
Nekrasov from the vaudeville, Blok from the gypsy ballad,
Mayakovsky from humorous poetry.'[47]) Again, Greenberg insists
upon the particular *material* attributes peculiar to painting: 'The
limitations that constitute the medium of painting – the flat
surface, the shape of the support, the properties of the pigment',
whereas the Formalists were concerned with *abstract* 'devices',

such as 'laying bare' and 'defamiliarisation', peculiar to the literary text (the Symbolists had made a fetish of the material – sound). Thus, while Greenberg's focus is upon the substance of the text, that of the Formalists was upon the ordering of the substance through the device. Eichenbaum: 'art's uniqueness consists not in the parts which enter into it, but in their original *use*'.[48]

It has been charged that Shklovsky's important notion of *ostranenie* (the device for 'making strange') had the purely aesthetic end of turning perception upon itself as its own object; as such, it might conceivably be assimilated to Greenberg's idea of Modernist painting as set exclusively upon, 'what is given in visual experience'. However, to the Formalists, the fore-grounding of the device *as such*, through its self-revelatory construction, has a necessary cognitive corollary:

Why need it be stressed that the sign is not confused with the object? Because alongside the immediate awareness of the identity of sign and object (A is A'), the immediate awareness of the absence of this awareness (A is not A') is necessary; this antinomy is inevitable, for without contradiction there is no play of concepts, there is no play of signs, the relation between the concept and the sign becomes automatic, the course of events ceases and consciousness of reality dies.[49]

The Formalists never confused the ends of poetics with the ends of art. Such a confusion, however, is to be found in Green-berg's writings. For example, when Jakobson writes: 'the main subject of poetics is the *differentia specifica* of verbal art in relation to other arts and in relation to other kinds of verbal behaviour',[50] he is defining the role of a branch of literary studies. When Greenberg says: 'What had to be exhibited was not only that which was unique and irreducible in art in general, but also that which was unique and irreducible each particular art',[51] Greenberg is defining the role of a branch of art. Greenberg collapses the project of art into that of art criticism, which leads him to make defensive remarks *vis-à-vis* the scientific status of art; whereas the Formalists were concerned only that *criticism* should become scientific. Jakobson is explicit:

Neither Tynyanov, nor Mukarovsky, nor Shklovsky, nor I have preached that art is sufficient unto itself; on the contrary, we show that art is part of the social edifice, a component correlating with others, a variable component, since the sphere of art and its relationship with other sectors of the social structure ceaselessly changes dialectically. *What we stress is not the separation of art, but the autonomy of the aesthetic function.*[52] (my italics)

III

Inescapably, the *work* of visual art is work in and on *representation.* Barthes observes: 'Representation is not defined directly by imitation: even if one gets rid of notions of the 'real', of the 'vraisemblable', of the 'copy', there will still be representation for so long as a subject (author, reader, spectator or voyeur) casts his *gaze* towards a horizon on which he cuts out the base of a triangle, his eye (or his mind) forming the apex'. He continues: 'The "Organon of Representation" (which it is today becoming possible to write because there are intimations of *something else*) will have as its dual foundation the act of cutting out (*découpage*) and the unity of the subject in that action'.[53]

The structure of representation, the eye and the base which captures it, is intimately implicated in the reproduction of ideology (we speak of a 'point of view', a 'frame of mind'). We know we see a two-dimensional surface, we believe we look through it into three-dimensional space, we cannot do both at the same time – there is a coming-and-going between knowledge and belief. We know that what is given in the material configuration, the 'image', does not exhaust the representation, made across the image in memory and association, yet the two *appear* as co-extensive – there is an alternation between perception and reflection. As perception is held in cognition, so cognition is held in ideology: natural meaning drains from an image, converting it into a vacant form to receive an ideological content, but in the instant we make this observation the literal meaning returns – literal meaning and ideological motivation are caught in a 'turnstile'.[54] In the same movement in which the phenomeno-

logical world is transformed into the 'real', so the real is trans-
formed into reality-in-ideology.
 Such operations upon meaning are those of an 'individual',
but the founding unity of this subject exists only in ideology.
Thus, Althusser: 'all ideology has the function (which defines it)
of "constituting" concrete individuals as subjects'. Ideology is
itself, 'a "representation" of the imaginary relationships of indi-
viduals to their real conditions of existence'.[55] In Althusser's
metaphor of the structure of representation 'window' becomes
mirror: ideology stands in a *specular* relationship to the subject.
This image of specularity implies another, that of the 'mirror-
stage' in the formation of the human being, described by
Lacan.'[54] Between its sixth and eighteenth month, the infant,
which experiences its body as fragmented, uncentered, projects
its potential unity, in the form of an ideal self, upon other bodies
and upon its own reflection in a mirror; at this stage the child
does not distinguish between itself and others, it *is* the other, it
is 'captured' by an image; its recognition of itself in the
'imaginary' order is of a reassuring coherence, but it is a *misrec-
ognition*. Our knowledge that we are subjects, free to choose
(an 'obviousness'), is similarly a misrecognition, an 'ideological
effect'. What we know as our individual subjectivity is our reflec-
tion in the world constituted in ideology, a world which in its
imaginary fullness is more whole, more free of contradiction,
than it is in lived experience:

 All ideology represents in its imaginary distortion not the
 existing relations of production (and the other relations that
 derive from them), but above all the (imaginary) relationship
 of individuals to the relations of production and the relations
 that derive from them.[57]

 The child's experience of imaginary fullness and coherence
is finally brought into crisis through its acceptance of sexual
difference, the structure of 'castration' opening the way to the
'symbolic' order of articulation on the basis of presence and
absence; the illusion of a centered and stable autonomy may
now be shed in acceptance of the lived facts of contradiction,

dialectic, intersubjectivity, the unending process of becoming. However:

> The imaginary and the symbolic being close correlates, there is always a possibility of a regression in man to the imaginary mode, with its hankering after the super-real, permanent object. When this happens there is a withdrawal from the open exchange of truth in human discourse, and the world becomes the representation of a petrified thing at the service of the hallucinatory satisfaction of a primal desire.[58]

Sections of the interwar years avant-garde recognised the institution of art as one of a complex of 'apparatuses' serving to reproduce ideological forms of consciousness. Across the institution 'art', an attempt was made to separate what was scientific in art from what was ideological, in order to demystify not only 'art' but the other symbolic practices, notably those of the mass media, with which art *in actuality* forms an organic whole. In this light, Cubism and its sequel appears differently from the way it is *normally* presented in the 'history of art' (that which abstracts 'art objects' from the history of art *practice*). Modernist historicism characterises the Cubists as opening the door upon 'objecthood', but it is a door through which they themselves declined to pass. The most 'hermetic' Cubist paintings contain fragments (Eco's *recognition semes*[59]) which can catalytically transform any reading couched purely in terms of surface autonomy. There is neither the presentation of 'pure signifier' (Modernism) nor 'pure signified' (realism) but rather an attempt perpetually to prevent the one from collapsing into the other. Cubism is not the fledgling 'non-representational' art it is presented as, it is a mature body of work on representation.

Cubism subverted the founding unity of the subject in its 'natural' understanding of the coherence of 'objective' reality; photography, meanwhile, was confirming it (the part played by the *camera obscura* in the development of Renaissance perspective is well known). The avant-garde development of photomontage was in part, as already observed, a repudiation of the class connotations of the technology of painting – photography had become the major 'visual' instrument in the formation of

mass culture – it must additionally be recognised however as an intervention at a critical moment in the history of representation. The use of photocollage in the deconstruction of monocular perspective thus appears as historically 'over-determined', doubly concerned with that which was *critical* in visual art at that particular historical conjuncture: that it should resist the return of the imaginary for which idealist abstraction and photographic 'realism' alike were preparing it.

In his discussion of the representational 'tableau', Barthes observes that the *découpage* it operates is selective, the instant cut-out total and perfect, 'a hieroglyph in which can be read at a single glance . . . the present, the past and the future; that is, the historical meaning of the represented action'.[60] He finds an early discussion of this 'perfect instant' in Diderot's discussion of painting, and in Lessing, where it appears in the *Laocoon* as the 'pregnant moment'. In one of its projections into the present it has become the 'decisive moment'[61] of documentary photography. In an earlier essay,[62] Barthes had spoken of the 'reality from which we are sheltered' given in photography. The 'cut-out', representation, separation, all take position within the structure of fetishism. In fetishism, an object serves in place of the penis with which the child would endow the woman (the fact of her 'incompleteness' threatening the child's own self-coherence). The fetishised object is thus doubly charged with significance: as guarantor of completeness, and as memory of lack. Fetishism thus accomplishes that separation of knowledge from belief characteristic of representation; its motive is the unity of the subject. The photograph stands to the subject-viewer as does the fetishised object: it is to be looked at; the look gives pleasure; it affirms an existence beyond itself; it simultaneously denies the presence of that existence.[63]

Dominant attitudes to photography valorise the fetish. Commercial photography and 'art' photography are alike in this, the 'glossy' effect of the former having its fetishistic counterpart in the 'fine print' of the latter. Not surprisingly, this identity of motivation of 'art' and 'commercial' photography is most conspicuous where the female body is depicted. It is not a contradiction to observe that the woman's body is simultaneously origin of unconscious trauma and object of conscious celebration.

Laura Mulvey has described the dominant psychical formations determining the representation of women within the patriarchal order;[64] she finds that amongst the means of flight from castration anxiety is, 'turning the represented figure itself into a fetish so that it becomes reassuring rather than dangerous', observing, 'fetishistic scopophilia builds up the beauty of the object, transforming it into something satisfying in itself'. Such determinations leave their trace within the photographs of Edward Weston and Helmut Newton alike.

Benjamin was wrong in supposing that photography would put an end to the 'fetishistic and fundamentally anti-technical notion of *Art*'. The fetishistic attitude to traditional art objects has by degrees become extended to photography and film. Nor has the societal effect of photography been superseded by that of films as Benjamin implied it would; rather it has become pervasive to the point where it has practically ceased to be visible. While films and paintings readily constitute themselves as *objects*, thus facilitating critical attention, photography, as constituted in the mass media, is received as an *environment* and passes relatively unremarked. Photography is encountered, in most aspects of daily life, as a fragmented or partial object: photojournalism, amateur, advertising, documentary . . ., and so on. Semiotically, these cannot be said to be the manifestations of a single fact. There is no single *signifying system* (as opposed to technical apparatus) upon which all photographs depend, in the sense in which all texts in English ultimately depend upon the English language; there is no 'language of photography' in the sense of *langue*. There is rather a heterogeneous complex of codes upon which photography may draw (to follow Metz, a *langage* of photography). Each photographic text signifies on the basis of a plurality of codes, the number and type of codes involved varying between texts; some of these are (at least to first analysis) peculiar to photography (for example, the various codes build around 'focus'), others are clearly not (for example, the 'kinesic' codes of bodily gesture).

The expression 'photographic text', although clumsy, is used here as it breaks with the notion of an unproblematically coherent *image* that the term 'photograph' implies. Amongst the intertextual references that a photograph (or any other image)

makes, are references to language itself. These references may
or may not have been intended by the producer of the text, but
they are present in any reading of an image. (For example, a
prominent area of darkness in an image is never merely an
indifferent fact to perception; it carries all the weight of signific-
ation that darkness has been given in social use, and many of its
'interpretants' will be linguistic – as when we speak metaphor-
ically of an unhappy person being 'gloomy'). Beyond the inter-
mittent 'literarisations' made across the image in 'inner speech',
we are also likely to encounter the written text as a material
presence within or alongside the image. It is particularly unusual
to come across a photograph *in use* which does not have a caption
or a title. It is more usual to encounter photographs attached to
long texts, or with copy superimposed over them. The ideological
resistance, in the name of the 'purity' of the *Image*, to the
consideration of linguistic matter within and across the photo-
graph is no more or less well founded than that which met the
coming of sound in the cinema.

Although there is no institution comparable to that of the
cinema within which the heterogeneity of 'photography' may be
grasped as a 'social fact', the most conspicuous photo-textual
social fact is advertising, and the early interest of the avant-garde
in advertising (for example, Mayakovsky, Heartfield) was not
gratuitous. Today, advertising constitutes a massive ideological
intervention in western culture. Confirming individual subjective
consciousness in its misrecognition of the 'real', representation
in advertising inscribes the imaginary position of the consumer
within this 'reality'; the subject consumes itself, ingests its own
reflection in ideology (all of this 'goes without saying'). We know
that advertising can be *read* by the mass of the population. This
intelligibility is no simple thing; characteristically it may only be
described by reference to complex intertextual operations which
link the actual text to an overlapping series of previous texts
'taken for granted' at a particular cultural and historical moment.
These prior texts, those *presupposed* by the advertisement, are
autonomous; they serve a role in the actual text but do not
appear in it, they are latent to the manifest text and may only
be read across it 'symptomatically' (like the dream in Freud's
description, advertising texts are typically *laconic*). We may

generally expect 'readability' to be a product of repetition: the entry into the text of the already read, the already seen, according to familiar rules of combination. With Shklovsky, poetics came to value the 'read-with-difficulty' achieved through 'deconstruction'; it has since come to be held within some art theory that deconstruction attacks ideology *necessarily*, as ideology is itself constructed within the dominant codes. We might note, however, that commercial publicity is often made as if the lessons of the Formalists were being assiduously applied (we may recall Jakobson's analysis of a campaign slogan); in this, publicity occasionally exhibits a high degree of what information theory calls 'originality' in regard to the codes.

Most recently, the idea that transgressions of the dominant codes are *inherently* 'political' has been strengthened in the course of Kristeva's critique of the Prague School and the Formalists. To Kristeva, as social relations are co-extensively bound within the symbolic practices which both found and represent them, the irruptions of unconscious processes into the systematic order of language – revealing contradictions inherent in the formation of the text – necessarily illuminate contradictions in social life. The 'symbolic' text, the site of signification and the object of linguistics and structuralist semiology, lives at risk. The 'real' which it founds in representation, the ideological appropriation it stresses, is under stress from the insistence of the 'semiotic' repressed by it. In an example given by Kristeva, the 'semiotic disposition' of 'poetic language' reveals itself in: 'articulatory effects which shift the phonemative system back towards its articulatory, phonetic base'; 'the overdetermination of a lexeme by multiple meanings which it does not carry in ordinary usage'; 'syntactic irregularities such as ellipses, nonrecoverable deletions, indefinite embeddings, etc.'; and other 'deviations from the grammatical rules of the language'.[65] These are symptoms of the operation of the primary process, in which a free flow of psychical energy associates ideas via the mechanism of condensation and displacement, bypassing and subverting the codes of discourse. (This simultaneous presence of the 'semiotic' and the 'symbolic' Kristeva terms *signifiance*, which is thus a more extensive system than the *signification* which unites signifier and signified in the symbolic.)

The transgression of codes more or less consciously brought about in poetic language simultaneously reveals the construction of language and its materiality (the phonetic base, *sound*). Its destination would seem to be the *Text* in Barthes's sense, 'music'. The 'musical' *Text* in painting would 'foreground' the constructional devices consonant with the form of the support (the systemic pre-given), and the material constituents of the visible surface, this in fact is Modernist practice. (Fried spoke of the way the visual configuration of Stella's paintings were 'generated' by the shape of the support, attributing Stella with an 'advanced attitude towards the framing edge'). Kristeva equates transgression of the codes *in itself* with the deconstruction of the ideological subject. We should bear in mind here that the case of abstract painting is unlike that of language in a fundamentally important respect; in language, the transgression of the code, no matter how extreme, is measured against the code. Whether in the occasional and involuntary form of the *lapsus*, or in the more or less voluntary act of poetry, the transgression produces meanings which are neither intended by a founding individual *nor gratuitous*; these meanings return as it were from another place, another 'point of view', to subvert the ideological formations within the code. 'Abstract' art does not transgress codes of representation, it leaves them alone, thus abandoning itself to ideological appropriation – the case of 'abstract' painting in recent history provides a practical illustration.

IV

In an essay of 1957 on 'The Late Thirties in New York', Greenberg writes: 'some day it will have to be told how "anti-Stalinism", which started out more or less as "Trotskyism", turned into art for art's sake, and thereby cleared the way, heroically, for what was to come'.[66] What was to come, as we know, over a period of unprecedented economic expansion in the US (which emerged at the end of the war with three-quarters of the world's invested capital and two-thirds of its industrial capacity), was the almost total 'depoliticisation' of American art.

'In July 1956', Egbert reports, 'the director of the U.S.I.A. declared before a Senate Foreign Relations sub-committee that it had become the Agency's policy to include no works by politically suspect artists in exhibitions overseas; and it was now indicated that there would be no further government sponsored exhibitions abroad of paintings executed since 1917, the year of the Bolshevik Revolution'.[67] But 1956 was also the year of Khrushchev's denunciation of Stalin at the Twentieth Congress of the CPSU. The Cold War 'thaw' which followed released a flood of modern American art upon the world in a series of US Government and Industry sponsored exhibitions. Much of the work toured was the 'abstract' art which had previously been considered politically subversive simply because it offended the philistinism of conservative politicians. Increasingly, however, abstraction came to connote not 'Bolshevism' but, by virtue of the *difference* it established in opposition to official Soviet socialist realism, 'freedom of expression' (Eco has described the mechanism of such inversions of ideological evaluation in terms of *code switching*[68]). Thereafter, throughout the programme of foreign intervention by the US in the 1960s, Modernist painting exhibited a high use-value in the promotion of American *cultural* imperialism.

The question of the 'political' effect of art is a complex one, not confined to crude cases of simple instrumentality in the service of a pre-formed 'message'. Consideration must be given not only to the internal attributes of a work but also to its production and dissemination in and across the institutions within which its meaning is constituted. Nevertheless, in its 'dialectical relation to the other domains of culture' the contents of art are not a matter of indifference, nor can they be legislated out of existence by the gratuitous adoption of the concept of an Edenic 'pure signifier'. Willy-nilly, art has meanings thrust upon it; one such meaning is a function of the *uses* to which the work may lend itself. Ideology abhors a vacuum; the exclusion of all trace of the 'political' from the signifieds of a work may merely deliver it into complicity with the status quo.

Modernist practice, including the current post-conceptual Modernism, has accepted Greenberg's proposal that art withdraw completely from the actual world of social and political

struggle in order to preserve 'the historical essence of civilisation' into an indeterminate future when all will have become 'cultivated' enough to appreciate it. At the end of 'Avant-Garde and Kitsch', in rather strangely appealing to socialism for the preservation of (bourgeois) culture, Greenberg asserts, 'Here, as in every other question today, it becomes necessary to quote Marx word for word'. He never does quote Marx; were he to do so he would find himself contradicted, for example, from the third of the *Theses on Feuerbach*:

> The materialist doctrine that men are products of circumstances and upbringing, and that, therefore, changed men are products of other circumstances and changed upbringing, forgets that it is men who change circumstances and that it is essential to educate the educator himself. Hence, this doctrine necessarily arrives at dividing society into two parts, one of which is superior to society.

The materialism to which Modernism lays claim is an undialectical positivism. It is a materialism condemned elsewhere in Marx's short text on Feuerbach in that, 'the thing, reality, sensuousness, is conceived only in the form of the object or of *contemplation*, but not as *human sensuous activity, practice*, not subjectively'. Modernist criticism characteristically seizes its 'objects' in a language which draws equally upon geometry and gastronomy in recommending them, from palette to palate, to the fine tastes of a discriminating consumer ('the plane-units multiplied in complete independence of the laws under which surfaces and their planes materialised in non-pictorial reality',[69] and, 'his paint matter is kneaded and mauled, thinned or thickened, in order to render it altogether chromatic, altogether retinal . . . Soutine's touch came as if from heaven'.[70] Recently, some Modernists have seized the opportunity to spice the culinary *jeu d'esprit* with the more rigorous language of 'deconstruction' and 'foregrounding'. Russian Formalism is particularly available to such misappropriation in that, as Kristeva put it, 'when it became a poetics, [it] turned out and still turns out to be a discourse on nothing or on something which does not matter'.[71]

In its implications for art theory, Formalist and structuralist analysis ranges beyond the prior categories of 'high' culture to identify 'aesthetic' strata within the general semiotic landscape, exposing the *community* of such formations across the totality of signifying practices. Its demonstration of the ubiquitousness of the 'poetic' was necessary to materialist art theory; as an end in itself however it was reductionist, yielding a universal poetics of pansemiotic features which elided all that distinguishes one signifying practice from another. However, it would be a pity if art theory/criticism/history, at a time when semiotic theory in general is filling in the spaces which the Formalists left blank (deferred until too late), and therefore changing the appearance of the picture, should retreat from the breadth of concerns of 'classic' semiotics (the inclusion of advertising, photography, and so on); particularly as, as noted above, there is a history of such concerns in art practice in the Modern period.

Art theory should not accept only those objects pre-constituted in ideology. A rigorous theory would begin by bracketing the dominant received notions of 'high' art practice. However, as these are intimately bound up with the society which produces them, the theorist is unavoidably precipitated into an awkward self-reflexivity. (For example, he or she might consider the determining influence of his or her own class position in a society ordered according to a system of privileges.) Tocqueville early recognised the danger for self-oriented culture producers, he warned:

> By dint of striving after a mode of parlance different from the common, they will arrive at a sort of aristocratic jargon which is hardly less remote from pure language than is the coarse dialect of the people. Such are the natural perils of literature among aristocracies. *Every aristocracy that keeps itself entirely aloof from the people becomes impotent*, a fact which is as true in literature as it is in politics.[72] (my italics)

Writing in 1939, in 'Avant-Garde and Kitsch', Greenberg expresses a familiar, fearful, placing of 'the plebeian' within a scenario which assumes that Victorian opposition between 'culture and anarchy':

It is a platitude that art becomes caviar to the general when the reality it imitates no longer corresponds even roughly to the reality recognised by the general. Even then, however, the resentment the common man may feel is silenced by the awe in which he stands of the patrons of this art. Only when he becomes dissatisfied with the social order they administer does he begin to criticise their culture. Then the plebeian finds courage for the first time to voice his opinions openly. Every man, from the Tammany alderman to the Austrian house-painter, finds that he is entitled to his opinion. Most often this resentment toward culture is to be found where the dissatisfaction with society is a reactionary dissatisfaction which expresses itself in revivalism and puritanism, and latest of all, in fascism. Here revolvers and torches begin to be mentioned in the same breath as culture. In the name of godliness or the blood's health, in the name of simple ways and solid virtues, the statue-smashing commences.[73]

Brecht, writing in 1938, saw things differently:

There is only one ally against the growth of barbarism: the people on whom it imposes these sufferings. Only the people offer any prospects. Thus it is natural to turn to them, and more necessary than ever to speak their language.[74]

Shortly after the October revolution there were Russians who declared that their existing railway system was bourgeois, that it would be unseemly for Marxists to use it, and that it should therefore be torn up and new 'proletarian' railways built. Stalin called these enthusiasts 'troglodytes'. In a Modernist analysis (albeit a fanciful one), railway systems might be defined as consisting essentially of tracks to support engines, and engines to run on tracks; passengers and freight would be seen as so much content extraneous to the system and serving only to retard its efficiency and speed.

'The "cultural heritage", rejection or conservation?' is actually a mystificatory problematic; the past of art is simply one of a number of terms to be engaged dialectically within a specific historical situation. Art practice has not been 'surpassed by and

in the media' (Enzensburger), nor is it a sanctuary for 'higher' values, as Greenberg would have it. But this brings us closer to the historical issue.

We began with the question of the appropriation of semiotics to Modernism; throughout the positions sketched above is a tendency to place the artist, the intellectual, always on the privileged side of the break between real and imaginary, science and ideology.

Such confidence occludes the current problem common to both art 'theorists' and 'practitioners' (a division of labour which is *part* of the problem): The continuing appropriation of culture in general as the place from which a class (and/or 'the intelligentsia') hands down its own Name.

The Absence of
Presence: Conceptualism
and Postmodernisms

The 'conceptual art' of the late 1960s to early 1970s was an affront to established values, hostility to the new work being often so intense as to suggest that more than merely aesthetic values were at stake. Today the excitement has died down. Recollected in tranquillity conceptual art is now being woven into the seamless tapestry of 'art history'. This assimilation, however, is being achieved only at the cost of amnesia in respect of all that was most radical in conceptual art. I want to say something of what I believe has been repressed in the almost universal tendency, in the art world of the 1980s, to 'lose' an entire decade – the 1970s – as a period in which 'nothing happened'. As what characterises the present moment in the art world is a certain notion of 'post-modernism', now being used to support a wholesale 'return to painting', then I shall address my remarks to these issues. In order to show you these objects from my own vantage point, however, I shall have to pass by way of some history and theory which may at times appear to be leading nowhere in particular. I ask for your patience, there is no other route.

The conceptualism of the late 1960s was a revolt against modernism – specifically, we should add, as formulated in the writings of the American critic Clement Greenberg. Greenberg

defined modernism as the historical tendency of an art practice towards complete self-referential autonomy, to be achieved by scrupulous attention to all that is *specific* to that practice: its own traditions and materials, its own *difference* from other art practices. This Greenbergian project is actually a particular nuancing of a more general set of assumptions. Simply put, the underlying assumptions of Greenberg's modernism go something like this: *Art* is an activity characteristic of humanity since the dawn of civilisation. In any epoch the *Artist*, by virtue of special gifts, expresses that which is finest in humanity (as Greenberg puts it, 'the historical essence of civilisation'). The visual artist achieves this through modes of understanding and expression which are 'purely visual' – radically distinct from, for example, verbalisation. This special characteristic of art necessarily makes it an autonomous sphere of activity, completely separate from the everyday world of social and political life. The autonomous nature of visual art means that questions asked of it may only be propertly put, and answered, in its own terms – all other forms of interrogation are irrelevant. In the modern world the function of art is to preserve and enhance its own special sphere of civilising human values in an increasingly dehumanising technological environment.

If these beliefs sound familiar – perhaps even self-evident – it is because they long-ago became part of the received common sense we in the West learn at our mother's knee. They are the extension, into the twentieth century, of ideas which first began to emerge in the late eighteenth century as part of what we know today as 'romanticism' (although some are of much earlier origin). They underpin not only Greenberg's modernism but also some conceptualism, as well as those current forms of painting and sculpture which lay claim to a 'post-modernist' status in that they have reverted to the figurative image (Greenberg's modernism was to be rigorously abstract – content, he wrote, was 'something to be avoided like a plague'). Although the beliefs and values of romantic modernism are disseminated throughout Western culture, they tend to be inflected differently according to national location. Our dominant domestic variety – the unquestioned, and unquestionable, common sense of the majority of British critics, historians, curators, dealers, teachers,

collectors, amateurs, and artists – is the Bloomsbury version, derived principally from the Edwardian aesthetes Clive Bell and Roger Fry. Bell and Fry inherited a certitude from the moral philosophy of G. E. Moore, according to whom some things are simply 'good in themselves'; amongst these things is 'the enjoyment of beautiful objects'. It is unlikely that anyone would disagree that this pleasure is *good*, but the question which Bell and Fry systematically suppressed is whether it is *sufficient* to account for the complex of very different practices in history which we clumsily and a-historically lump together as 'Art'. This suppression Bell and Fry achieved with the doctrine of the 'purely visual' (specifically, the 'significant form' which can give rise to 'aesthetic emotion'), a notion which has a history going back to Plato. In the *Phaedo*, Plato puts into the mouth of Socrates a doctrine of two worlds: the world of murky imperfection to which our mortal senses have access, and an 'upper world' of perfection and light. Discursive speech is the tangled and inept medium to which we are condemned in the former, while in the latter all things are communicated visually as a pure and unmediated intelligibility which has no need for words. The idea that there are two quite distinct forms of communication, words and images, and that the latter is the more direct, passed via the Neo-Platonists into the Christian tradition. There was now held to be a divine language of *things*, richer than the language of words; those who apprehend the difficult but divine truths enshrined in things do so in a flash, without the need for words and arguments. As E. H. Gombrich has observed, such beliefs 'are of more than antiquarian interest. They still affect the way we talk and think about the art of our own time'.[1] The antiquated legacy of Bloomsbury is today a self-complacent cult of 'taste' and 'response' which stifles 'intellectualisation' to protect a supposed 'authenticity' of expression and feeling – that which comes as 'second nature', or as Pascal observed, 'first habit'. The source of stimulus of the aesthetic response (this aesthetics is unwittingly Pavlovian) is the *art object*, which in turn is the representative of the sensibility of the *artist*. At this point we touch the bed-rock of conservative aesthetics, where two ideological elements are fused: 'humanism', and what the French philosopher Jacques Derrida has called 'logocentrism'.

'Humanism' is one of a complex of words which have as their common root the Latin word for *man*. Raymond Williams, in *Keywords*, notes the sixteenth century emergence of the word 'humanist' to describe a scholarly interest in 'human as distinct from divine matters'; a good part of this interest was involved in the rediscovery and re-evaluation of classical, 'pagan', civilisation. In *Roget's Thesaurus*, which originated in the nineteenth century, the term 'humanism' is placed under the general heading *Philanthropy*, where it is flanked on the one side by 'benevolence' and on the other by 'internationalism'. Today, 'humanism' is perhaps most strongly connected with considerations of, and defence of, 'human rights – usually, the defence of the rights of the *individual* against oppression, particularly from the various forms of the state and its representative bodies. The 'individual' presupposed in humanism is an autonomous being, possessed of self-knowledge and an irreducible core of 'humanity', a 'human essence' in which we all partake, an essence which strives over history progressively to perfect and realise iteslf. This individual is known to us as, for example, the star of such television shows at Lord Clark's *Civilisation* and Dr Bronowski's *The Ascent of Man*, and it is of course the central figure of that form of art history which likes to view the past as a parade of 'Great Men' [*sic*]. From even this sketchy account we may appreciate the difficulties facing those who have argued against the humanist picture of history and individuality: to do so not only goes against the grain of common sense, but every 'theoretical anti-humanist', from Freud to Foucault, is assumed to be an enemy of civilised aspirations; the rejection of *humanism* (a philosophical doctrine) is understood as a callous assault on *humans* (people, or more heinously, on the left at least, *the people*). I shall come back to humanism, but first I want to say something about 'logocentrism'.

Derrida coined the term 'logocentrism' to refer to our tendency to refer all questions of the meaning of 'representations' – novels, films, photographs, paintings, and so on – to a singular founding presence which is imagined to be 'behind' them, whether it be the 'author', 'reality', 'history', 'zeitgeist', 'structure', or whatever. Derrida has argued that such ways of thinking are endemic throughout Western history. He points out that

from its beginning the whole of the Western philosophical tradition has been suffused by what he calls a 'metaphysics of presence' founded on the privileging of speech over writing. When I speak I am aware of no real distinction between my thoughts and feelings and my words, and if the person to whom I am speaking doubts my meaning I can supply words of clarification. The words I speak seem transparently to reveal what is 'on my mind' or 'in my heart', but once committed to writing they are separated from me; they become subject to interpretation by the reader, and thus to possible *mis*interpretation; moreover, the reader cannot be certain that they are indeed *my* words – separated from their origin, and thus from the guarantor of their meaning and authenticity, written words become doubly suspect. However, the belief that meaning can ever be present, pre-constructed in its full integrity, 'behind' a unit of language, or any other representational form, is an *illusion* of language. In whatever form, meaning is only ever produced within a complex play of differential relationships in which the final *closure* of meaning upon a point of original certainty is endlessly deferred. In sharing this common condition of all signifying systems, speech is on the same level as writing, and any other form of representation (this includes so-called 'non-representational art'). If we think here of the role of the 'critic' we can see that it has extensively been to put an end to doubt concerning a work's meaning, and therefore its worth – to offer the reassuring security of an *explanation* and an *evaluation*: in short, to return the reader from the uncomfortable and precarious position of producer of meaning to the easier position of *consumer*.

When we consider what Derrida calls 'logocentrism' – the belief that all questions of meaning are to be referred to a privileged *origin* – together with 'humanism' – the view of 'man' as in full and spontaneous possession of himself and of his own expression – we can see one of the reasons why painting continues to be so very highly valued, not only in conservative aesthetics but also, to a somewhat lesser extent, on the left. In the eighteenth century, one of the earliest achievements of an emergent romanticism was the breaking down of the hierarchy of genres according to which 'history painting' had for two centuries been assumed to be inherently superior to such categories as

'still-life' or 'landscape'. One of the things conceptual art attempted was the dismantling of the hierarchy of media according to which painting (sculpture trailing slightly behind) is assumed inherently superior to, most notably, photography. The fact that this hierarchy, albeit shaken, is still intact is due I believe to a complex of reasons – the privileging of painting, we may say, is 'overdetermined' – one of them is to do with the conflation of humanism and logocentrism: 'humanity', 'the human essence', call it what you will (in theology, it is 'the soul'), is an abstraction, but it has a corporeal representative – the human body (we need only think here of the centrality of this body in Renaissance painting). Paint, the brush mark (or the dribble, it makes no difference) is the index, the very *trace*, of this expressive body, and thus of the 'human essence' to which it plays host. In the original version of logocentrism the crucial distinction was between speech (authentic, valued) and writing (inauthentic, denigrated); in the modern period the ground of the distinction has been shifted: today, any form of inscription *directly* linked to human agency, without the mediation of modern technology, is to be valorised; other forms of inscription are to be denigrated on grounds precisely analogous to those invoked by Plato and Aristotle in their defence of the oral tradition against the progressive incursions of writing. The surface of the photograph offers no reassurance of the founding presence of a human subject. It is either glossy, 'slick', or it is matt, 'implacable' – both appearances are grounds for suspicion. From a distance the surface offers a seamless modulation of tones which seem distributed at the arbitrary whim of a brute and contingent reality, examined closely it fragments into infinitely evenly-spaced dispersions of grains – we can find no *trace* of an author. No humanity, only *technology* – optical, chemical, electronic – and there is no more fiercely defended tenet of the humanist faith today than that of the inherently alien and alienating nature of modern technology (although I have yet to hear a single harsh word against central heating).

The period of early humanism in which 'easel-painting' emerged in the West was a period of transition from feudalism to capitalism. Wealth, power, and privilege were no longer derived exclusively from the land ownership and hereditary rights of an

aristocracy; wealth was now being amassed by a new and rapidly developing merchant class – socioeconomic transformations which would have been unthinkable without a concomitant change in dominant beliefs from a rigid, theologically-based, view of individuals as fulfilling roles in life ordained by God, to an emerging secularised belief in the autonomy of the individual. Two concepts within, and essential to, that new form of Western society – *exchange* and *individuality* – were embodied in the form of the easel painting. First, the new easel painting had the advantage over the previous mural painting of being mobile, for the first time it became possible for painting to become not only an object of *use* – for example as decoration, or as instruction to the mainly illiterate congregation in a church – but painting now also became an object of *exchange*, a commodity amongst other commodities in a market economy. Secondly, the value of a painting in this market, in these early days of humanism, became increasingly linked to the notion of individuality: the individuality of the consumer, certainly, hence all those portraits of princes and rich merchants which fill our picture galleries to this day. Even more, however, the value of a painting was linked to the individuality of the producer, to the idea of authorship. Paintings were no longer produced entirely by anonymous craftsmen, they were the work of 'creative individuals'. In the Renaissance, when painting first became a market commodity, the factor of *difference* necessary to establishing the relative value of such commodities became based on the *skill* of the painter. In those earliest days such things as the subject matter of the painting, the compositional scheme and the main colours, were not decided by the artist, they were dictated by the client. The skill of the artist in executing the client's commission became the *significant* factor in establishing its value, this skill became the object of connoisseurship; a language concerned with judgements of taste and fashion came increasingly to establish and maintain the value of a painting, and much the same is true today. I have said that the prestige of painting today is 'overdetermined'. Here then is another determining factor – the economic – which is nevertheless not to be disentangled from the humanism and logocentrism to which I have already referred.

The major achievement of painting in the Renaissance was,

The End of Art Theory

of course, not the work of an individual, it was a collective achievement: the development of the perspectival system of representation. It is this same system of depiction that the camera was invented to reproduce. So it was that, on the occasion of the official launch of the Daguerrotype process at the Institut de France on 19 August 1839, the painter Paul Delaroche is reported to have exclaimed, 'From today painting is dead!' In a most fundamentally important sense Delaroche was right. We can clearly see from the course of history since the invention of photography that the central social role of picturing the world – whether real or imaginary – has passed from the old manual skills of painting and its allied technologies, such as engraving, to the so-called 'mass-media' technologies which are broadly photographic – still photography, in its various forms, together with cinemaphotography and video. I have a first-class diploma in painting from the Royal College of Art – which means, I suppose, that I am legally entitled to practise painting anywhere in the United Kingdom. At the time that I was a student at the RCA, during the early 1960s, there was a Stained Glass Department there. During the Mediaeval period, stained glass must have been *the* most impressive visual medium; in the 1960s, however, at the RCA, the painting students thought the Stained Glass Department to be a bit of a joke, an anachronism, and in fact today it no longer exists. What happened to this once great visual technology was that it became displaced by other technologies more adapted to the changing forms of society. The experience of brilliant colour is a commonplace today, and if I want to be thrilled at a purely sensational level then I can sit in the front row of the cinema and fill my senses with the latest Spielberg epic – for, for most people today, religion also has been displaced from the centre of life. We can trace the historical emergence of stained glass; its period of ascendency, its period of superiority, its period of decline. Similarly, painting has not always existed, we know more or less when it began, we know a great deal about its development, and about its 'greatest moments'. It seems clear to me that, apart from Cubism's moment of brilliance, like a star that burns most brightly in the moment it extinguishes itself, painting has been in steady semiotic decline since the rise of the photographic technologies. It is

practically impossible in Western societies to pass a normal day without seeing photographs. In one context or another – newspapers, magazines, billboards, books, family snapshots – photographs permeate the everyday environment almost to the extent of the written word. In such an environment, painting seems inevitably to speak only of the past; to say, 'I am a painting', to the almost total exclusion of anything else. (Greenberg saw this clearly, and celebrated the fact.) Those RCA painters of the 1960s, to whom I belonged, sneering at the Stained Glass Department for being hopelessly out of its time, might have looked at themselves, with their antiquated paraphernalia of easels and palettes and hog's-hair brushes.

I have referred to painting as a technology which has been surpassed – in itself of course this argument would be mere *technologism*, an unthinking affiliation to whatever is new, a stupidity. The point I am trying to make, however, concerns a sense of the term 'apparatus' which goes beyond the mechanical to include institution and psychology. As I have already observed, regardless of what we think about it, it just happens to be the case that we in contemporary Western society grow up with and within photographic imagery – I include cinema and television here because they act together with 'still' photography to form what I have called elsewhere an 'integrated specular regime'[2] integrated at the level of the basic technology – the optical system designed to reproduce *quattrocento* perspective; integrated at the level of myth – in their mutual exchange and reinforcement of key themes and figures of our society; integrated at the psychic level – in that our society, saturated with hallucinatory imagery to an extent which is historically totally unprecedented, has become *phantasmagoric*. It seems to me that a form of visual art truly *involved* in the terms of *this* society, the one we live in – not the fantasy of a previous one, or some perpetually deferred future utopia – must of necessity speak this imaginary vernacular, must of necessity begin, as Brecht put it, 'not with the good old things, but with the bad new ones'. It is this reason, more than any other, which for me makes work in and *on* photography imperative. (Photography is itself, of course, quite capable of being assimilated to conservative aesthetics; but the assimilation is never entirely successful, some-

thing in photography *resists*, and a 'special effort' must be made
to render photography, uneasily, assimilable. For example, as
I have remarked, one of several reasons for the recourse to
photography in conceptual art was to exorcise a ghostly 'logos'
in the ideological machinery of art; the author as punctual origin
of the meanings of the work. It is significant therefore that, in
the intervening years, the photographic work which has had most
critical, curatorial and commercial success has been that in which
the images consistently feature either their own authors, or the
landscape – 'Nature' in romanticism figuring as a surrogate auth-
orial subject, equally a fount of 'higher' truths, equally in oppo-
sition to the 'de-humanising' modern world.)

The history I have very schematically summarised so far –
humanist, logocentric, capitalist, technological – has resulted in
a conception of art practice which has collapsed inwards upon
itself to produce an entity of truly awesome ideological density:
the *art object*. The art object is no more an *object* than the wine
and wafer of Holy Communion are what they appear to be to
our brute senses. The art object is the 'human essence' made
form, 'civilisation' made substance. This is the object of Green-
berg's modernism, the 'objecthood' of his disciple Michael Fried.
Conceptual art, as we know, had a special relationship to this
object: it wanted to explode it. It is as if conceptualism wanted
to take that object – the historical accretion of so many things, so
many practices, so many assumptions, but now so suffocatingly
compact – and blow it apart, scattering its components so that
they now lay *beyond*, as well as within, the confines of the
museum and the art journal, beyond the airless cloisters of
official art history and criticism. (It is because of this frag-
menting, analytical, impulse that the practices of conceptualism
were heterogeneous – conceptualism cannot be slotted into a
history of *style*.) An inevitable consequence of this impulse, one
in fact which had been inarticulately implicit from the beginning,
was that artists began to recover the previously elided social and
political dimensions of their practices – 'art history' could no
longer appear as a sort of tunnel driven through history, a tunnel
along which wander the spirits of 'Great Artists', shackled like
the ghost of Marley to their 'Great Works' and calling upon the
living to join their solemn procession. The impulse of conceptual

art was not, as was widely misunderstood, to *leave* art (it was never an 'anti-art' – an empty avant-gardist gesture), it was rather to *open* the institution and its practices, to open the doors and windows of the museum onto the world around it. This world, certainly, is a world of objects, but these objects are constituted *as* objects only through the agency of representations – language and other forms of signifying practice. The idea of art as *object* began, as I have remarked, with commodity connoisseurship in the Renaissance; it further developed within eighteenth century aesthetics, primarily with Lessing, as a notion of the specificity of the 'visual' as against the 'literary'. Greenberg's aesthetics are the terminal point of this historical trajectory. There is *another* history of art however, a history of *representations* (hardly a dramatic revelation, and no more avant-gardist, or 'fashionable', than is the Warburg Institute). For me, and some other erstwhile conceptualists, conceptual art opened onto that *other* history, a history which opens onto history. Art practice was no longer to be defined as an artisanal activity, a process of crafting fine objects in a given medium, it was rather to be seen as a set of operations performed in a *field* of signifying practices, perhaps centred on a medium but certainly not bounded by it. The field of concern was to be, as I put it in a publication of 1973, 'the semiotic practices of a society seen, in their segmentation of the world, as a major factor in the social construction of the world, and thus of the values operative within it'.[3] As a statement of intent, this had the advantage of being sufficiently vague to allow *anything* to happen. The ensuing decade has been a period of working out and working through various specific responses to the problem of going beyond conceptual art. I have mentioned the re-emergence, out of conceptualism, of attention to the political; an initial, and continuing, consequence has been the production of work in which political issues of the day are represented – often, and it seems to me increasingly, by means of painting. Another response, one which has tended to eschew such means, has been based less upon a notion of the 'representation of politics' and more on a systematic attention to the *politics of representation*. It is in terms of this attention that a theory of the subject,

involving a critique of humanist presuppositions, has become crucially important.

The theory of the subject which it is necessary to oppose to the traditional 'common-sense' picture of the individual is that of psychoanalysis. Psychoanalysis is a theory of the process by which the tiny human animal, the infant, is transformed into a socially functioning (or dysfunctioning) individual. It is often believed that psychoanalysis is 'only about subjective experience' to the exclusion of considerations of society and history, but nothing could be further from the truth – psychoanalysis is a theory of the *internalisation* of the social in the formation of the individual. 'The motive of human society', wrote Freud, 'is in the last resort an economic one'. Just as Marx saw that the economic imperative, the need to produce the means to support life, gives rise to certain specific forms of society, so Freud saw that these same imperatives, and consequent social forms, engender particular structures of identity. One of Freud's books has the title *Civilisation and its Discontents*; it contains no utopian prescription for a contented society, its message is that there can be no civilisation *without* discontents. In submitting to the socioeconomic imperative the gratification of the instinctual demands of the individual must be deferred or denied, 'repressed'; a result of this inevitable process of repression is the formation of an *unconscious* along with the conscious individual. 'To thine own self be true', wrote Shakespeare, when humanism was new; psychoanalysis shows us the difficulty, if not impossibility, of what is being asked of us here – not because of the material and social impediments which face us, but because the self we know by introspection – consciousness – does not know its unconscious; our self-image, and the images we have of others, are always to some degree *fictional*. The word 'fiction' here may bring with it such notions as 'narrative' and 'staging', a vocabulary of *representation* which is entirely appropriate to the field of human actions. To invoke Shakespeare again, 'All the world's a stage', but there is of course a difference between being in the world and being on stage; although we may speak of 'playing a role' in society, we are really thinking of such things as the jobs we may perform, we do not mean to imply that our *self*, our 'individuality' has in any way been 'written' elsewhere.

The common-sense view, the one which just seems *obvious*, is that we are each born into the world as a little 'self' which is just as much simply *there* psychologically as it is physiologically – a little seed of individuality which over time sprouts to form the adult subject we eventually become; but psychoanalysis has built up a different picture: we become what we are only through our encounter, while growing up, with the multitude of representations of what we *may* become – the various positions that society allocates to us. There is no essential self which precedes the social *construction* of the self through the agency of representations. The most important question asked of any of us is a question which, at the time it is asked, we do not understand: 'Doctor, is it a boy or a girl?' – the answer to that question will determine the general form of the demands society will make of us. A normal baby has at birth either an anatomically male or a female body, but it is not born with a correspondingly 'male' or 'female' psychology. For example, we are all familiar with a certain stereotype of the woman: an essentially passive and dependent creature whose emotions rule her reason and whose exclusive aim in life is homemaking and motherhood. This version of essential 'femininity' was in the quite recent past represented as being as inescapably natural to women as their biological gender. If it is more difficult to get away with such an oppressive stereotype today it is due to the achievements of the women's movement. In the field of cultural theory, feminism has set out to describe the way in which the collusion of women in their own oppression has in the past been achieved precisely *through* representation.

Feminist theorists have argued that the predominant traditional verbal and visual representations of women do not reflect, 'represent', a biologically-given 'feminine nature' – *natural*, therefore unchangeable; on the contrary, what women have to adapt to as their 'femininity', particularly in the process of growing up, is itself the *product* of representations. Representations therefore cannot be simply tested against the real, as this real is itself *constituted*, as everyday common-sense 'reality', *in* representations. (This is what it means to say: 'there is no reality outside representation'.) A search for, or contestation of, the 'truth' of the representation therefore becomes irrelevant (for

all that this violates common-sense intuition); what is to be interrogated is its *effects*. I have taken my example of the construction of subjectivity here from the recent history of feminism. It is comparatively recently that the perception and definition of the field of 'the political' has undergone a radical expansion beyond the traditional ghetto of party politics and considerations of 'class struggle' to now include, amongst other things, considerations of sexuality; 'sexuality' understood not in the reductive terms of the caricature in which it appears in the popular media, but in the complex and subtle understandings to be derived from psychoanalysis, where considerations of sexual difference are seen as governing relations within and between the individual, language, and power. It has now become possible to ask a question which could not previously even have been thought: 'What are the *forms* of visual imagery consequent upon the forms of construction of the fiction of the subject?'

I have spoken of the peculiar status of the *art object* in traditional aesthetics: an object of awe – part holy relic, part gilt-edged security. It is significant that, independently, both Marx and Freud, in their very different but mutually complementary projects, found it necessary to invoke a concept of *fetishism*. In Freud the fetish is that which 'stands in for' the absent female penis, reassuring the male in his anxiety that the same loss might befall *him*. As a teacher I have found that of all of Freud's ideas this is the one which provokes the most hostility and derision – especially from men. We should remember three things: first, Freud is not talking about ideas which are consciously held – they are *unconscious*; secondly, unconscious castration anxiety originates in early childhood when the very small boy first takes account of the fact that not all bodies are like his own – given the primitive state of his thinking and information the idea that the female body is a body from which something has been removed is a perfectly reasonable hypothesis (and subsequent knowledge will not erase the unconscious inscription of that phantasy); thirdly, in a patriarchal society, the little boy is becoming increasingly aware of the superior privileges afforded to men (TV action films alone would be enough to instil this idea) – his penis is not only a narcissistically highly-invested source of masturbatory pleasure, it is also his ticket of access to

an exclusive club. No man escapes castration anxiety; although not all men become 'clinical' fetishists as a result (that is, unable to achieve sexual pleasure without the fetish), nevertheless they are all fetishists to some degree or other. Marx pointed to the fact of 'commodity fetishism' in capitalist society, Freud identified a primary contributory cause. (The consequences for a classic Marxist theory of ideology will be obvious to those familiar with it – no change in the form of the economy could have the least effect on fetishism.)

It might be objected that although clinical fetishism in *women* may be rare almost to the point of non-existence, many women nevertheless appear to fetishise the commodity. One response to this observation would be to point out that an object may be overvalued for many reasons other than fetishism. This does not, however, dispose of the question of female fetishism. The French psychoanalyst Jacques Lacan has broadened the Freudian notion of castration anxiety to include both men and women. Lacan observes that from the moment we are expelled from the womb and suffer that first physical separation from the mother's body our lives are a succession of experiences of loss (chronologically, the next painful experience of separation we must suffer is that of weaning from the breast, or its substitute). Such early experiences instil a sense of 'lack' in all of us, men and women alike, and much of our subsequent behaviour may be seen as compensatory attempts to eradicate this sense: hence the often surprisingly excessive overvaluation of some thing, or person, or idea. Lacan sees sexual difference, the presence or absence of the penis, as simply the organising metaphor for all other experiences of lack, and it is thus that he differentiates the 'phallus' – the symbolic term – from the 'penis' – the organ. The reason for this, Lacan's, often criticised 'phallocentrism' is quite simply that, like Freud, he is describing the symbolic organisation of the society in which we in the West actually live – which is *patriarchal*; to *describe* something does not entail either that one approves or disapproves of it, and in fact what Freud or Lacan themselves thought about the society in which they lived should be a fact of some indifference to us compared with the more critical question of what *use* we can make of their theories.

It is precisely because society *is* patriarchal that I believe

we should keep in mind Freud's original account of fetishism, premised on the *male* body, when we consider the forms of our society and its cultural products. In Freud's account, the fetish is revered as irreducibly and irreplaceably *unique*; moreover, it has a punctual quality, it is not in any way diffuse or extended in space or time, it is as if *framed*. The comparison with the art object need not be laboured. The fetish is unique amongst signs (more correctly, 'signifiers'): it exists, paradoxically, to deny the existence of the very thing to which it refers – the absence of the female penis; in this it masquerades as entirely self-sufficient, not really a *sign* at all, but an *object* purely and simply. Again, the comparison with the art object is obvious. The fetish, in short, is *pure presence*, its function being precisely to deny absence, to fill the 'lack in being' – and how many times have I been told that photographs 'lack presence', that paintings are to be valued precisely *because of their presence*!

I began by referring to the hostility with which conceptual art was initially received – it was the attack upon the *object*, upon *presence*, which caused it. For a short time it seemed as if the *object*, as we know it, had indeed been got rid of. Without losing their interest in, or indeed love of, the painting and sculpture of the past, a whole generation of artists were no longer interested in repeating the hard-won successes of their forbears. This situation did not last long. An apparatus set up precisely to process *objects* soon produced a flurry of revivals of painting. 'Pattern Painting' was one such short-lived cause of art-world excitement. I remember it only because when it was at its critical, curatorial, and commercial apogee, I was the guest of a French museum which had a particularly good Matisse. I had been given the use of an apartment in the museum and would often visit the painting 'after hours'. I was struck by the difference in accomplishment between that Matisse and the 'new' Mattisse-inspired pictures which filled the art magazines and galleries at that time – the latter were so much more *successful*. The Matisse itself was rather awkward, I had the impression of someone who did not quite *know* what they were doing, someone working 'at the edge' of what was possible and acceptable. Precisely what defines an *academy* is that it knows a success when it sees one, the criteria are already in place – success is then defined in terms of

conformity to established criteria and *proficiency* in the execution of the exercise. Today, extreme dexterity in the manipulation of a pencil-line, such that a thigh may pop out from the paper and hit you in the eye, will again earn you a round of applause from the British Art establishment and a gold medal from the Royal College of Art – such a talent being held to speak for the common humanity of us all – and we are in the middle of a massive *revivalism* of painting; but, it may be objected, is not such a return to the past precisely one of the features of that which is truly new – our present 'postmodernism'?

Perhaps the most publicly visible manifestations of postmodernism occurred first in architecture, where an eclectic collage of contrasting architectural styles pillaged from disparate periods of history, together with borrowings from the contemporary vernacular, came to disturb the austerely elegant functionalism of the International Style. A salient feature of postmodernism in general, although it is not to be reduced to this feature, is indeed the reference to tradition and to the vernacular. This is a feature of art since conceptualism, where there has been not only a return to painting but a return to past *styles* of painting, together with a resurgence of the vernacular such as has not been seen, in painting, since Pop Art. This may certainly be called 'post-modernist' in so far as modernism saw tradition in terms of a perpetual and progressive *evolution* in which there was never any question of *regressing* to earlier, historically super-seded, stages; as for the vernacular, this was quite simply anathema to modernism, whose very *raison d'être* was its oppo-sition to modern 'mass culture'. However, we need to pay atten-tion to what is actually represented in each individual instance of such postmodernist gestures. We may 'return to the past' in order to demonstrate that it is never simply past; rather, it is the locus of meanings which are lived by, and struggled over, in the present. On the other hand, we may return to the past in order to celebrate the timelessness and immutability of the values of the present status quo. Again, we may refer to the vernacular in order to open the art institution onto the wider semiotic environment in which we live, to bring about a mutual interrog-ation of 'art' and 'mass-media' meanings and values; or we may uncritically quote the vernacular, with a mixture of condescen-

sion and awe, to add a *frisson* of 'street credibility' to a product
of high culture. The guardians of the status quo know that their
main task – one which is massively undertaken by the advertising
industry – is to peddle the old as if it were new, otherwise how
could they get the young to go along with them? We must
therefore be suspicious of the way in which the idea of 'postmod-
ernism' is being appropriated by a currently ascendant Neo-
conservatism, suspicious of that strategy – familiar from the firm
of Saatchi, Saatchi, and Thatcher – which combines a rhetoric of
renewal reminiscent of that used by manufacturers of detergents
('*New* Spirit in Painting', '*New* object' sculpture) with a reaffirm-
ation of conservative values.

There is no more central item of the conservative credo in this
'new' period of economic 'realism' than the founding value of
'hard work' (present levels of unemployment notwithstanding).
Hard work is one of those things which, like beautiful objects,
simply are 'good in themselves'. It was an advertisement which
brought this thought to my mind when, recently, I was standing
waiting for a train in the London Underground. In series with
the images of a motor car, a young woman's legs, and a bottle
of whisky, there appeared a poster for a Tate Gallery exhibition
of British painting since 1960. The poster combines a colour
photograph of what we instantly recognise as the corner of a
painter's studio (all the signs of laboured and frantic activity:
thick encrustations of paint, hastily pinned-up sketches) together
with the exhibition title, 'The Hard-Won Image'. It flickered
briefly in my attention and I have not seen it since, nor have I
seen the show. The experience was momentary, but no less
meaningful for that. The poster's headline – 'The hard-on', sorry,
'hard-*won* image' – tells me that I must interpret this scene as a
metaphor of value and valour. I am reminded that raw materials
are invested with value in direct proportion to the labour
invested in them, and it seems to me that this metonymically
represented artist is chosen to metonymically represent *all* pain-
ters because his toil is so conspicuously *muddy*; an honest,
natural, form of labour which partakes of humanist myth: 'man's'
eternal struggle with the brute earth in order to wrest from it its
hard-won fruits. Beyond this image of muddy masculine prowess
I find myself directed to another – the hard-won trenches of

Flanders fields, the muddy sites of bloody manly pride. I could go on. (I am reminded, for example, of that simple infantile pleasure whose first displacement under the interdictions of socialisation is 'finger painting', for the hard-won image is clearly something one has to strain to achieve; and this brings me to an infantile theory of birth, and 'Little Hans' in the Freud case-history who is convinced that he and his father can both give birth to babies.)

'I could go on', but my attention has already been caught by another poster on the wall of the Underground, another scenario of masculine endeavour – an invitation to an 'adventure holiday' in which a glistening Marlboro cowboy pits his will against a mountain. I am reminded of the recent, massively capitalised, 'revival' of large-scale expressionist painting (we had better call it *exhumation* – this 'living tradition' proving itself to be merely *undead*). It is impossible not to suspect that such icons of frantic masculine mastery now have more than a little to do with the symptoms of anxieties generated by the feminist politics of the 1970s. Late-modernism stood for *order* – the obedience to function of the International Style, the respect for 'specificity' and 'tradition' in Greenberg's aesthetics – everything in its proper place, doing its duty, fulfilling its preordained role in patriarchal culture. We should remember that the word 'patriarchy' does not refer to 'men' in general, but to the *rule of the father*. It is precisely the terms of this rule, the terms of centralised *authority*, which are at stake across the various forms of today's politics, including the politics of culture. It seems likely that 'conceptualism' is destined, for the moment at least, to be represented as that 'movement' which, by undermining 'modernism', paved the way for 'post-modernism'. None of the 'isms' here, however, were, or are, unitary phenomena; nor do such cultural phenomena simply give way to one another like television programmes in an evening's viewing. Aesthetically, culturally, politically, conceptualism comprised both tendencies for change and conservative tendencies. The same is true of this present period of 'postmodernism'. What we can see happening in art today is a return to the symbolic underwriting of the patriarchal principle by means of the reaffirmation of the primacy of *presence*. The function of the insistence upon presence is to eradicate

the threat to narcissistic self-integrity (the threat to the body
of 'art', the body-politic) which comes from *taking account* of
difference, *division* (rather than effectively *denying* difference
by valorising one term of an opposition in order to suppress the
other): division of form from content (political subject matter
can be fetishised as 'presence' just as much as can the avoidance
of any subject matter whatsoever); division of the private (art
as 'private experience') from the social (which after all only
maps the division of family life from work in industrial capitalist
societies, including those in the East); division of the word from
the image (I have written at length elsewhere about what a
complete nonsense *that* is);[4] division of the masculine from the
feminine in the interests of producing 'men' and 'women';
division of theory from practice; division of the inside of the
institution from its outside (for example, the almost complete
isolation of art-historical and critical discourse from the wider
analytical discourses – including psychoanalysis and semiotics –
which surround them); and so on. What was radical in conceptual
art, and what, I am thankful to say, has not yet been lost sight
of, was the work it required – beyond the *object* – or recognising,
intervening within, realigning, reorganising, these networks of
differences in which the very definition of 'art' and what it
represents is constituted: the glimpse it allowed us of the possi-
bility of the absence of 'presence', and thus the possibility of
change.

But nevertheless . . .

I have remarked that the history and pre-history of modern
art in our patriarchal, phallocentric, culture is stamped by the
presence of fetishism, the fetishism of *presence*. I do not intend
to imply that art is to be *reduced* to fetishism, or that fetishism
lies 'behind' all representations in a relation of cause to effect –
I would rather prefer a metaphor used by Foucault in a different
context and speak of the 'capillary action' of fetishism. Funda-
mental to Freud's account of fetishism is what he calls 'disavowal'
– that splitting between knowledge and belief which takes the
characteristic form, 'I know very well, but nevertheless . . .'
Disavowal is the *form* of fetishism – that which operates to

protect a sense of narcissistic self-integrity by effacing difference, otherness, the *outside*. Today, what has become in effect the 'official' posture of the art establishment is a disavowal in respect of history.

I have been using the expression 'postmodernism' to refer to art produced after Greenberg's late-modernism lost its ideological hegemony – the moment of conceptualism and after. But if the expression 'post-modernism' is to take on anything more than such a merely tautological meaning then we have to look beyond the self-defined boundaries of the 'art world' – *Art* – to the more general cultural/political/intellectual *epistemological* upheavals of the post-war period. If, for expository convenience, and in the manner of allegory, we were to 'personify' a figure of 'pre-modernism' then it would be characterised by the self-knowing, punctual, subject of humanism, 'expressing' itself, and/ or its world (a world simply there, as 'reality') via a transparent language. 'Modernism' came in with the social, political, and technological revolutions of the early twentieth century and is to be characterised by an existentially uneasy subject speaking of a world of 'relativity' and 'uncertainty' while uncomfortably aware of the conventional nature of language. The 'post-modernist' subject must live with the fact that not only are its languages 'arbitrary' but it is *itself* an 'effect of language', a precipitate of the very symbolic order of which the humanist subject supposed itself to be the master. 'Must live with', *but nevertheless* may live 'as if' its condition were other than it is; may live 'as if' the grand narrative[5] of humanist history, 'the greatest story ever told', were not yet, long ago, over – over at the turn of the century, with Marx, Freud, and Saussure; over with nuclear weaponry and micro-chip technology; over, in the second half of the twentieth century, with the ever-increasing political consciousness of women and the 'third world'. Yes, we know the twentieth century has happened, and yet nevertheless it hasn't; thus, to speak only of this country, the press reporting of the Falklands conflict and the Royal marriage, and the return to heroism in painting and to hard-won images as dutiful and competent as a Victorian embroidery sampler.

'Truth' was a principal character in the allegorical canvases of humanism; in postmodernist allegories Truth has been replaced by the twins 'Relativity' and 'Legitimation'. A response to the

radical heterogeneity of the possible has always been the
homogeneity of the *permissible* – expressed in terms of narrative,
in terms of allegory; offering us the images of those roles we
may adopt, those subjects we may become, if we are ourselves to
become socially *meaningful*. It is these narratives, these subjects,
which are at issue *now* in the moment of postmodernism. All
this rummaging through the iconographic jumble of the past is
symptomatic of it – in art and in fashion as well as, increasingly,
in politics. As I have observed, this archaeological activity may
reveal the foundations of our 'modern' belief-systems, simul-
taneously clearing the ground for reconstruction which will not
obliterate the past but which will maintain, precisely, its *differ-
ence*; or the activity may end where it began, in nostalgia, in
repetition, in the affirmation that the present and the past are
somehow the *same*. It is the repression of difference in order to
preserve, unthreatened, the same, which generates the symptom
'fetishism'. Psychoanalysis shows us how jealously, and with
what skill, we guard our symptoms; they are not something we
wish to give up for they speak our *desire*. But the same desire
may find other symptomatic means, may find alternative
symbolic forms (they are not all equal in terms of their conse-
quences) *en route* to a 'redistribution of capital' in the economy
of desire. In the meantime, the consequence of modern art's
disavowal of modern history remains its almost total failure to
be about anything of consequence.

Seeing Sense

Although photography is a 'visual medium', it is not a 'purely visual' medium. I am not alluding simply to the fact that we rarely see a photograph *in use* which is not accompanied by writing (albeit this is a highly significant fact), even the uncaptioned 'art' photograph, framed and isolated on the gallery wall, is invaded by language in the very moment it is looked at: in memory, in association, snatches of words and images continually intermingle and exchange one for the other. It will be objected that this is indistinct and insignificant background noise to our primary act of *seeing*. If I may be excused a physiological analogy, the murmur of the circulation of the blood is even more indistinct, but no less important for that.

I

In a familiar cinematic convention, subjective consciousness – reflection, introspection, memory – is rendered as a disembodied 'voice-over' accompanying an otherwise silent image-track. I am not suggesting that such an interior monologue similarly accompanies our looking at photographs, nor do I wish to claim that in the process of looking at a photograph we mentally translate the image in terms of a redundant verbal description. What I 'have in mind' is better expressed in the image of transparent

51

coloured inks which have been poured onto the surface of water in a glass container: as the inks spread and sink their boundaries and relations are in constant alternation, and areas which at one moment are distinct from one another may, at the next, overlap. Analogies are of course *only* analogies, I simply wish to stress the fluidity of the phenomenon by contrast with the unavoidable rigidity of some of the schematic descriptions which will follow.

'Photography is a visual medium.' At a strictly physiological level it is quite straightforward what we mean by 'the visual': it is that aspect of our experience which results from light being reflected from objects into our eyes. We do not however *see* our retinal images: as is well known, although we see the world as right-way-up, the image on our retina is inverted; we have two slightly discrepant retinal images, but see only one image; we make mental allowances for the known relative sizes of objects which override the actual relative sizes of their own images on our retina; we also make allowances for perspectival effects such as foreshortening, the foundation of the erroneous popular judgement that such effects in photography are 'distortions'; our eyes operate in scanning movements, and the body is itself generally in motion, such stable objects as we see are therefore *abstracted* from an ongoing phenomenal flux,[1] moreover, attention to such objects 'out there' in the material world is constantly subverted as wilful concentration dissolves into involuntary association, and so on. The detail of these and many other factors as described in the literature of the psychology of perception, cognitive psychology, and related disciplines, is complex, the broad conclusion to be drawn from this work may nevertheless be simply expressed:

> What we see . . . is not a pure and simple coding of the light patterns that are focused on the retina. Somewhere between the retina and the visual cortex the inflowing signals are modified to provide information that is already linked to a learned response . . . Evidently what reaches the visual cortex is evoked by the external world but is hardly a direct or simple replica of it.[2]

The fact that seeing is no simple matter has of course been

acknowledged in visual art for centuries. It is a fact which painting, facing the problem of representing real space in terms of only two dimensions, could not avoid (for its part, sculpture particularly emphasised the imbrication of the visual and the kinesthetic, the extent to which seeing is a muscular and visceral activity). At times the aims of visual art became effectively *identified* with those of a science of seeing; Berenson complained of the Renaissance preoccupation with problems of perspective: 'Our art has a fatal tendency to become science, and we hardly possess a masterpiece which does not bear the marks of having been a battlefield for divided interests'. Across the modern period, at least in the West, it has been very widely assumed that an empirical science of perception can provide not only a necessary but a sufficient account of the material facts upon which visual art practices are based. Thus, in this present century, and particularly in the field of art education, the psychology of perception has become the most readily accepted art-related 'scientific' discipline, the one in which 'visual artists' most readily identify their own concerns (correspondingly, where philosophical theories have been used they have generally had a phenomenological orientation). Certainly such studies in the psychology of appearances are necessary, if only to provide a corrective to the naïve idea of purely retinal vision. But if the explanation of seeing is arrested at this point it serves to support an error of even greater consequence: that ubiquitous belief in 'the visual' as a realm of experience totally separated from, indeed antithetical to, 'the verbal'.

Seeing is not an activity divorced from the rest of consciousness; any account of visual art which is adequate to the facts of our actual experience must allow for the imbrication of the visual with other aspects of thought. In a 1970 overview of extant research, M. J. Horowitz has presented a tripartite model of the dominant modes of thought in terms of 'enactive', 'image', and 'lexical'.[3] *Enactive* thought is muscular and visceral, is prominent in infancy and childhood, and remains a more or less marked feature of adult thinking. For example: on entering my kitchen I found that I had forgotten the purpose of my visit; no word or image came to mind, but my gesture of picking up something with a fork led me to the implement I was seeking. The enactive

may be conjoined with the visual. Albert Einstein reported that, for him: 'The psychical entities which seem to serve as elements in thought are certain signs and more or less clear images . . . [elements] of visual and some of muscular type'.[4] The enactive also merges with the verbal: Horowitz supplies the example of a person who was temporarily unable to find the phrase, 'he likes to pin people down', an expression called to mind only after the speaker's manual gesture of pinning something down. We should also note the findings of psychoanalysis concerning the type of neurotic symptom in which a repressed idea finds expression via the enactive realisation of a verbal metaphor; an example from Freud's case histories – Dora's hysterical vomiting at the repressed recollection of Herr K.'s sexual advances, an idea which 'made her sick'.[5]

Mental *images* are those psychic phenomena which we may assimilate to a sensory order: visual, auditory, tactile, gustatory, olfactory. For the purposes of this essay, however, I shall use the term 'image' to refer to visual images alone. If I wish to describe, say, an apartment I once lived in, I will base my description on mental images of its rooms and their contents. Such a use of imagery is a familiar part of normal everyday thought. However, not all imaged thought is so orderly and controlled. We may find ourselves making connections between things, on the basis of images, which take us unawares; we may not be conscious of any wilful process by which one image led to another, the connection seems to be made gratuitously and instantaneously. The result of such a 'flash' may be a disturbing idea which we put instantly out of mind, or it may provide a witticism for which we can happily take credit; or more commonly it will seem simply inconsequential. At times, we may deliberately seek the psychic routes which bring these unsolicited interruptions to rational thinking. In the 'day-dream', for example, the basic scenario and its protagonists are consciously chosen, but one's thoughts are then abandoned to an only minimally controlled drift on more or less autonomous currents of associations. The sense of being in control of our mental imagery is, of course, most completely absent in the *dream* itself. Dreams 'come to us' as if from another place, and the flow of their images obeys no rational logic. Freud's study of dreams led him

to identify a particular sort of 'dream logic' radically different from the logic of rational thought: the *dream-work*, the (il)logic of the 'primary processes' of the unconscious. In a certain common misconception, the unconscious is conceived of as a kind of bottomless pit to which has been consigned all that is dark and mysterious in 'human nature'. On the contrary, unconscious processes operate 'in broad daylight'; although they are structurally and qualitatively different from the processes of rational thought and symbolisation enshrined in linguistics and philosophical logic, they are nevertheless an integral part of normal everyday thought processes taken as a whole. The apparent illogicality which so obviously characterises the dream invades and suffuses waking discourse in the form of slips of the tongue, and other involuntary acts, and in jokes. Additionally, and most importantly to this present discussion, the intrusion of the primary processes into rational thought ('secondary processes') governs the mechanisms of visual association.

Freud identifies four mechanisms in the dream-work: 'condensation'; 'displacement'; 'considerations of representability'; and 'secondary revision'. In *condensation*, a process of 'packing into a smaller space' has taken place: 'If a dream is written out it may perhaps fill half a page. The analysis setting out the dream thoughts underlying it may occupy six, eight or a dozen times as much space'.[6] It is this process which provides the general feature of *over-determination*, by which, for any manifest element, there can be a plurality of latent elements (dream-thoughts). By *displacement*, Freud means two related things. First, that process by which individual elements in the manifest dream stand in for elements of the dream-thoughts by virtue of an association, or chain of associations, which link the two. Thus displacement is implicated in the work of condensation: displacements from two or more separate latent elements, along separate associative paths; may eventually reach a point of intersection. The second, related, meaning of the term 'displacement' is that process according to which the manifest dream can have a different 'emotional centre' from the latent thoughts. Something quite trivial may occupy centre stage in the dream, as it were 'receive the emotional spotlight'; what has occurred here is a displacement of feelings and attention from the thing, person, or situ-

ation which is in reality responsible for the arousal of those feelings. It is thus possible for something as inconsequential as, say, an ice-cube to become in a dream the object of a strong feeling.

Of *considerations of representability*, Freud writes:

> imagine that you had undertaken to replace a political leading article in a newspaper by a series of illustrations . . . the people and concrete objects mentioned in the article could be easily represented . . . but you would expect to meet with difficulties when you came to the portrayal of all the abstract words and all those parts of speech which indicate relations between various thoughts.[7]

In *The Interpretation of Dreams* Freud describes the various ways in which the dream deals, in visual terms, with such logical relations as implication, disjunction, contradiction, and so on. We should note a particular role of the verbal in the transition from the abstract to the pictorial: 'bridge words' are those which, in more readily lending themselves to visualisation, provide a means of displacement from the abstract term to its visual representation. Thus, for example, the idea of 'reconciliation' might find visual expression through the intermediary of the expression 'bury the hatchet', which can be more easily transcribed in visual terms. This representational strategy is widely to be found in advertising, which relies extensively on our ability to read images in terms of underlying verbal texts. It may be appreciated that such readings readily occur 'wild', that is to say, where they were not intended.

Secondary revision is the act of ordering, revising, supplementing the contents of the dream so as to make a more intelligible whole out of it. It comes into play when the dreamer is nearing a waking state and/or recounting the dream. Freud had some doubts as to whether this process should properly be considered to belong to the dream-work itself (in an article of 1922 he definitely excludes it). However, it is not important to our purposes here that this be decided; we should note that secondary revision is a process of dramatisation, of narrativisation.

Returning now to Horowitz's schema of types of mental representation, *lexical* thought is 'thinking in words'. It should be stressed however that this is not simply a matter of the silent mental rehearsal of a potentially actualised speech. Lev Vygotsky has identified an *inner* speech fundamentally different in its nature from externally directed communicative speech. Inner speech: 'appears disconnected and incomplete . . . shows a tendency towards an altogether specific form of abbreviation: namely, omitting the subject of a sentence and all words connected with it, while preserving the predicate'.[8] Inner speech in the adult develops out of the 'egocentric speech' (Piaget) of the small child. We should remark that Freud describes the primary processes as preceding the secondary processes in the mental development of the individual; they are preverbal in origin and thus prefer to handle images rather than words, where words *are* handled they are treated as far as possible like images. Thus, when Vygotsky observes that, in inner speech: 'A single word is so saturated with sense that many words would be required to explain it in external speech',[9] we may be confident that the reference is to that same centrally important aspect of the primary processes that we encounter in Freud's work as 'condensation'. Freud notes that, in dreams, words and phrases are just meaningful elements among others, accorded no more or less status than are images, and their meanings have no necessary relation to the meanings they would carry in waking speech. Thus Lyotard has spoken of 'word-things', the result of condensation:

> their 'thingness' consists in their 'thickness'; the normal word belongs to a transparent order of language: its meaning is immediate . . . the product of condensation, as the name indicates, is, on the contrary, opaque, dense, it hides its other side, its other sides.[10]

I prefaced my references to Horowitz's compartmentalised model of thought by stressing the fluidity of the actual processes it describes. Horowitz himself writes:

> Normal streams of thought will flow simultaneously in many compartments without clear-cut division between modes of

representation. Enactions blur into imagery in the form of kinesthetic, somesthetic, and vestibular or visceral images. Image representation blends with words in the form of faint auditory images of words. Words and enactive modes merge through images of speaking.[11]

Inescapably, the *sense* of the things we see is constructed across a complex of exchanges between these various registers of representation. Differing perceptual situations will however tend to elicit differing configurations and emphases of response just as sculpture will tend to prioritise the enactive and kinesthetic suffusion of visual imagery, so photographs predominantly tend to prompt a complex of exchanges between the visual and verbal registers: as I began by observing, the greater part of photographic practice is, *de facto*, 'scripto-visual'; this fact is nowhere more apparent than in advertising, and it may help here to refer to a particular example.

II

The particular conjuncture into which this advertisement was launched, in Britain in the early 1960s, included a best-selling novel by Alan Sillitoe, and a popularly successful film based on this novel – directed by Tony Richardson and featuring Tom Courtenay – which retained the title of the original text: *The Loneliness of the Long-Distance Runner*. The fact that Tom Courtenay was at that time a prominent emerging young 'star' of British theatre and cinema ensured that the institutional spaces of television, and newspapers and magazines, were also penetrated. During the particular months in which this advertisement appeared therefore, the expression 'the loneliness of the long-distance runner' was transmitted across the apparatuses of publishing, cinema, television, and journalism, to become inscribed in what we might call the 'popular pre-conscious' – those ever-shifting contents which we may reasonably suppose can be called to mind by the majority of individuals in a given society at a particular moment in its history; that which is 'common knowledge'. Two attributes therefore are immediately

The loveliness of the
long-distance tuner

entrained by this content-fragment of the popular pre-conscious which serves the advertisement as *pretext*: success and contemporaneity; additionally, the visual image across which the fragment is inscribed is clearly open to the implication of the erotic. Ambition, contemporaneity, eroticism, together with the substantial primacy of the visual in their inscription: *the day-dream*.

In his 1908 essay, 'The Relation of the Poet to Day-Dreaming', Freud remarks that day-dreams serve one, or both, of two impulses: 'Either they are ambitious wishes, serving to exalt the person creating them, or they are erotic'.[12] To identify these two wishes in all day-dreams is not, of course, to suggest that the manifest contents of such phantasies are themselves stereotyped or unchangeable: 'On the contrary, they fit themselves into the changing impressions of life, alter with the vicissitudes of life; every deep new impression gives them what might be called a "date-stamp"'.[13] As for thinking in pictures, in his 1923 paper, 'The Ego and the Id', Freud remarks that 'in many people this seems to be a favourite method . . . in some ways, too, it approximates more closely to unconscious processes than does thinking in words, and it is unquestionably older than the latter both ontogenetically and phylogenetically'.[14] The child, prior to its acquisition of language, inhabits a model of thought not adapted to external reality but rather aimed at creating an imaginary world in which it seems to gratify its own wishes by hallucinatory objects. The day-dream – the conscious phantasy in which the subject constructs an imaginary scenario for the fulfillment of a wish – is one form of survival of such infantile thinking into adult life.

Ambition, eroticism, contemporaneity. The theme of ambition is obviously central to advertising, as is the erotic (which is, anyhow, latent in all acts of looking). In this particular advertisement the expression, 'the loneliness of the long-distance runner' offers a phantasy identification within a syndrome of success, and with a successful figure – as a certain familiar style of promotional language might have put it: 'Tom Courtenay *is* the long-distance runner', ahead of his competitors, the 'leading man' both in the fiction and in reality. This particular expression at that particular conjuncture brings the ambitious wish up to date. The conjunc-

tion of ambition and eroticism here is economically achieved through a pair of substitutions – a 'v' for an 'n', and a 't' for an 'r' – which tacks the manifest verbal text onto its *pre-text* in the pre-conscious. By this device, the verbal fragment faces onto both manifest and latent contents of the image.

The text says that the tuner is lovely, what it simultaneously *means* (through reference to conventional associations surrounding women) is that the woman is lovely; thus the word 'loveliness' acts as a relay linking the radio to the woman – a movement which facilitates the displacement of an emotional investment ('cathexis') from the one to the other. The woman is 'lovely', she is also 'lonely': the suppressed term here serving as the material absence which nevertheless anchors the meaning of the woman's posture and, beyond, the entire 'mood' of the picture. Apart from the configuration of the woman's pose, the mood is given most predominantly in the way the scene has been lit; it is the sort of lighting popularly referred to as 'intimate' – a word which also takes a sexual sense. The term 'intimate' here is not reached by purely subjective association, the association is conventionally determined to the point that we may consider this lighting effect to belong to the complex of 'considerations of representability' in respect of this term. The suppressed term 'lonely', then, in conjunction with the connotations of the lighting, anchors the particular sort of *narrative* implications of the moment depicted in the image, implications readily linked to the phantasy of seduction, a theme very widely encountered across advertising.

Along the axis woman/radio we encounter a double oscillation between revelation and concealment. First, the visible marks which dictate the reading 'woman' also suggest the reading 'naked' – there is not a single signifier of clothing. However, from the point of view offered by the shot, this additional reading cannot be confirmed; but it nevertheless insists even in the means of concealment: the veil of hair, a time-honoured convention for signifying feminine nudity without *showing* it (see, for example, conventional pictorial representations of Eve, and the verbal text of 'Lady Godiva'). Secondly, while the woman's body is hidden, averted, the radio is completely exposed – lit and positioned to offer itself in precisely that 'full-frontal nudity' denied at the

other terminal of the relay. Through the agency of this oscil-
lation, then, set in motion by the ambiguity of the woman, the
cathexis of the *product* is further overdetermined.

This sketch analysis of an advertisement is to indicate how
manifest visual and verbal elements engage with each other and
with latent registers of phantasy, memory, and knowledge, much
as cogs engage gear trains: transmitting, amplifying, trans-
forming, the initial input. Obviously, in the act of looking at
such an advertisement we do not conduct the sort of conscious
analysis I have just outlined; this is not what I am claiming; I
am saying that a substantial part of its *sense* is achieved in the
way I have just described, albeit we experience these effects 'in
the blink of an eye'. Moreover, and most importantly, such
effects are not erased, they become inscribed in memory;
Horowitz: 'Perceptions are retained for a short time, in the
form of images, which allows continued emotional response and
conceptual appraisal. In time, retained images undergo two kinds
of transformation: reduction of sensory vividness and *translation
of the images into other forms of representation* (*such as words*)'[15]
(my emphasis). It is here that we encounter a general social
effect of photographs. The social order is, in a sense, built of
blocks of verbal discourse of varying degrees of formal organis-
ation. A significant social effect of a photograph is the product
of its imbrication within such discursive formations. It is easily
appreciated that advertising activates such formations as, for
example, those which concern family life, erotic encounters,
competitiveness, and so on. The role of the verbal in advertising
will be just as readily conceded – writing is physically integrated
into nearly all advertisements. But 'art' photographs are not
exempt from such determinations of meaning, determinations
which are achieved even where actual writing is absent. I shall
take my examples, again, from the period of the 1960s.

Throughout the 1960s in America, in the setting of the growing
escalation of, and protest against, the war on Vietnam, blacks
and women organised against their own oppression. In 1965 the
Watts riots effectively marked the exhaustion of the predomi-
nantly Southern black strategy of nonviolent political struggle,
and the emergence of the concept of black power. In 1967 the
Black Panthers went publicly armed and uniformed in Oakland

and carried their weapons into the California State House in Sacramento. In this same year the national women's peace march in Washington marked the effective inauguration of the Women's Liberation Movement. It is surely reasonable to suppose that the knowledge of events such at these suffused the collective consciousness of Americans in the 1960s. Let us now consider two 'art' photographs of this period.

About a quarter of the way into Lee Friedlander's book *Self Portrait*[16] is a photograph captioned 'Madison, Wisconsin, 1966'. In it, the shadow of the photographer's head falls across a framed portrait photograph of a young black person. The portrait is set in an oval aperture cut in a light coloured mount, an oval now tightly contained within the shadow of the head. Placed in this context the oval is made to serve as the schematic outline of a face, the shadows of Friedlander's ears are stuck absurdly one to each side, but the face which looks out from between the ears is black. Item 109 in the catalogue to the Museum of Modern Art exhibition *New Photography U.S.A.*[17] is an untitled photograph by Gary Winogrand taken in Central Park Zoo in 1967. It shows a young white woman close beside a young black man, each carries a live chimpanzee which is dressed in children's clothing. In the most basic social terms, what are we to make of these images produced at that historical conjuncture?

In everyday social life it is the face which carries the burden of identity; in these terms, to exchange one's face for that of another would be to take the other's place in society. Friedlander's photograph suggests the idea of such an exchange of identities – if I am white it invites me to imagine what it would be like if I were black. In Winogrand's picture my identity and my social position are secure.[18] We are all familiar with expressions of irrational fear of the 'mixed marriage': from the comparitively anodyne punning of the joke about the girl who married a Pole – and had a wooden baby – to the cliché insults of the committed racist, according to whose rhetoric the union of white and black can give issue to monkeys. In terms of these considerations therefore it should be clear that Friedlander's photograph is open to readings couched in terms of social change, to which Winogrand's image is not only closed but hostile.

A final example: the catalogue to a 1976 exhibition of Gary

Winogrand's photographs[19] contains an image in which four
women, talking and gesturing amongst themselves, advance
towards the camera down a city street. The group of women,
who are of varying degrees of middle age, is the most prominent
feature in the right-hand half of the image; equally prominent
in the left half of the image, visually just 'touching' the women,
is a group of huge plastic bags stuffed full of garbage. This
photograph is also printed on the cover of the catalogue; the
author of the introduction to the catalogue tells us:

> When four aging women gossip their way past four ballooning
> garbage bags, it earns power for the eye that sees them. If
> that eye laughs and gloats it condemns the women to nothing
> more than participation in an eternal joke.

Concluding the montage of aphorisms which is Winogrand's
own written contribution to the catalogue, Winogrand states: 'I
like to think of photographing as a two-way act of respect.
Respect for the medium, by letting it do what it does best,
describe. And respect for the subject, by describing it as it
is'. But what the world 'is' depends extensively upon how it is
described: in a culture where the expression 'old bag' is in circu-
lation to describe an aging woman that is precisely what she is
in perpetual danger of 'being'. Neither the photographer, nor
the medium, nor the subject, are basically responsible for the
meaning of this photograph, the meaning is produced, in the act
of *looking* at the image, by a way of *talking*.

We cannot choose what we know, and neither can we choose
what part of our dormant knowledge will be awakened by the
stimulus of an image, reciprocally reactivated and reinforced
by it. Regardless of how much we may strain to maintain a
'disinterested' aesthetic mode of apprehension, an appreciation
of the 'purely visual', when we look at an image it is instantly
and irreversibly integrated and collated with the intricate psychic
network of our knowledge. It is the component meanings of this
network that an image must *represent*, there is no choice in
this. What flexibility there is comes in the way in which these
components are assembled (and even here we may have less
freedom than we like to believe). To be quite explicit: such

'racism' or 'sexism' as we may ascribe to these or other images is not 'in' the photographs themselves. Such 'isms', *in the sphere of representation*, are a complex of texts, rhetorics, codes, woven into the fabric of the popular pre-conscious. It is these which are the *pre-text* for the 'eternal joke', it is these which pre-construct the photographer's 'intuitive' response to these frag-ments of the flux of events in the world, producing his or her recognition that there is something 'there' to photograph. *It is neither theoretically necessary nor desirable to make psychol-ogistic assumptions concerning the intentions of the photographer*; it is the preconstituted field of discourse which is the substantial 'author' here, photograph and photographer alike are its prod-ucts; and, in the act of seeing, so is the viewer. As Roland Barthes has put it:

> The 'I' which approaches the text is already a plurality of other texts, . . . subjectivity is generally thought of as a plenitude with which I encumber the text, but this fake plenitude is only the wash of all the codes which make up the 'I', so that finally, my subjectivity has the generality of sterotypes.[20]

Such a radical displacement of 'the artist' from his or her traditional position of founding centrality in the production of meaning does, of course, run completely counter to the dominant discourse of the art institutions. This discourse itself exercises its own massive determinations on the received sense of art photographs, and it is therefore necessary to give some account of it. The discourse in dominance in art photography is, *de facto*, that of 'modernism'; there has, however, been an inconsistency in the application of a modernist programme to photography.

III

The first paragraph of John Szarkowski's introduction to the catalogue which contains Winogrand's Central Park Zoo picture tells us: 'New pictures derive first of all from old pictures. What an artist brings to his work that is new – special to his own life and his own eyes – is used to challenge and revise his tradition,

as he knows it'.[21] There is a vivid similarity in this passage to
the style and content of Clement Greenberg's writing, indeed
the criteria for evaluating photographs employed throughout
Szarkowski's texts corresponds almost identically to the
programme for modernist art laid down by Greenberg. The 1961
essay 'Modernist Painting' is probably Greenberg's most succinct
statement of his view of modernism, and may therefore serve
here as a convenient checklist.[22] In this essay Greenberg defines
modernism as the tendency of an art practice towards self-refer-
ence by means of a foregrounding of: the tradition of the prac-
tice; the difference of the practice from other (visual arts) prac-
tices; the 'cardinal norms' of the practice; the material substrate,
or 'medium' of the practice.

In reference to *tradition*, Greenberg states: 'Modernist art
continues the past without gap or break, and wherever it may
end up it will never cease being intelligible in terms of the past'
– Szarkowski's endorsement of this position is quoted above. In
respect of *difference*, Greenberg writes: 'Each art had to deter-
mine through its own operations and works, the effects exclusive
to itself. . . . It quickly emerged that the unique and proper area
of competence of each art coincided with all that was unique in
the nature of its medium'. Szarkowski says, in an interview: 'I
think in photography the formalist approach is . . . concerned
with trying to explore the intrinsic or prejudicial capacities of
the medium as it is understood at that moment'.[23] Greenberg
argues for the destruction of three-dimensional space in painting,
'for flatness alone was unique and exclusive to pictorial art'. He
argues for a renewed emphasis on colour, 'in the name of the
purely and literally optical, . . . against optical experience as
revised or modified by tactile associations'. Flatness, the 'purely
optical', and other such things as, 'norms of finish and paint
texture', belong to what Greenberg calls *cardinal norms* of the
art of painting'. Szarkowski devotes his catalogue introduction
to the 1966 Museum of Modern Art exhibition *The Photogra-
pher's Eye*[24] to cataloguing such cardinal norms of photography,
which he identifies as: 'The Thing Itself', 'The Detail', 'The
Frame', 'Time', and 'Vantage Point'. What is not to be found in
Szarkowski's discourse is Greenberg's emphasis on the *medium*
defined in terms of material substrate. Greenberg insists on the

materiality of the painted surface as a thing in itself in the interests of an anti-illusionism; to make a comparable insistence in respect of photography would be to undermine its founding attribute, that of illusion; we might further note that it might very well evict the camera itself from the scene, returning photography to, literally, *photo-graphy* – drawing with light. This elision, this unresolved (albeit understandable) failure to complete the journey upon which it has embarked (modernism is *nothing* if not totally internally coherent), marks a contradiction which runs like a fault-line through Szarkowski's discourse: illusion cannot be totally abandoned, but neither can the full consequences of retaining it be accepted.

We should recall that the modernist programme for painting dictated that the art work be a totally autonomous material *object* which made no reference whatsoever to anything beyond its own boundaries: the painted surface itself, its colour, its consistency, its edge, its gesture, was to be the only 'content' of the work. Any form of representation other than self-presentation, in Greenberg's words, 'becomes something to be avoided like a plague'. This impetus is in direct line of descent from the desire of Bell and Fry, early in this century, to free art from concerns 'not peculiarly its own'. Bell, writing in 1913, stated: 'To appreciate a work of art we need bring with us nothing but a sense of form . . . every other sort of representation is irrelevant'; and he complained of those who: 'treat created form as if it were imitated form, a picture as though it were a photograph'.[25] In the same movement in which, in the West, the issue of representation in art became a dead issue, photography became consigned to the far side, the 'wrong' side, of that divide which Cubism had opened up between the nineteenth century and the modern period. Initiatives to recover photography from this remote shore (in the history of which Steiglitz figures so prominently) were therefore unavoidably directed towards securing 'picture' status for photographs. The general programme of modernism showed the way: the *art* of photography is achieved *only* through the most scrupulous attention to those effects which are irreducibly derived from, and specific to, the very functioning of the photographic apparatus itself – representation may be the contingent vulgar flesh of

photography, but its spirit is 'photographic seeing'. Szarkowski
is thus able to judge: 'Winogrand . . . is perhaps the most
outrageously thoroughgoing formalist that I know. What he is
trying to figure out is what that machine will do by putting it to
the most extreme tests under the greatest possible pressure'.[26]
However, although content in photographs may be ignored, it
will not go away. The fear perhaps is that to *speak* of it would
be to backslide into Naturalism, that it would necessarily be to
abandon the gains of the modernist discourse which has provided
art photography in the modern period with its credentials and
its programme. On the contrary, it would be to pursue the
modernist argument with an increased rigour.

The modernist programme for a given practice is centred upon
that which is irreducibly *specific* to the practice; in a sense, that
which remains after eliminating the things it is *not*. The initial
definition of this specificity is therefore crucial, as all subsequent
modes of action and evaluation will depend on it. In a 1964
article in the *New York Review of Books*[27] Greenberg himself is
in no doubt as to the locus of the specificity of photography.
First, it is *not* modernist painting: 'its triumphs and momuments
are historical, anecdotal, reportorial, observational before they
are purely pictorial'. But then neither is 'brute information' art,
in fact: 'The purely descriptive or informative is almost as great a
threat to the art in photography as the purely formal or abstract'.
Greenberg concludes:

> The art in photography is literary art before it is anything else
> . . . The photograph has to tell a story if it is to work as art.
> And it is in choosing and accosting his story, or subject, that
> the artist-photographer makes the decisions crucial to his art.

Greenberg, however, offers no suggestion as to how an
impression of narrative can be given by a single image. Szar-
kowski, writing some two years later, can continue to assert:
'photography has never been successful at narrative. It has in
fact seldom attempted it'. Photographs, he finds: 'give the sense
of the scene, while withholding its narrative meaning'.[28] 'Narra-
tive meaning' here is clearly equated with the sort of factual
account of an event which might be sought in a court of law.

Obviously this cannot be derived from a single image alone. But what is this 'sense' which Szarkowski mentions but does not discuss; this 'story' which Greenberg names but cannot explain? Greenberg's equation of 'story' with 'subject' raises more questions than it answers, but they are productive questions – questions raised around the ambivalence of his use of the term 'subject': subject of the photograph (the thing pictured); subject of the story (that which it is 'a tale of'). My purpose here has been to argue that we may only resolve this ambivalence through the introduction of a third term – the *seeing* subject (the individual who looks), and that to introduce *this* subject is, in the same movement, to introduce the social world which constructs, situates, and supports it.

To speak of the 'sense' and 'story' of a photograph is to acknowledge that the reality-effect of a photograph is such that it inescapably implicates a world of activity responsible for, and to, the fragments circumscribed by the frame: a world of causes, of 'before and after', of 'if, then . . .', a *narrated* world. However, the narration of the world that photography achieves is accomplished, not in a linear manner, but in a repetition of 'vertical' readings, in stillness, in a-temporality. Freud remarks that time does not exist in the unconscious, the dream is not the illogical narrative it may appear to be (this is the dramatic product of secondary revision), it is a *rebus* which must be examined element by element – from each element will unfold associative chains leading to a coherent network of unconscious thoughts, thoughts which are extensive by comparison with the dream itself, which is 'laconic'. We encounter the everyday environment of photographs as if in a waking dream, a day-dream: taken collectively they seem to add up to no particular logical whole; taken individually their literal content is quickly exhausted – but the photograph too is laconic, its meaning goes beyond its manifest elements. The significance of the photograph goes beyond its literal signification by way of the routes of the primary processes: to use a filmic analogy, we might say that the individual photograph becomes the point of origin of a series of psychic 'pans' and 'dissolves', a succession of metonymies and metaphors which transpose the scene of the photograph to the spaces of the 'other scene' of the unconscious, and also, most

importantly, the scene of the popular pre-conscious: the scene of discourse, of *language*.

E. H. Gombrich has traced the lineage of the belief in the ineffable purity of the visual image. In the *Phaedo*, Plato puts into the mouth of Socrates a doctrine of two worlds: the world of murky imperfection to which our mortal senses have access, and an 'upper world' of perfection and light. Discursive speech is the tangled and inept medium to which we are condemned in the former, while in the latter all things are communicated visually as a pure and unmediated intelligibility which has no need for words. The idea that there are two quite distinct forms of communication, words and images, and that the latter is the more direct, passed via the Neo-Platonists into the Christian tradition. There was now held to be a divine language of *things*, richer than the language of words; those who apprehend the difficult but divine truths enshrined in things do so in a flash, without the need of words and arguments. As Gombrich observes, such traditions, '. . . are of more than antiquarian interest. They still affect the way we talk and think about the art of our own time'.[29] Today, such relics are obstructing our view of photography.

Re-reading *Camera Lucida*

'(*those who fail to re-read are obliged to read the same story everywhere*)'
(*S/Z 15–16*)

La Chambre Claire – Note sur la photographie was the last book by Roland Barthes to be published during his lifetime; the translation, *Camera Lucida – Reflections on Photography*, is the latest of about a dozen works by Barthes to become available in English. There has been a tendency amongst those who have so far written about *Camera Lucida* to regard it as Barthes's last word on photography. In the strictly literal sense this is of course true; in any other sense it makes a nonsense of what Barthes stood for. In a preface of 1963 he characteristically remarks that to write is, 'to become someone to whom *the last word* is denied; to write is to offer others, from the start, the last word' (CE xi). Of course that 'last word' offered to his commentator is itself no more than a thread in a web of texts which will grow for as long as Barthes's work is discussed – as long as the *written* Barthes survives.

Barthes was first of all a literary theorist; one of the many aspects of literature he wrote about was the way in which a reader constructs the image of a whole character from the fragmentary indications offered by the text. Barthes reminded us of

71

such truths, contrary to common intuition, as that the narrator of a story is a character amongst the others: 'the *I* which writes the text, it too, is never more than a paper-*I*' (IMT 161). Thus, on the otherwise blank page which opens his 'autobiography', *Roland Barthes by Roland Barthes*, he inscribes (in his own handwriting, to get the most out of the paradox): 'All this must be considered as if spoken by a character in a novel'. I never knew Barthes in person, 'in the flesh'; the Barthes I know is a person 'in the text' – as contradictory, and otherwise complicated, as any corporeal being; in the brief space available to me here I want to follow some of the traces of Barthes's written-*I*/*eye* as they emerge within a discourse on photography.

If Barthes had never written specifically about photography he would still be a figure of primary importance for the theory of photography because of his pioneering work in 'semiology'. Although it had long been common for people to speak loosely of 'the language of' this or that activity – including, of course, 'the language of photography' – it was only in the late-1950s to mid-1960s that Barthes, and others, undertook to interrogate the supposed analogy between 'natural language' (speech and writing) and signifying systems other than language *from the standpoint of linguistic science*. These early investigations demonstrated that there is no single signifying system upon which all photographs depend (in the sense in which all texts in English ultimately depend upon the English language); there is, rather, a heterogeneous complex of codes upon which photography may draw. Each photograph signifies on the basis of a plurality of these codes (for example: codes of gesture, of lighting, and so on), the number and type of which varies from one image to another, and very few of which are unique to photography. (I would emphasise, 'signifies *on the basis of*', as it was never claimed that the consideration of such codes would *exhaust* the signification.)

By the early-1970s semiology had undergone a radical transformation from within, in the course of which the linguistic model became displaced within a broader complex of methodologies – most notably those of Freudian and Lacanian psychoanalysis. Within the area of theory today the term 'semiology' is most commonly used to refer to the early approach, with its

almost exclusive emphasis on (Saussurian) linguistics; the word 'semiotics' is now most usual to designate the ever-changing field of cross-disciplinary studies whose common focus is on the general phenomenon of *meaning* in society. (Other, more or less equivalent, expressions for its current forms include: 'textual semiotics', 'deconstructive analysis', and 'post-structuralist criticism'.) In this second revolution in theory, all the more surprising in that it followed so closely on the massive upheaval of structuralism itself, emphasis was shifted, as the title of one of Barthes's essays from this period puts it, 'From Work to Text' (IMT 155). In structuralist semiology the particular object of analysis (novel, photograph, or whatever) was conceived of as a self-contained entity, a 'work', whose capacity to *mean* was nevertheless dependent upon underlying formal 'structures' common to all such works – the task of theory was to uncover and describe these structures. This approach provided what we might call an 'anatomy' of meaning production; however, as an 'anatomical' science, it was unable to say anything about the constantly changing 'flesh' of meaning. *Text*, as conceived of by Barthes (with the prompting of, mostly notably, Jacques Derrida and Julia Kristeva), is seen not as an 'object' but rather as a 'space' between the object and the reader/viewer – a space made up of endlessly proliferating meanings which have no stable point of origin, nor of closure. In the concept of 'text' the boundaries which enclosed the 'work' are dissolved; the text opens continuously into other texts, the space of *intertextuality*. Perhaps the most simple example I can offer here, to give a rough idea of the notion of 'intertextuality', is of the drink advertisement which shows a glass slipper containing ice-cubes and a measure of vermouth; consciously or not, I am referred instantaneously to: 'Cinderella' (rags to riches; romantic love); 'drinking from a slipper' (*fin-de-siècle* playboys and chorus-girls; physical sexuality); 'American-ness' ('on the rocks' – for example, scenes in B-movies of drinking in piano-bars); 'failure' (for example, an unsuccessful marriage is conventionally referred to as 'on the rocks'); and so on. All of this, and more, belongs to the fields of what Barthes calls the '*déjà-lu*': the 'already read', 'already seen', everything we already know and which the text may therefore call upon, or 'accidentally' evoke. These intertextual fields

are themselves, of course, in constant process of change (another reason why there can be no final closure of meaning). This brief example is perhaps already enough to show the impossibility of assigning a 'sum' of signification: the parts will not add up to a non-contradictory whole. I am of course aware that, in the case of advertising certainly, but also in most other cases of the use of photographs, the proliferation of connotations is 'controlled' by means of an 'anchoring' caption – if there were more space available to me I would argue that such apparent 'closure' is ultimately spurious; even without the argument, however, it may be appreciated – from the work of graffiti artists, for example – that though the caption may come dressed as a policeman it may be made to play the clown. It might also be objected that my associations in respect of the advertisement cited take the trajectory of a phantasy – romantic attraction; sexual possession; post-coital disillusion – which is the pattern of a vast number of actual narratives (films, books, TV plays, and so on), and as such is itself subject to narrative *closure*; but it is not the *only* phantasy projection possible here, and if it were to be *told* then the telling would itself open out onto other, mutually contradictory, texts, which in turn, . . . and so on.

One of the most far-reaching consequences of textual analysis has been what Barthes called, in the title of another essay, 'The Death of the Author'. The Author says Barthes, is a conception which:

> suits criticisms very well, the latter then allotting itself the important task of discovering the Author (or its hypostases: society, history, psyche, liberty) beneath the work: when the Author has been found, the text is 'explained' – victory to the critic. Hence there is no surprise in the fact that, historically, the reign of the Author has also been that of the Critic. (IMT 147)

To Barthes's (infinitely extensible) list of 'hypostases', the 'ghosts' in the textual machinery, there can of course be added 'structure'; the semiological writings which have survived (in the sense they are still *used*) are those in which 'structure' functions in the analysis as a heuristic device rather than a real goal. It

would be wrong however to view 'post-structuralism' as the
negation of 'structuralism'; Barthes himself remarks:

> the frayed nature of the codes does not contradict structure
> (as, it is thought, life, imagination, intuition, disorder, contra-
> dict system and rationality), but on the contrary (this is the
> fundamental affirmation of textual analysis) is an integral part
> of structuration. It is this 'fraying' of the text which
> distinguishes structure – the object of structural analysis,
> strictly speaking – from structuration – the object of . . .
> textual analysis (V 157).

My task here is to provide a (re-)reading of Barthes's work
on photography which pays attention both to the 'fraying' of his
texts (where 'his' meanings 'edge out' into the seas of intertex-
tuality), and to their structure (consistency of analytic 'motifs',
and their patterning, repetitions, transformations, across the
totality of his work). It should be clear that this is no hunt for
that Chimera of dominant criticism, what Barthes 'really said';
even less (even greater conceit), what Barthes 'really meant'.
My purpose is simply to negotiate the shifting currents of his
texts in the hope they will carry me in a direction in which I
wish to go.

If, in the spirit of early structuralism, we were to reduce the
corpus of Barthes's writings on photography to its 'bare bones'
we would find that his analysis is invariably *binary*, the nature
of the opposition between the two terms being subject to some
transformation. Proceeding less formally, but in accordance with
this insight, the following chronology emerges:

Barthes's semiology begins with the final section of *Mytho-
logies*, Myth Today', written in 1956. In the course of this essay
he discusses a photograph. On the cover of *Paris Match* he sees
a picture of a black soldier giving the French salute: 'a rich, fully
experienced, spontaneous, innocent, *indisputable* image'; but
Barthes discerns an additional message at work here, which is:
'there is no better answer to the detractors of an alleged
colonialism that the zeal shown by this Negro in serving his so-
called oppressors' (M 116). Thus, the very 'naturalness' of the
photograph, Barthes observes, here lends the ideology ('myth')

of imperialism the status of an indisputable truth. This distinction
between the image and the concept which appropriates it is
retained by Barthes in his 1961 essay 'The Photographic
Message', where he introduces linguistic concepts to refine the
distinction and give it the status of a general law: the 'brute fact'
(for example, 'there is a black soldier saluting') is the *denotation*,
the parasitic message (for example, 'the indigenous population
is not exploited') is the *connotation*. In these terms he now
identifies what he calls, 'the photographic paradox': 'the co-
existence of two messages', where a, 'connoted (or coded)
message develops on the basis of a *message without a code*' (IMT
19); (the distinction is carried over, in virtually the same words,
into his 1964 paper, 'Rhetoric of the Image', IMT 32).

In a short preface to the 1970 edition of *Mythologies* Barthes
repudiates the form of his project in that book (albeit not the
project itself – the 'capital enemy' remains 'the bourgeois norm').
Semiological analysis, he remarks, 'has become more developed,
precise, complicated, differentiated; it has become the theor-
etical site where there can play . . . a certain liberation of the
signifier'. Precisely what this 'play of the signifier' entails I have
already tried to indicate – it can be seen most fully in his *S/Z*
(1970) the classic demonstration of 'textual analysis' (just as
Barthes's *Système de la Mode*, soon to appear in translation, is
the classic work of structuralist semiological method). In the
opening pages of *S/Z*, a lengthy analysis of a short story by
Balzac, Barthes remarks: 'denotation is not the first meaning,
. . . it is ultimately no more than the last of the connotations'
(S/Z 9). Put more briefly: *all* meaning is *in* culture (to return to
the man on the cover of *Paris Match* – what is there which is
truly 'innocent' in the attribution, 'black', and, 'soldier'?). The
idea of the 'pure' fact, literally *insignificant*, nevertheless persists.
Barthes's other book published in 1970 is *L'Empire des Signes*,
his book about Japan (or, more strictly, as he himself remarks,
about his *fantasy* of Japan), and his own favourite amongst his
works (because, he once said, of its associations with a happy
period in his love-life). *L'Empire des Signes* is, in effect, a book
of sustained praise of the attitude of the *haiku*. Amongst the
haiku he quotes is one by Bashô, which is itself, contradictorily
(a 'meta-*haiku*'?), about the attitude of the *haiku*:

How admirable
He who does not think: 'Life is ephemeral'
On seeing a flash of lightning. (E 96)

The *haiku*, Barthes says (in a passage he will repeat almost word for word ten years later), 'does not make meaning of the subject', it merely, 'reproduces the designating gesture of a small child who points a finger . . . while saying only: that!' The *haiku* may instruct us in that mental discipline which can appear to silence meaning, but the appearance is illusory – to be outside of language, in real terms, means infancy; to be outside of all meaning whatsoever means death. Psychoanalysis has shown us that the mental processes of which we are conscious are not the only meaning-producing processes which are taking place: the coveted 'absence' of meaning may mean merely that meaning has left the room, and is holding a party in the basement. I shall return to this point. For the moment, in respect of Barthes's 'photographic paradox' of the 'message without a code', we should remember that there is no paradox in the real, only in the way the real is *described*; the paradox is a purely linguistic (more specifically, *logical*) entity. Barthes's particular paradox is born of the uneasy union of two inherently contradictory discourses: semiotics and phenomenology.

The terms 'denotation'/'connotation' do not appear in Barthes's 1970 essay on photography, 'The Third Meaning', but the trace of the opposition so important to classic semiology may nevertheless be discerned, in this essay, in the distinction between 'informational' and 'symbolic' levels of meaning. Far from being seen as radically distinct, however, these two are now classed together as that which, 'presents itself quite naturally to the mind' – which Barthes now calls the *obvious* meaning. The 'obvious' meaning covers all of the semantic area which was previously divided between denotation and connotation, but a small portion of territory has now been ceded to support a 'third meaning': 'the supplement that my intellection cannot succeed in absorbing', which Barthes terms the *obtuse* meaning. This meaning is supported by, 'what, in the image, is purely image (which is in fact very little)' (IMT 61). It is this 'very little' which Barthes is now concerned to isolate. Semiotics had already

accounted in some detail for the manner of production and circulation of those meanings which are fully in the *public* domain. Barthes now turned his attention to that *slight*, but nevertheless important, meaning-effect/affect of photographs which had previously slipped into the interstices of an analysis which had privileged social meaning at the expense of the private. This level of meaning, says Barthes: 'is that of *signifiance*, a word which has the advantage of referring to the field of the signifier . . . and of linking up, via the path opened up by Julia Kristeva who proposed the term, a semiotics of the text' (IMT 54). Barthes opens up several paths in 'The Third Meaning' without travelling very far down any of them. I shall return to the directions in which these paths lead, for the moment I must observe only that Barthes's final essay on photography – a decade later – will only assert the futility of such journeys.

Barthes has been quoted as saying: 'it is necessary to choose between being a terrorist and being an egoist'; it is the exercise of this choice which distinguishes Barthes's work from 1975 onwards from all his work before that year. *Roland Barthes by Roland Barthes* institutes the 'privatisation' of Barthes's discourse, his abandoning of the voice of the *tutor*, which continues with *A Lover's Discourse* and *Camera Lucida*. In *Camera Lucida* Barthes is concerned with photographs only in so far as they contribute to 'those little touches of solitude' of which, he says, life consists. Contemplating a photograph of his recently deceased mother he has, 'no other resource than this *irony*: to speak of the "nothing to say"'. This photograph, and others, 'touch' him in a certain way. That aspect of a photograph which may *move* an individual, in a way which is strictly incommunicable, Barthes calls the *punctum*. It is the *private* nature of the experience which defines the *punctum*. Certainly there are photographs which many people, in common, will find moving, but here, 'emotion requires the rational intermediary of an ethical and political culture'; it, 'derives from an *average* effect, almost from a certain training'; it is a matter of general 'human interest'. This *common ground* of meaning – whether it concerns the emotional, the practical, the historical, or whatever other aspect of shared experience – Barthes terms the *studium*. Clearly, we are here back to the 'two levels of meaning', which

is the basis of all Barthes's writing on photography; specifically, we are returned to the distinction in 'The Third Meaning', between the 'obvious' and 'obtuse' meanings of a photograph. Now, however, the tentativeness of the earlier essays is absent, the boundaries are now fixed, the paths are closed. The 'obvious meaning' becomes the *studium*, the 'obtuse meaning' becomes the *punctum* – the translation into an inert language, a *dead* language, signals that we have arrived at a terminus. The process of change is now *arrested* (Latin is also a juridical language) in the name of an experienced certitude. It is to the nature, and status, of this certitude that I now wish to turn.

Barthes describes his project in *Camera Lucida* as a search for the 'essence' of photography. In terms of everyday language, to speak of a 'search for essence', sounds rather mystical, ineffable. To people who have been raised in the English-speaking world it can conjure up those images of consumptive and spiritually anguished poets which are the bequest of our domestic Romantic tradition. We would be wrong however to situate Barthes's use of the term within such a context. Barthes quite explicitly relates his project to that of *phenomenology*. Barthes dedicates *Camera Lucida* to Sartre's book *L'Imaginaire*, which is an extended discussion of mental imagery from the point of view of phenomenology. In the technical language of phenomenology, 'essence' (*eidos*), is simply the common factor, or factors, which unites all of our otherwise very different encounters with, in this case, photographs. I say 'unites our encounters', rather than 'unites photographs', because phenomenology sets out to describe subjective experiences rather than material objects. The reason for this is that the phenomenologist would say that the only thing I can be *certain* of about the material world is that I have mental representations of (it). I place 'it' (the world) in brackets here because that is what the phenomenologist would have me do: my consciousness is to laden with the baggage of everyday commonsense assumptions that I see only what I *know*, I must therefore store this baggage out of the way, put my knowledge 'on the shelf' (even if it is 'scientific' knowledge) in order to 'reduce' my experience of the world to the terms of 'raw' apprehension. It is in this sense that we should take Barthes's assertion

in *Camera Lucida* that, looking at certain photographs, he, 'wanted to be a primitive' (CL 7).

A further concept crucial to phenomenology, is that of 'intention': things exist for me only in that I *actively* 'intend' them in consciousness (I do not simply, *passively*, 'perceive' things). The mind is not simply a *screen* upon which the world projects its appearances; in 'making something' of appearances the mind, in a sense, is also a *projector*, projecting a world of things *onto* those appearances. To give only a most basic and familiar example, I never see a 'cube' *as such*, I can see no more than three sides at any one time; or again, I 'intend' circular coins where I almost invariably *see* only a variety of ellipses. The notion of 'intentionality' is crucial to a reading of the account of photography in *Camera Lucida*, which is in fact practically identical to Sartre's descriptions in *L'Imaginaire*. Here is Sartre, early in the book, talking about a photograph:

> My intention is here now; I say: 'This is a portrait of Peter', or, more briefly: 'This is Peter'. Then the picture is no longer an object but operates as material for an image . . . Everything I perceive enters into a projective synthesis which aims at the true Peter, a living being who is not present.

The real object therefore, present to perception (here, the photograph) is, 'an "analogue" of another object', and no more or less an analogue than is a purely *mental* 'representative' of the absent object of 'intention'. An immediate problem, therefore, for a theory of photography based exclusively on phenomenology would be that it would not distinguish between a photograph and, for instance, an image 'seen' in a crystal ball (another of Sartre's examples). In fact Barthes in *Camera Lucida* is, like Sartre, concerned not so much with the general phenomenon of the photograph as such, but rather with the yearning 'intentionality' of the imagination. At the beginning of the final section of *The Psychology of the Imagination* (the English translation of *L'Imaginaire*). Sartre writes: 'the act of the imagination is a magical one. It is an incantation destined to produce the object of one's thought, the thing one desires, in such a way that one can take possession of it. In that act there is always something

of the imperious and the infantile'. These words might have come straight out of *Camera Lucida* (where Barthes does in fact speak of photography as 'a magic'). Of course, to become *infantile* is another way in which we may understand the phrase 'be a primitive'. I shall come back to this point by way of a comment on the translation of Barthes's book.

On the very first turn of the page of Barthes's text in *Camera Lucida* I read, 'what Lacan calls the *Tuché*', whereas the French gives me simply, 'the *Tuché*', together with a margin note referring me to pages 53–66 of Lacan's *Le Séminaire, Livre XI*. Only four lines later I read, '*tathata*, as Alan Watts has it, the fact of being this'; again, the French has it, '*tathata*, the fact of being this', together with a reference to page 85 of Watts's *Le Bouddhisme Zen*. It cannot be objected that there would be little point in referring English readers to French publications, the Lacan text cited here has been translated (as, *The Four Fundamental Concepts of Psychoanalysis*, Hogarth, 1973 – the relevant pages are 53–69), and Alan Watts's writings are originally in English. Just as the translation is, in the matter of margin notes, under-researched, so there are points at which the sense of it seems to me to be inadequate. Immediately after the mention of Watts, the translation reads, '*tat* means *that* in Sanskrit and suggests the gesture of the child pointing his finger at something and saying: *that, there it is, lo!*' Other readers may have shared my own incredulity at this child who speaks like a character in a Hollywood Biblical epic. In fact Barthes's child says not, '*that, there it is, lo!*', but, '*Ta, Da, Ca!*'. The original, '*Ta, Da, Ca!*', is first of all a subversive joke, a mimicry of *Tathata* which reduces a dramatic and mysterious incantation to childish prattle; but it is *doubly* subversive in that, in the same movement, it points to what is *serious* in the prattle. What is 'overheard' here is an utterance produced during the child's transition from the infantile world of brute experience 'without mediation, satiety, or void' ('infant' is from *infans* – 'without speech'), to a world of *things* ordered by words. The child here *plays* with 'its' language (as it might play with its food), jubilating in the demonstration of its grasp of the representative function of the sounds, yet no less aware of their material substance and its structuring (an awareness it will later lose, language coming to appear

increasingly 'transparent'). There is an instance of such play
which is famous in the literature of psychoanalysis: in *Beyond
the Pleasure Principle*, Freud describes watching a child alter-
nately expel from its cot, and then recover, a cotton reel on a
string, to the accompaniment of its utterance of 'ooh!'
and 'da',
which Freud interprets as approximations of the German words
fort and *da* – 'gone' and 'there'. Freud interprets the child's
'game' as its attempt to master the painful experiences of its
mother's absences: the disappearance and reappearance of the
mother being symbolised by the absence and presence of the
reel. Lacan's own discussion of Freud's interpretation focuses
on the fact that the opposition 'absence/presence' is in turn
symbolised by a phonemic opposition: O/A (*ooh/da*). Lacan
argues that what Freud allows us to observe here is a moment
in the infant's entry into language, the language that will later
permit it to *communicate* its experience to others, but only at
the cost of stripping the experience of its irreducible and unre-
peatable *particularity*. No verbal statement will ever succeed in
expressing *that* child's experience of the absence of *this* mother
under *those* circumstances (nor, ideologies of the 'purely visual'
notwithstanding, will any other form of representation).
According to Lacan it is in such gaps between the plenitude of
experience and the paucity of symbolism that *desire* is born. The
'fort/da' game is invoked by Lacan in the specific passage cited
by Barthes: the *Tuché* is the specific 'encounter with the real'
which nevertheless will always elude the subject's grasp: in trying
to signify it, we lose it. In a Lacanian terminology I can say that
what we encounter in the *Real* (as a plentidue which is effaced
in the very moment it is experienced), which slips our grasp in
the *Symbolic* (language, and all other socially conventional forms
of signification), we will strive to 'conjure up' in the *Imaginary*
(for my purposes here, the realm of imagination and *phantasy*).

It is a commonplace to observe that desire and phantasy are
closely connected (together, they result in the 'day-dream'), and
that photographs are commonly involved in our 'phantasising'.
In adopting the spelling '*ph*antasy' I locate the term within the
context of psychoanalysis, (which we might call the *science* of
phantasy). In a classic, Freudian, setting the word 'phantasy'
refers to imaginary scenarios which can be *conscious* (as in the

day-dream), *preconscious* (not conscious, but which may emerge into consciousness under favourable conditions), and *unconscious* (radically inaccessible to consciousness, except in the disguised form of dreams, slips of the tongue and other lapses – and, of course, *conscious* phantasies). I have written elsewhere on the topic of photographic imagery as a vehicle of phantasy investments, and I shall not try to summarise what I have already said, as the account is already condensed. Without going into detail, I wish simply to note that, *in its point of departure*, Barthes's approach to the photograph in *Camera Lucida* is compatible with the sort of psychoanalytic/intertextual approach I have suggested. I say 'in its point of departure' as Barthes's method in *Camera Lucida*, although it is founded on the idea of subjective *investment* (here, 'intention') in the photograph, may not draw upon psychoanalytic concepts for the simple reason that phenomenology does not recognise the *unconscious*. (Although Barthes uses Freudian and Lacanian psychoanalytic theory very extensively throughout his work, he nevertheless writes of himself: 'His relation to psychoanalysis is not scrupulous (though without his being able to pride himself on any contestation, any rejection). It is an *undecided* relation' (RB 150).)

Camera Lucida, then, for all its reference to Lacan, is based on a method of analysis – phenomenology – which rejects the concept of the unconscious. Such a rejection has severe consequences in that it denies photography theory a body of research which, I believe, is crucial to its development. Freud made it clear enough, in various parts of his work (see his discussions of voyeurism, fetishism, and psychogenic disturbances of vision), and Lacan has since made it perfectly explicit in his introduction of the notion of the *scopic drive*, that unconscious desire operates in our looking and being looked at. (We are all, of course, well aware of the occasions when the link between desire and looking is apparent to consciousness. I would stress that it is not the character of our *experience*, as such, which is in dispute – Lacan's discussions of looking owe much to Sartre's own in chapter 4 of *Being and Nothingness* – it is the operation of *unconscious* processes within the experience which is at issue.) Although *Camera Lucida*, we might say, represses the notion of the uncon-

scious, Barthes's paper, 'The Third Meaning' invokes the concept of the unconscious through its reference to *signifiance*.

Julia Kristeva distinguishes between *signification* and *signifiance* (a term she adopts from Benveniste): *signification* is meaning which is produced on the side of what she calls (after Lacan) the *symbolic* – that is the area within which the Barthes of *Camera Lucida* would locate the *studium*, the public arena of socially determined meaning production; *signifiance*, on the other hand, is radically distinct in that it belongs to what Kristeva calls the *semiotic*. Kristeva's use of this word is very particular and should not be confused with the more general use of the term: The *semiotic* is that area of meaning which must be repressed in the process of socialisation of the 'speaking subject'; it is anterior to language and intimately linked to rhythms and pulsions of the *body*; it is (dis)covered in terms of the 'primary processes' of the unconscious (metaphor and metonymy) which are in turn known only through the disturbances they create in the orders of rational discourse. Kristeva's work is situated within a Lacanian problematic, even while critical of it, and is not to be assimilated to the biologistic reductionism which has tended to be the fate of psychoanalytic theory in the English-speaking world. Freud himself was quite explicit in situating the 'drives' 'at the boundary of the somatic and the psychic'. Anglo-Saxon empiricism would turn a blind eye to the 'boundary area' and shift the entire question of the origins of subjectivity onto the body alone – thus supporting the conservative myth of the 'time-lessness' of 'human nature', supposedly determined by the (undoubtedly) perpetual facts of birth, ageing, death, and so on. (To appreciate that this is a conservative position we need only consider its consequences for feminism.) Barthes himself succinctly replied to this ubiquitous mythologising of 'the human condition' (central to all liberal-humanist ideology – in the area of art/photography criticism see, for example, the writings of John Berger and Peter Fuller) in his short essay on Steichen's 'Family of Man' exhibition (M 100–102).

The concept of *signifiance* in the work of Kristeva is bound up with considerations of the infantile period of life, that period before speech when the nurseling is most intimately identified with the body of the *mother*. Psychoanalytic theory has described

how, in the primitive stages of emergence of language, sound imagery joins with other forms of imagery (visual, tactile, and so on) around certain early encounters with the real to establish 'elementary signifiers' of the unconscious: certain 'image fragments' become associated with certain early experiences which thereby make a 'lasting impression' on the infant/child; these images, and the emotional charge they carry, remain in the unconscious mind of the adult; from time to time, some conscious event (for example, looking at a photograph) will have some aspect to it which will 'allow' an associative connection with the unconscious fragment; the emotional charge carried by the unconscious fragment will then 'spark' across the gap to the configuration in conscious perception, investing it with a 'feeling' for which there is no rational explanation. It is in this way (albeit the account I have given is highly simplified) that I would account for Barthes's *'punctum'*. Barthes himself provides support for this account. In *Camera Lucida* he writes about a photograph of an American family by James Van der Zee; the detail which 'touches' him in this image, he says, is the strapped shoes of one of the women: 'This particular *punctum* arouses great sympathy in me, almost a kind of tenderness' (CL 43). Barthes makes no further comment until, some ten pages later, he 'remembers' the photograph ('I may know better a photograph I remember than a photograph I am looking at', p. 53); he now realises that it was not the shoes which moved him, it was the *necklace* the woman wore: 'for (no doubt) it was this same necklace (a slender ribbon of braided gold) which I had seen worn by someone in my own family'. The relative he has now been reminded of is a deceased maiden aunt: 'I had always been saddened when I thought of her dreary life'; after the aunt died her necklace remained, 'shut up in a family box of old jewelry'. We can here see the process of *significance* at work: the investment of emotional 'affect' (*cathexis*) in the ankle-strap; the metaphorical displacement from the circle round the ankle to the circle round the throat; the metonymical displacement from the woman in the photograph to the maiden aunt, 'whose necklace was shut up in a box'; we quickly arrive at the sources of the emotion in the themes of death and sexuality, played out within a family scenario, which are the very substance of psychoanalysis. (The

identification of such 'sources' is *not* however, the aim of textual
semiotics – this, strictly, here, would be a matter between
Barthes and his analyst. Semiotics is interested in the potential
field of such displacements and their 'mechanisms', in so far as
this bears on the general phenomenon of the production of
meaning).

Barthes is well aware of all this. In introducing the Van der
Zee picture he remarks: 'Very often the *punctum* is a 'detail',
that is, a partial object. Hence, to give examples of *punctum* is,
in a certain fashion, to *give myself up'*. The French at the end
of this last sentence reads, *'me livrer'*, which certainly means,
'give myself up' (in the sense of a surrender to justice), but the
verb *livrer* also carries the meaning, 'to betray a secret'. Further,
'partial object' certainly translates the original *'objet partiel'*, and
communicates the idea of *bias*, but *objet partiel* is also the stan-
dard translation of the English psychoanalytic term *part-object*,
introduced by Melanie Klein in her account of the phantasy
world of the child to designate a real or phantasied part of the
body (for example, the breast), and its symbolic substitutes,
towards which a 'component instinct' is directed.

The 'encounter with the real' which we may expect to be
represented most strongly in the unconscious is the *trauma* (for
example, in the 'fort/da' case, the mother's absence). 'Trauma'
is from the Greek word for 'wound', its Latin equivalent is
punctum. In 1963 Barthes spoke of the difficulties of writing a
letter of sympathy to a friend who has just lost someone he
loves; the 'phrases' he invents do not satisfy him; he realises that
the message he wishes to commmunicate, 'could after all be
reduced to a simple word: *condolences'*; but this, the most
'sincere' message, is the least possible, it would appear cold.
Barthes observes that the warmth and sincerity of his sympathy
can only be communicated by *artifice*, by invention. He recog-
nises in this the very condition of literature itself: 'Like my
condolence note, everything written becomes a work only when
it can vary, under certain conditions, an initial message (I love,
I suffer, I sympathise)'. *Camera Lucida*, written in the brief
interim between the death of Barthes's mother and Barthes's
own death, says, 'I suffer', and says it with surpassing artifice.
Its originality is in its deployment of a number of radically hetero-

geneous discourses (for example, psychoanalysis and phenomen-
ology), whose synthesis is achieved not at the level of theory
(which would be impossible), but at the level of *literature*.
Camera Lucida, as a totality, may be read as the autobio-
graphical novel that Barthes often said he wished to write. A
novel which in its originality does not announce itself *as* a novel
(such 'obvious' novels Barthes despised as complicit with an
exhausted 'sociolect'; as belonging to the 'readerly' (*lisible*),
rather than the 'writerly' (*scriptible*).

The review of *Camera Lucida* as a work of fiction is yet to be
written. My task here has been to take the book at face value (so
often a mistake with Barthes) as a contribution to photography
theory. *Camera Lucida*, in this perspective, is primarily an
evocation of *intentionality* as it strives to conjure the image of a
loved person through the intermediary ('*medium*') of a snapshot.
Its significance for theory is the emphasis thus placed on the
active participation of the viewer in producing the meaning/affect
of the photograph. The theoretical perspectives this entails, in
terms of Barthes's own work as a whole, are those centred on
the notions of intertextuality and *signifiance*. These perspectives
are alluded to, in respect of photography, in 'The Third Meaning'
– they are only 'spelled out' in detail in connection with Barthes's
first love, literature; however, he observes:

> Our aim is to manage to conceive . . . the plurality of the text,
> the opening of its 'signifiance'. It is clear then that what is at
> stake in our work is not limited to the university treatment of
> the text . . . nor even to literature in general; rather it touches
> on a theory, a practice, a choice, which are caught up in the
> struggle of men [*sic*] and signs.

An indication of what a consideration of 'the plurality of the
text' might mean in terms of a photographic *practice* is to be
found in a lengthy footnote to 'The Third Meaning'. Barthes has
posited a hypothetical 'filmic of the future' which will lie not in
movement, 'but in an inarticulable third meaning that neither
the simple photograph nor figurative painting can assume since
they lack the diagetic horizon, the possibility of configuration'
(IMT 66). In the footnote with which he interrupts himself at

this point, he cites those existing practices which *do* combine still and story – the photo-novel and the comic strip – and he remarks:

> I am convinced that these 'arts', born in the lower depths of high culture, possess theoretical qualifications and present a new signifier (related to the obtuse meaning) . . . There may thus be a future – or a very ancient past – truth in these derisory, vulgar, foolish, dialogical forms of consumer subculture.

Roland Barthes was a teacher, several of his books are the products of seminars conducted with his students. He complained of a particular difficulty of teaching – to be required to impose a generally applicable body of knowledge and techniques (to be systematic, scientific), while yet wishing to relate to one's audience at an individual level (to be spontaneous, 'natural'): 'The choice is gloomy: conscientious functionary or free artist, the teacher escapes neither the theatre of speech nor the Law played out on its stage' (IMT 192). Given the situation, neither attitude of the teacher can ever appear to be entirely convincing. The problem is not confined to teaching: *all* discourse issues not only from some *position* (no possibility of 'neutrality' – moral, political, economic, aesthetic, or whatever), but also from some *one*. It would be 'bad faith' for me to pretend I have no *stake* in what I am saying; but equally, I am not doing my job as a *critic* if I simply assert my views without explaining how and why I think they have a general validity, a validity which is independent of the personal history of he or she who utters them. It is partly because this existential situation of the critic has led to two quite different types of project that it has become necessary today to distinguish between 'criticism' and 'theory' – the former being the most widely encountered; the latter, culturally marginalised, encountered mainly in specialist journals and seminar rooms.

'Theory' is generally indicted by criticism as *obscure*, and no one was put in the dock more often on this charge than Barthes himself. In *Mythologies* he asks:

Why do critics thus periodically proclaim their helplessness or
their lack of understanding? It is certainly not out of modesty:
no-one is more at ease than one critic confessing that he
understands nothing about existentialism; . . . and no-one
more soldier-like than (another) pleading for poetic
ineffability.

Barthes concludes: 'All this means in fact that one believes
oneself to have such sureness of intelligence that acknowledging
an inability to understand calls in question the clarity of the
author and not that of one's own mind'. It is, finally, a way of
soliciting the complicity of the public by saying, in effect: 'I
whose profession it is to be intelligent, understand nothing about
it; now you wouldn't understand anything about it either; there-
fore, it can only be that you are as intelligent as I am' (M 34).
 Such conflicts aside (it has always been the fate of theory
which announces itself as such to be called before the bar of
conservatism), the existential dilemma remains – *Camera Lucida*
is one response to it. Early in the book, Barthes speaks (again)
of a 'discomfort' he had 'always suffered from': 'the uneasiness
of being a subject torn between two languages, one expressive,
the other critical'. The critical language (theory), moreover,
divides him, 'between several discourses, those of sociology,
of semiology, and of psychoanalysis'. Dissatisfied with any one
discourse, alert always to its reductive capacity, he would, 'gently
leave it and seek elsewhere'. In *Camera Lucida* (appearances
notwithstanding) he abandons the discourse of theory (abstract,
general) as inappropriate to the object of his text – which is his
mother (all the photographs illustrated in the book are substitutes
for the one he does not show – the 'Winter Garden' picture of
his mother – which is in turn nothing but a means of access to his
mother). The 'leave-taking' in *Camera Lucida* is not all gentle;
Barthes expresses impatience with those of, 'Photography's
commentators (sociologists and semiologists)', who turn a theor-
etically blind eye to the (phenomenological) *experience* of the
photograph, its 'magic'. Barthes here attacks what the methodo-
logies he himself did so much to advance have become in the
hands of certain practitioners. In his essay on teaching he
remarks that he has no desire to see the 'notes' taken during his

courses – partly out of discretion (such notes are very personal things), but, more likely, from fear of contemplating himself in a reduced state, 'like a Jivaro treated by his fellows'. Where the 'shrinking' of Barthes has taken place, however, it has more often been the work of the critics than of his students: there is another side to the critical coinage which announces its lack of understanding – it is the side which claims to understand very well the 'Jivaro head' it substitutes for the original, and which can then serve it as an Aunt Sally, or a talisman, as the need arises.

Although Barthes was for most of his career reviled by 'popular opinion' (which is to say, by those critics who pretend to speak on behalf of it), the situation changed when in the last few years of his life he began to speak 'not as a terrorist but as an egoist' – here at last was a Barthes with whom the critics could identify. The passage in *Camera Lucida* where Barthes lambasts the scientist of the sign (his own other self) has become widely quoted amongst precisely the sorts of critics Barthes opposed. Barthes was once asked at the end of a lecture, by someone obviously irritated by what they took to be Barthes's wilful 'difficulty', if the Freudian 'super-ego' wasn't *really* just what we all know as 'conscience'. Barthes replied: 'Yes, if you leave out all the rest'. It was rather like being asked if 'lightning' isn't the same thing as 'Zeus's thunderbolt' – yes it is, if you're happy to ignore the difference between the 'world-view' of modern meteorology and that of classical mythology. On page 88 of *Camera Lucida* does Barthes reject systematic approaches to photography, or does he not? Yes, he does, if you leave out all the rest. *Camera Lucida* itself leaves something out; in a strictly literal sense, in respect of *this* book at least, it is Barthes's last word: I close my copy of *Camera Lucida*. The back cover is, entirely, a photograph of Barthes. I close my copy of *La Chambre Claire*. There is no photograph. The back cover carries an emblematically enlarged quotation from a work called, *Practice of the Tibetan Way*. It seems peculiarly apt to me that the English-language version of this work should conclude with a portrait of the author; whereas the author chose to end it all with a paradoxical text which again sets in play that hopelessly irresolvable choice he faced as writer and teacher: the oscillation

between the 'two languages', between egoism and terrorism, actor and policeman – now set in the testing context of personal grief. The quotation reads:

> Marpa was very moved when his son was killed, and one of his disciples said: 'You have always told us that all is illusion. Is it not so with the death of your son, is not that an illusion?' And Marpa replied: 'Indeed, but the death of my son is a super-illusion'.

Agency of the letter in the unconscious

TREE

s dimension that the psychoanalyst has not yet
because of his quite justified feeling that his c
ue entirely from it. Here is the other diagram:

LADIES GENTLEMEN

ee that, without greatly extending the scope of t
n the experiment, that is, by doubling a noun tl
osition of two terms whose complementary mean
:o reinforce each other, a surprise is produced by a
ation of an unexpected meaning: the image of ɪ

Tea with Madeleine

'Desire' and the 'image' – two terms. And then a third term, the position from which I speak, the 'man.' Three terms then – 'man', 'desire', 'image' – a triangle of terms where the consideration of one point moves me to the next.

To take the first – 'man'. 'Male', and the opposing term which gives it its sense, 'female', labels a body. The most important question asked of any of us is a question we do not, at the time, understand: 'Doctor, is it a boy or a girl?' 'Female' and 'male' are anatomical terms. 'Masculine' and 'feminine' are sociological and psychological terms, which designate gender roles and/or psychological characteristics along a spectrum between 'active' and 'passive'. Social roles and psychology may be *assigned*, by social convention and institutions, on the basis of anatomy, but they are not otherwise determined by anatomy.

If '*The* woman' does not exist, as Lacan puts it, striking out the definite article (~~The~~), then it follows that '*The* man' does not exist either. If I move now, therefore, from my first term, 'man', to my second term, 'desire', then I am allowed to do so, forming the expression, 'man's desire', only if I strike through 'man' – placing it, in Derrida's expression, 'under erasure': I need the term in order to go on speaking, but it signifies the very concept of which my argument must be most suspicious.

Now to move to 'desire'. The term comes to us, in this context, from the French, *désir*, which in turn translates Freud's *Wunsch*

Tea with Madeleine

To start again. A train is stopping now at some nameless station and a little girl is turning to her brother in the carriage and is about to say: 'Idiot! Can't you see we're at Gentlemen'. This in reply to: 'Look, we're at Ladies!' (At this point he rushes off down the corridor to pee – not so much because he has to, but rather to reassure himself it's still there.) Tea has now appeared. They look at each other and put it in their mouths. It is a *Brief Encounter*. They look at one another and suffer. The lady behind the counter is 'common' but speaks with a refined accent (the judgement of Celia Johnson's friend): she is of indeterminate identity and stands behind the bar, there, in the position of the TREE. Jack, meanwhile, finds it *occupé*. She, meanwhile, has bolted – rushing out to throw herself under the express; the body in pieces; but she doesn't do it. She goes back into the buffet. The last time that happened was the beginning of it all. The express roared through and she got a cinder in her eye; she went back into the buffet and he said, 'I happen to be a doctor', and he got it out for her.

Olympia's eyes are on the floor, waiting for Spalanzani to pick them up and throw them at Nathanael, who has just burst in. Coppola is hot-footing it through the other door with Olympia over his shoulder, *sans* eyes of course. Nathanael is upset. It was Coppola who sold him the

(also, we might add, *Lust*). *Whose* desire? And for *what*? 'Who',
here already under erasure, is of course split: fundamentally, it
is the *unconscious* subject that desires. 'What', here, leads almost
directly to the third term, 'image' – 'almost' directly, as desire
is for an image only via the detour of an object. But the conscious
object of desire is always a red herring. The object is only the
representative, in the real, of a psychical representative in the
unconscious (Freud's 'ideational representative' of the instinct).
In fact, desire *is* the instinct, as the Lacanians put it, 'alienated
in a signifier' – the *trace* of a primal, *lost*, satisfaction. The real
object, present – most poignantly, the 'love-object' – is 'chosen'
(does *choice* ever really come into it? – '*coup de foudre*') because
something about it allows it to represent the lost object, which
is *irretrievably* absent. (Thus Freud identifies the structural
unhappiness inherent in all sexual relationships; thus Lacan
declares, 'There is no sexual relationship' – no possibility of the
union of mutually complementary beings, only the more or less
happy *juxtaposition* of two island universes.) The lost object is
something which – it is believed – will repair the rent which has
opened up between the subject and the maternal body (the
breast is the prototype of all lost objects). The 'image' here,
upon which desire turns, is a psychic image; it may be 'visual',
but it may equally be tactile, auditory, olfactory, kinaesthetic,
gustatory . . ., or it may be a complex of various such images
which coalesce through the agency of purely formal associations
– for the Lacanians, 'through the agency of the signifier'. In the
triad of terms making up the expression, 'man – desire – image'
therefore, 'man' goes under erasure and 'image' goes in scare-
quotes. Thus we arrive at an inelegant but necessary deconstruc-
tion: The ~~man~~('s) desire (in/for) the 'image'.

That's my first trip around the terminological triangle. I began
by rejecting an essential 'man', simply given in biology. Lacan
refers to, 'he who finds himself male without knowing what to
do about it'. Over the last decade or more we have seen, in the
feminist movements, 'those who find themselves female' and
moreover, at least in the sphere of political action, 'knowing
what to do about it'. In so far as the visual image has been seen
to assist or incite the oppression of women, we have witnessed
a women's *resistance* to the image. '*The* man' may be a fiction,

spyglass which he used to watch Olympia's room. He didn't know he had danced with such a doll. This is the end of *Casanova*. Outside the cinema it's pouring with rain, pissing down. I had a friend who was driving through a strange town in a rainstorm. He needed to pee, so he stopped the car when he saw a public convenience. It was pissing it down, so he dashed across the road and ran straight into the Ladies.

Trevor Howard runs into Celia Johnson while she's out shopping and they go and have some tea together, and then they go to the pictures. But most of the time they are at the station and a train is always about to come in, either hers or his. They're always having to go, on different trains. He's closing the door behind him, standing up now. She's closing the door behind her and sitting down. And she's looking out of the window and dreaming. It's this fantasy about being young and free and together and they're in Venice, except she realises it's just the canal with the willows near where she lives, and this is where she has to get off. Back to her husband and child. Love for duty's sake, says Kant, can be commanded; pathological love cannot.

Kant says she can't.

Desire comes uncommanded: 'Love at first sight'; but, 'Love is blind', sustained only in so far as we are mistaken about what it is we want. In *Vertigo*, Scottie, an ex-detective, is hired by an old college friend to follow Madeleine, the friend's wife. He falls in love with her at first sight, in Ernie's Restaurant. But Madeleine is not the college friend's wife, she is an impostor, planted to deceive Scottie as part of a plot to kill the real wife. Later in the film, Scottie witnesses Madeleine's death. He has not fully recovered from the trauma of this event when he discovers Judy, a shop girl who physically resembles Madeleine. But Judy (it is revealed to the audience but not to Scottie) is in fact the Madeleine with whom Scottie originally fell in love – it was not she but the *real* wife whose death Scottie witnessed. Throughout the film Scottie's desire is for an image, the truth of which is consistently denied to him.

but it is a fiction with real social effects. I believe the calculation of these effects cannot be made in advance of specific conjunctures; I do not believe in *lists* of 'good' and 'bad' images. No image, in and of itself, can be 'sexist'; in and of itself it is a signifier, it is only when that signifier is articulated with others in complex discursive formations in a particular society at a particular moment that we can judge that the consequent meaning-effect/affect is, or is not, 'sexist', *oppressive*. So I think the question of *contents* of the image is, in this context, a matter for political calculation rather than theoretical speculation. For me, theory comes in when we ask the question: 'What is the *form* of visual imagery consequent upon the form of the construction of the fiction of *the* man?'

In social terms, 'at street level', it seems quite obvious that men's desire often results in images which perpetuate the oppression of women. How is this fact to be articulated with the theoretical insight that *the* man – the putative 'author' of these images – is a fiction? (Just as Barthes reminds us that the author of a novel is as much a fictional character as the other characters we construct at the instigation of the text.) Here, again, we must begin with Freud – with the concept of psychic bisexuality. The question of precisely how 'men' and 'women' emerge from an initially undifferentiated pre-Oedipal sexuality has provoked storms of confusion, and biologism is the port in which many seek shelter. To deny that biology *determines* psychology is not, however, to deny that the body *figures*. In certain religions, men wear a lock of hair long, so that when they die God may grasp it in order to lift them into heaven. Lyndon Johnson is supposed to have said: 'If you've got them by the balls, their hearts and minds will follow'. As a male, *the* man has me by the penis.

The body *figures*, is *represented*, in psychic life. In male psychic life these representations turn between the poles of having/not having the phallus. This is so for the female too, but the male has the means of representing the phallus, as an integral part of his body, in the form of the penis. Male desire, in so far as it leaves its trace in the image, is premised on castration anxiety. I believe we must truly 'return to Freud' here in taking the idea of castration quite literally. I believe Lacan's emphasis on the metaphorical nature of the penis/phallus, a greater emphasis

Image and truth only come together for Scottie at the end of the film, a coincidence which brings about the real death of the person he desired. (Incidentally, Scottie's love for Madeleine fulfills the conditions outlined by Freud in his 1910 paper, 'A Special Type of Choice of Object Made by Men'.) Her voice is distant. It's a little glitter in the darkness. The line crackles and the darkness is swept with snow. The glittering point disappears. Then it's black again. 'Hello'. The glittering again. She says – close to her is a man he does not know – 'I love you'. By the telephone is a printed message from the management. An adult movie in your room. Call the desk. They'll bill you seven dollars. The cables run in pipes. The bodies wait, entangled in the lines. There is nothing on the screen but snow.

There was an old Marx Brothers on TV. At the end, there's a huge society party held on a summer night in the grounds of some nob's estate. The lawns run down to the water's edge, the edge of the North Atlantic. And there, on a huge floating stage, is a symphony orchestra, playing for all it's worth. I don't remember how, but it slips its moorings (I suppose the Marx Brothers did it). Nobody in the orchestra notices – they're all too engrossed in their music; sawing and blowing, and the conductor flailing his arms like crazy. They float away. We keep cutting back, between scenes of the party – point-of-view shots from land. Each time the orchestra is a bit further away, still floating, but quieter, smaller. Then just a spark in the blackness. Then nothing.

It's snowing again. Things were getting hot for Shklovsky. The Cheka were arresting members of the Socialist Revolutionary Party. So he fled to Finland, across the ice, at night, the blizzard lighting up his headlights. It's cold. So cold it freezes your nuts off and shrivels your prick to the size of a trouser button. The size of a pea. You might as well have a cunt between your legs. Shklovsky is crying. Damn. Her make-up is running. She'll look a mess if she ever gets there. She peers into the blizzard trying to pick out the glittering light at the edge of the ice. Distant. A little glitter in the darkness.

than is to be found in Freud, perhaps allows us to see the woman better at the cost of rather dimming our view of the man. Julia Kristeva has spoken of Don Juan as representing the unrestrained masculine libido, endlessly bent on conquest. But we can interpret Don Juan's behaviour another way: the most poignant moment for Don Juan is not the *invasion* of the woman's body, but its *investigation*. The most poignant moment for Don Juan takes place, we might say, between the bedroom door and the bed – it's the moment of undressing. It is Don Juan's disappointment at the answer to the question, 'what does *this* woman's body look like?' which hurls him onto the *next* woman in this 'endless metonymy' (we might say, 'endless monotony') of desire. If we did not lack, says Lacan, we would not desire. If the woman's body did not lack, Don Juan would be happy with, 'This sex which is not Don Juan'. I'm reminded here of a Roman fresco of Pan unveiling the body of a sleeping maiden, only to discover that he's uncovered a hermaphrodite. The author of the book in which I saw this image commented that such paintings were intended as a joke – but we may remember that where there is a joke there is a repressed wish. For me, this painting is the very *emblem* of men's desire as inscribed in the image.

Man's desire in/for the image is lodged under the sign of *fetishism*. The fetish is that fragment which allays the fetishist's castration anxiety by serving as a reassuring substitute for that which he construes as 'missing' from the woman's body. Laura Mulvey has remarked on the universal tendency of men to fetishise the entire body of the woman – an attempt to make the totality represent the part which is 'lacking'. In this connection we might remember the ancient prototype of this perfect woman, Zeuxis's painting of Helen of Troy: commissioned to paint the likeness of Helen, the most *perfect* woman (and in the absence of the original), Zeuxis assembled a composite figure of the best individual features of the most perfect females in the land. The body of the 'perfect' woman is a paradox, it is that of which every fragment is a totality.

Man's desire is, most fundamentally, in and for that which can be *seen*. If the penis serves as privileged signifier of the phallus, we are told by several writers, it is because it is *visible*. For

.........

It's too hot in this café in the hotel in Warsaw. An extravagant display of long-stemmed chrysanthemums shields the pianist from his audience. *I Fall in Love too Easily.* The dress looks like silk. Tight. The sleeves are slashed. Her face is angular; the nose prominent. She is leaving the table she shares with an older woman. *Love For Sale.* Now she is returning, striding past the chrysanthemums, through the thick smoke of cigarettes. *Don't Blame Me.* One foot rests squarely on the ground; the other, arrested in its forward motion, touches the ground only with the tips of the toes. *'Round Midnight.* Western journalists and businessmen circulate amongst the women who lounge on the couches in the bar, dipping into their purses for lipsticks and currency-conversion tables. Room numbers are noted. Framed in the doorway. Blonde, darkening towards the roots. Rouge, blending into white. Green eyes. Yellow light in the corridor. Yellow walls. Yellow dress. Yellow carpet.

In a dim yellow puddle of light. On the aeroplane. She was reading. A large man's bulk leans over her, his voice dragging in time with the dull grind of the engines: 'You *have* to be negro, with hair like that'. She says: 'I want to be alone. I'm sorry. I'm reading'. The book resting against her thighs is by Virginia Woolf. In *A Room of One's Own*, she argues that writing is not 'spun in mid-air by incorporeal creatures' but is produced by real individuals in specific material circumstances. Women (like working-class men, also) have had only very limited access to the means of literary production: an appropriate education, publishing houses, uninterrupted periods of leisure, and so on, . . . and on, and on, his dull voice dragging along with the sound of the engines.

I. Sleep. A woman, a beautiful actress, bends over a child in a taxi. They are in a train. Departure is imminent. The woman's face, in close-up, is heavily caked in make-up, not adequately masking open pores. '*You're*, not my mummy!' I get off the train and run down the platform. I am in Chicago. I must find the airport. How did I come to

example, Freud and Lacan apart (looking now for a woman to speak), Catherine Johns, in her book on the erotic imagery of Greece and Rome, remarks: 'The vulva is rarely seen: its situation makes it invisible in any normal position even to its owner'. But I'm made to think of that mainstay of the pornographic photographic genre, the masturbating woman. There she is, eyes closed, touching herself, all laid out for the male voyeur: he sees her, she doesn't see him. But what he cannot see, and never will see, is what *she* is seeing with her closed eyes. We're reminded again that to say 'image' is not necessarily to say 'visible'. We might judge then that the Judy Chicagos – those who would make a meal of the visible vulva – are already working on the side of *the* man in privileging the visible; and, of course, this is indeed the theme of much feminist argument, for example, that of Irigaray: that which is on the side of the woman privileges such things as touch, and scent, above the visual; all those things we experience in 'extreme close-up', where vision blurs, where form separates, fragments, dissolves and spreads. Cameo of mother and child, certainly, but this is not only a female province. Men may not become mothers (Little Hans's fantasies apart), but they have all been children (I'm stating the obvious to remind us of Kristeva's position, with its stress on a *shared* pre-Oedipal experience, as against that of Irigaray, with its assimilation of the pre-Oedipal to a 'woman's language' premised on the woman's body; for Kristeva, as for Freud – albeit the intent may be different – the 'feminine' is an attribute of both women *and* men).

Whether or not we want to accept the idea that the visual is a male domain, it does not help the worker in the visual arts industry to be offered early retirement in lieu of a progressive visual art practice. One direction in which the idea of a 'feminine language' (Kristeva's sense) has led has been into an emphasis on the *trace* (in terms of Peircian semiotics, the 'indexical' sign – particularly, here, the indices of the fetishised aspects of visual art), it is the trace of the *Artist*, this Other source of imaginary plenitude, this punctual guarantee of authenticity, this Being who does not lack. Another sort of response to the primacy of the visual – other than the attempt to find visual equivalents, or analogues, of primarily non-visual experiences – has been the

be so far from home? I must find my way back before it is too late.

Julia Kristeva admonishes me: 'Woman, as such, does not exist!' I have my fourth glass of white wine over the white cliffs of Cape Farewell, the southernmost tip of Greenland. The cliffs rise to 11 000 feet. Beyond the cliffs, the ice cap begins. In Milan, in the hot summer of 1972, at the conference, JK wore a white dress; when she spoke, someone in the audience released a white bird. It's said that, because of his wartime heroism, Kennedy never doubted his masculinity. I pick up *Nothing Sacred* and begin reading about Lulu. I am. Enraptured. The thought occurs, 'I wish I could have written this'. The plane bucks, alarming me. I look to the steward. Mummy does not return my gaze, he is looking elsewhere and smiling; I know I am safe. It is then that it occurs to me, 'Perhaps I would have had to be a woman to write like this'. It's theoretically unsound, but it's out. It was then that Julia Kristeva snapped at me.

'What's wrong with you?' asked Wanda.

I pointed to the mirror.

'Ah, yes, how beautiful', she cried. 'What a pity we cannot keep this moment'. 'And why not?' I replied.

Wouldn't any painter, even the most famous, be proud to immortalize you with his brush? . . . I am seized by all the shivers of death and nothingness at the dreadful thought that this extraordinary beauty, these marvelous features, these eyes with the strange green fire, this demonic hair and all the splendor of this body, risk being lost to the world . . . But the hand of the artist must rescue you from all that. It must not be that, like us, you disappear entirely and definitively, without leaving a trace of your existence. Your image must survive when you yourself shall be long fallen into dust; your beauty must triumph over death. (Sacher-Masoch, *Venus in Furs*)

It is the woman's body which reminds men of death. Kristeva says it's not the woman who is repressed under

response of 'troubling' vision, the attempt to undermine its apparent certainties. We can think here of cubism, with its unsettling of classical, single-point-of-view perspective; or of Russian Futurist photography, which attempted to 'defamiliarise' the visual world by offering, literally, a 'new angle' on things. Or again, there has been the practice of intruding words into the space of the image. In all of these cases, however, the disturbances are local and temporary, or may be otherwise contained: the representational jumble of a cubist picture is ordered by a formalist logic and held within a single (often golden) frame; new angles on things are only new for as long as they are new; and the words which appear on advertisements do not, simply by their presence, destabilise regimes of the publicity image.

At this point, my speech – having begun, perhaps, on the side of the hysterical – is now becoming more historical. I am also an 'artist' – if that means anything at all in this post-Derridean context, it means someone (and he or she is, of course, far from being alone in this) who must draw practical lessons from theory. If, in order to produce anything, women artists had to wait until the vexed theoretical question of woman's relation to castration had been finally resolved, it would suit men very well – this is a small corner of the market-place, and no stallholder welcomes increased competition. Paradoxically, it is within this same market-place that we must peddle our politics (as I've said elsewhere, a 'politics of representation' rather than a 'representation of politics'). The application of theory in forging a strategy is a wager the outcome of which cannot be certain. How *are* we to avoid the imitation of the fetish?

Structurally, fetishism is a matter of separation, segregation, isolation; it's a matter of petrification, ossification, glaciation; it's a matter of idealisation, mystification, adoration. Greenbergian modernism was an apotheosis of fetishism in the visual arts in the modern period. For a long time Western art aspired to the condition of non-significance. 'Content', said Greenberg, 'is something to be avoided like a plague'. Strong words; *anxious* words. The art object was to signify nothing; that is to say, it must not serve in the place of something which is absent *as the signifier of that absence* but rather it must serve, like the fetish, to *deny* that absence. The modernist art object denies that there

patriarchy so much as maternity – that reminder of the blind continuity of the species at the expense of the individual *me*. Besides, I don't want my mother to become someone else's mother – so I'm jealous of the child my lover wants. The periodic fluctuations of the woman's body remind us of the organic, of change – birth, growth, death, birth . . . Men would repress all this in the interests of sustaining the illusion of their own immortality. Liquidity, shape-shifting, *all* change, must be subject to the strictest control.

The *image* is on the side of the feminine. Polysemic. Swept away along streams of associations it provokes but does little to control. 'Text' is its pilot (Barthes: 'anchorage'). The image is potentially frivolous. It wanders. A 'serious' book is one which contains no pictures (and where the words do not seek to 'paint' pictures). 'Thinking in pictures . . . is unquestionably older than [thinking in words] both ontogenetically and phylogenetic- ally . . .' (Freud). The image is on the side of the pre- Oedipal. The word stands to it in the relation of the Law – words added to an image always have an air of paternal guidance and/or reproval.

But there is another way of looking at this. We must be suspicious of this appealing assimilation of image to liberty and word to prison. Patriarchy depends on its divisions. First: *the* woman/*the* man. But *the* image/*the* text is just such a form of patriarchal organisation. Just as, in patri- archy, the concept of *the* woman is the repository of that 'feminine' which a man must evict from himself in order to become *the* man, so the concept of *the* image is made up of that which must be expelled from the text in order that the word may become *Law*. To demand that the image be liberated from the word therefore is to make a gesture whose implicit essentialism exacerbates the problems it seeks to cure.

Is she boring him? She takes a sip of her tea and then changes the subject. When she tells her dealer she intends moving, he says, 'Good. That apartment was bad for your image – it wasn't an *artist's* place'. So there it is, confirmed. She always suspected that her refusal of *that* otherness

is anything lacking in the field of vision, it represents a canonised empiricism which seeks to cover over the activity of the unconscious in the visual field. The more recent lurch towards expressionism has changed nothing. Today's expressionism, in the wake of modernism, is the obverse face of the same coin, the flip-side of the long-playing record of fetishism in the visual arts. The fulfillment of lack is now guaranteed by that mythical Other-who-does-not-lack, locus of fertility, the *Genius*. The artist here figures both as phallic mother and as infant (*in-fans* – 'without speech'). It is *his* trace which is left on the canvas – it's not really a metaphor to say that the recent market for freshly-done expressionism has been dealing in shit. From, 'this object does not lack', we moved to, 'this artist, whose trace this is, does not lack' – either way, there's no *difference*.

Fetishism denies, 'disavows', difference. To do so it presents a *fragment* as self-sufficient. To move against fetishism in visual art is to move 'beyond its fragments', beyond its divisions: division of form from content (political subject-matter can be fetishised just as much as can be the avoidance of any subject matter whatsoever); division of the private from the social (which after all only maps the division of family life from work in industrial capitalist societies, including those in the East); division of the word from the image (I've written at length elsewhere about what a complete nonsense *that* is); division of the masculine from the feminine in the interests of producing 'men' and 'women'; division of theory from practice; division of the inside of the institution from its outside (for example, the almost complete isolation of art-historical and critical discourse from the wider analytical discourses – including psychoanalysis and semiotics – surrounding them).

This breaking down of divisions is not a unifying, ecumenical, movement – not a denial of difference by other means, not just another road to fetishism. It is in the interest of showing the *meaning* of sexual difference as, precisely, a *process of production*; as something mutable, something historical, and therefore something we can do *something* about.

had contributed to her lack of commercial success. The imago of the *Artist* had always stood beckoning in the wings of her imaginary. How tempting to go on stage as that character. Reviving the pleasures of her art student days she would entertain critics and curators in her *Studio*. It would be dirty and exciting, showing them things there. Sketches pinned roughly to the walls, paint-caked pallets, oil-soaked rags – the smell of turpentine. (The smell of the make-up, the pin-ups on the walls of her adolescent bedroom.) All the chaotic paraphernalia of creativity her visitors desire. But the apartment/office from which she works resembles any other – no *sign* of a revolution of the spirit, no coquettish display; hence, low sales.

He swallows his coffee and wipes his mouth, disappointed that breakfast is over. He often goes to bed looking forward to breakfast. Lunch is a guilty evasion of the day's work. Dinner too often a defiantly excessive solace for the shame of the day's failures. But breakfast is a feast of the innocent. He prefers to take this pleasure alone, but this is the only time he can fit her into his day. The 'Garden Café' of her hotel overlooks a car park, in what is known as a 'hooker's district'. On the walls are many bad lithographs (obviously from the same hand) in which a variety of domestic flora lounge unhappily in badly-drawn planters. She lounges unhappily opposite him. He shouldn't have said that about her apartment, why was he getting at her?

As she leaves the restaurant he glances at her again. She does not appear to see him. Amongst her symptoms: all the people she sees seem like wax figures; in a bunch of flowers she can only see one flower at a time. She will scatter the nosegay of narcissi on the black waters of the bay. He will descend into that darkness beneath the bridge, where she floats like Ophelia, for love of the face he glimpses just below the surface, believing it to be that of someone other than himself. Throughout the film they will miss each other, or they will miss their trains, waiting until the last possible moment, until they can't wait to go any longer. Then, finally, each will be lost to the other, closing their respective doors behind them.

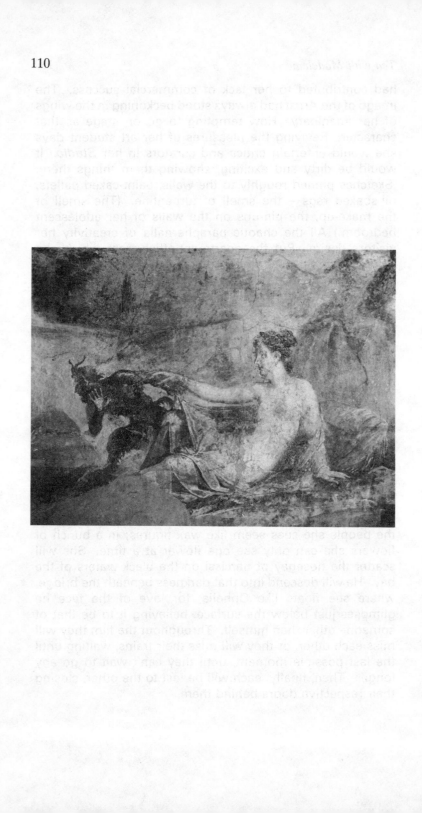

Diderot, Barthes, *Vertigo*

The title of this essay[1] came by way of, 'Diderot, Brecht, Eisenstein', an essay by Roland Barthes to which I shall refer later. Recent theory has been very interested in the facts of which my extemporaneous substitution of one phrase for another is an instance: meaning is only ever produced in difference, and the final closure of meaning is only ever deferred – the combination of observations which Derrida enshrined in his neologism, *différance*, but to which C. S. Peirce had already referred in his notion of 'unlimited semiosis'. Meaning is never simply 'there' for our consumption, it is only ever *produced* in a process of substitution of one term for another in a potentially limitless series. In the *social* world, however, meaning must come to rest somewhere; what is it that sets limits on the meanings of images?

The meaning of the photograph in my passport derives ultimately from the authority of the state, which may in the last resort assert its truths by physical force. However, most images we encounter in daily life derive their meanings from more complexly mediated interdependent systems: concrete institutions, discursive formations, scripto-visual codes, and so on. All of these determinations have been, and are being, discussed in theories of representations – they demand a sociology, a social history, a political economy and a semiotics of the image, and they are concerned with what 'common sense' tells us about an image. However, it has been objected that such theories are

unable to account for those meanings which are 'subjective' – irreducibly individual, inviolably private; moreover, it has been maintained that, at least in respect of art, it is *these* meanings which are the most important.

It is partly in response to this lacuna of theory that, in recent years, a psycho-analytically-informed semiotics has been evolved. There has been considerable criticism of this development of theory, not least from a 'left' which disparages psycho-analysis as being concerned with the 'merely subjective'; it seems to me that a 'progressive' politics indifferent to subjective experience, in *all* of its aspects, is itself a mere parody of the political impulse, but apart from this the charge against psycho-analysis is simply *false*: psycho-analytic theory does not construct a realm of the 'subjective' *apart* from social life, it is a theory of the *internalisation* of the social *as* 'subjective' – and, as such, has profound implications for any theory of ideology.[2] What follows is intended as a sketch account of one aspect of the workings of a putative 'trans-individual unconscious',[3] characteristically manifested in the form of fleetingly inconsequential subjective affects, but which nevertheless underpins the meanings of images. My point of departure is from some observations by Barthes, observations he leaves untheorised, but which I suggest should be seen as indicating a necessity for a 'psychopathology of everyday representations'. Most particularly, my discussion concerns a type of relation between 'movie' and still images.

I

At the beginning of his 1970 essay, 'The Third Meaning',[4] Roland Barthes speaks of his being fascinated by film-stills – but while he is watching the film, he says, he forgets the stills. Reading this, I was reminded of a recurrent experience of my own: often, having seen a film, all that remains of it in my memory is an image, or a short sequence of images. The film-still, a material entity; the mnemic-image, a psychic entity; what they have in common is that they are both *fragments* abstracted from a whole, but fragments which have nevertheless achieved a sort of representative autonomy. In his 1973 paper, 'Diderot,

Brecht, Eisenstein',[5] Barthes again touches on the 'representative fragment', this time in discussing a concept in the work of Diderot – *tableau*.

The concept of the tableau has a history prior to Diderot: humanist scholars of the mid-sixteenth century elaborated a theory of painting which they based on isolated remarks in the writings of classical authors. From Aristotle's *Poetics* they took the doctrine that the highest calling of any art is to depict human action in its most exemplary forms; the human body, they held, was the privileged vehicle for the depiction of such 'histories'.[6] The consequent programme of so-called 'history painting', which dominated painting in the West from the mid-sixteenth to the mid-eighteenth century, was elaborated in great detail in the body of humanist art theory now known by the emblematic slogan *'ut pictura poesis'* – 'as is painting, so is poetry' – a device abstracted from the *Ars Poetica* of Horace, which the Renaissance reversed in emphasis to establish the dependency of the visual image on the written text.[7] As the painter of 'histories' had to show in a single instant that which took time to unfold, then that instant had to have a singularly privileged position within the total action. It was therefore recommended that the moment selected by the painter for visualisation should be the *peripateia* – that instant in the course of an action when all hangs in the balance. Thus, for example, Rubens paints Paris in the act of extending the golden apple towards the group of three godesses who await his judgement, and arrests Paris at that precise moment when alternative futures open before him; in the very next instant however *Venus* will receive the golden apple, and the fate of Paris, and that of his nation, will be irrevocably sealed – committed to war, with Paris himself to be among the dead.

By the beginning of the eighteenth century the ideal of discursive clarity, embodied in human gesture, had become lost or subsumed within the increasingly decorative practices we know as Rococo, the work of Diderot's contemporary, Boucher, exemplifies this transition from the semantic to the decorative body. Where 'history painting' – painting rooted in a discursive programme – survived, it tended to take the form of allegory of an ever increasing complexity and obscurity. Allegory in the

Renaissance had begun with conventional symbols whose range
of references was legislated by such 'dictionaries' as Andrea
Alciati's *Emblematum liber* of 1531 (the first) and Cesare Ripa's
Iconologia of 1593 and 1603 (the definitive)[8]; by the eighteenth
century, however, symbolism had become increasingly esoteric
and/or a matter of purely individual invention, to the point
where it was often felt necessary to produce extensive explana-
tory pamphlets along with the paintings.[9]

It was against the Rococo tendency towards formal decorative-
ness and semantic obscurity that the concept of the *tableau*
emerged; first, at the beginning of the eighteenth century, in the
writings of Lord Shaftesbury, and later, with more elaboration,
in the work of Diderot and some of his contemporaries. The
concept of the tableau represented, at least initially, a reaffirm-
ation of the values of *ut pictura poesis*; it represented the ideal
of a formally unified, centred, *concentrated*, composition whose
meaning would be communicated 'at a glance' – intelligible, in
Diderot's words, to, 'a man of simple common-sense'. (We
should note that Diderot's recommendations for painting here
are practically indistinguishable from his ambitions for the
theatre, where his intervention was primarily on behalf of the
mise-en-scène: 'Gesture', he writes, 'should frequently inscribe
itself (*s'écrire*) in the place of discourse'; and he speaks of some
scenes in his *Père de Famille* as being, 'more difficult to paint',
than others.[10] The concept of peripateia once again became
central (although the paintings of Greuze, much approved of by
Diderot, seem most often concerned with *post*-peripateian
triste). Barthes does not use the term 'peripateia' in 'Diderot,
Brecht, Eisenstein'; he nevertheless does speak of this moment,
he remarks that it is the moment Lessing calls the 'pregnant
moment' (we might add that still-photography inherits this
concept under the title of 'decisive moment') and he further
remarks that Brecht's theatre and Eisenstein's cinema are
composed of series of such 'pregnant moments'. The word
Barthes takes from Diderot to name *this* moment is 'hieroglyph'.

Western interest in the hieroglyph goes back at least as far as
31 BC, when Egypt became part of the Roman Empire. In the
mid-sixteenth century, part of the humanist project of reconciling
the texts and artefacts of antiquity with Christian doctrine

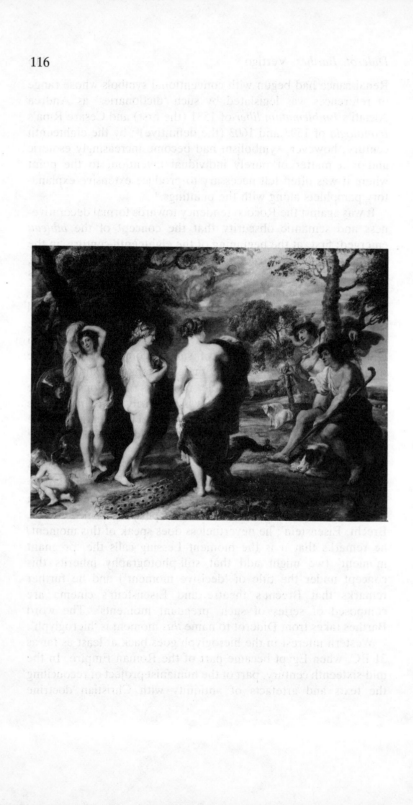

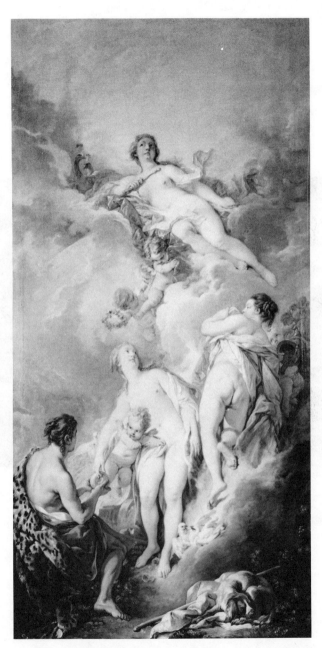

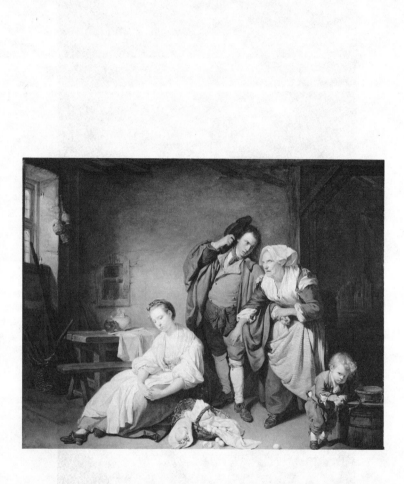

involved a theory of the hieroglyph. The theory was derived, via the Neo-Platonists, from the Platonic doctrine of two worlds, and the mode of communication operative within each: in the murky and imperfect world in which we mortals are condemned to live, verbal discourse is the appropriately confused medium through which we are condemned, impossibly, to attempt to communicate; in the luminous and perfect 'upper world', however, all meaning is communicated instantaneously and unambiguously through the medium of *vision*. Thus, the humanist Ficino translates this passage from Plotinus: 'The Egyptian sages . . . drew pictures and carved one picture for each thing . . . each picture was a kind of understanding and wisdom and substance given all at once, and not discursive reasoning and deliberation'.[11] The hieroglyph then, by definition, communicates instantaneously and stands *outside* discourse; this certainly, is the way in which Diderot understood the term. For Diderot, the syntactically-ordered linear progression of speech and writing is alien to the actual experience of *thought*: 'Our mind does not move in stages, as does our expression'. Such alienating linguistic structures may, however, be partially overcome as language approaches the condition of poetry, where words succeed in effacing themselves *as* words by giving rise to *images*. It is this state of language that Diderot refers to as 'hieroglyphic'; here: 'discourse is no longer simply a suite of energetic terms which expose thought nobly and forcefully, but a tissue of hieroglyphs gathered one upon the other which paint what is to be represented'.[12] We should note that in Diderot, as in the Barthes of 'Diderot, Brecht, Eisenstein', the ideal of a radically *extra*-discursive, 'hieroglyphic', mode of communication tends always to be attracted into the gravitational field of discourse, convention, morality. Nevertheless, in 'The Third Meaning' (an essay which complements, 'Diderot, Brecht, Eisenstein') Barthes does speak of a meaning which will not be pinned down by words – in his 1970 paper Barthes calls it the 'obtuse' meaning; ten years later, in *Camera Lucida*, he calls it the *punctum*.

Fragments of certain photographs, Barthes says, move him in a way which is strictly incommunicable, purely personal. Certainly there are photographs which many people, in common, may

find moving, but here, he says: 'emotion requires the rational intermediary of an ethical and political culture'. The *punctum*, on the contrary, is unpredictable and private, it is that in the image, says Barthes, which is 'purely image', (which is, he says, 'very little'); the meaning of the *punctum* is perfectly clear, but yet it cannot be made public. The privileged example of the *punctum* offered by Barthes in *Camera Lucida* occurs in his discussion of a photograph of a New York family by James Van der Zee[13] – 'privileged' for my purposes here because, in a book which is not a text of theory, it nevertheless indicates the path a theorisation of the *punctum* must take. The detail which 'touches' him in this image, he says, is the strapped shoes of one of the women: 'This particular *punctum* arouses great sympathy in me, almost a kind of tenderness'. Barthes makes no further comment until, ten pages later, he 'remembers' the photograph ('I may know better a photograph I remember than a photograph I am looking at'); he now realises it was not the shoes which moved him, it was the necklace the woman wore: 'for (no doubt) it was this same necklace (a slender ribbon of braided gold) which I had seen worn by someone in my own family'. The relative he has now been reminded of is a deceased maiden aunt who had spent most of her adult life looking after her mother: 'I had always been saddened when I thought of her dreary life'; after the aunt died her necklace was, 'shut up in a family box of old jewelry'. What Barthes in effect does in this brief account is to retrace, as it were, 'in reverse', part of the path taken in the original investment of the image-fragment (the strap) by a feeling ('a kind of tenderness'). The terminal point of the cathexis is the ankle-strap, in 'stepping-stone' fashion the next displacement is from the circle around the neck; from here, the movement is from the neck of the woman in the photograph (material image) to the neck of the aunt (mental image): the aunt whose necklace was 'shut up in a box'; whose body in death was, 'shut up in a box'; whose sexuality in life had remained, 'shut up in a box'. We arrive here at a preliminary account of the sources of the emotion in memories circulating around the themes of death and sexuality, played out within the space of the family, which are the substance of psycho-analysis.

In the example of Barthes's commentary on the Van der Zee

photograph we might say that a highly-cathected image-fragment 'takes the place of', 'stands in for', a narrative – it is the *representative* of a narrative. Barthes's expansion of the narrative, the written 'transcription', is itself laconic in the extreme, it is only *vaguely* a narrative: 'her necklace was shut up in a box'; what stands out, as if 'in focus' against an incomplete background of indistinct detail, is 'a situation in an image'. We are here in the presence of *fantasy*. What for the moment I can only call an 'ambivalence in respect of movement' is implicit in psychoanalytic accounts of fantasy, something of which I must now resume.

II

Unlike most other animals, the human infant is born into a state of nurseling dependency in which it is incapable of actively seeking its food; nourishment must be brought to *it*, as when the mother provides the breast. When hunger reasserts itself, therefore, the suckling initially has no recourse but to attempt to resurrect the original experience of satisfaction in hallucinatory form; thus Freud writes: 'The first wishing seems to have been a hallucinatory cathecting of the memory of satisfaction'. We may see in this scenario the Lacanian schema according to which 'desire' insinuates itself between 'need' and 'demand': the infant's *need* for nourishment is satisfied when the milk is provided; the infant's *demand* that its mother care for it is also met in that same instant; *desire*, however, is directed neither to an object (here the substance, 'milk') nor to a person, but to a *fantasy* – the mnemic traces of the lost satisfaction. It should be noted that the origins of fantasy here are inseparable from the origins of *sexuality*. In the 1905, 'Three Essays on the Theory of Sexuality', Freud posits a 'libido' present, quantatively, 'in full' from birth but nevertheless having, as it were, no 'address' until it progressively colonises, 'props' against, zones of the body associated with important physiological functions. Thus, in the above example, the act of sucking, initially functionally associated with the ingestion of food, becomes enjoyed as 'sensual sucking' – an activity in its own, erotic, right. In this earliest

emergence of sexuality, in which it is supported by a life-preserving function, the functional and the libidinal are but two faces of the same experiential coin: on the one side the ingestion of milk, on the other the accompanying excitations. It is at this stage that the infant must construct out of the primal flux of its earliest perceptions that primitive hierarchy in which the breast can emerge as 'object'. Hardly has this been achieved however than the object is 'lost' with the realisation that the breast, in real terms, belongs to the mother. The first fantasy then is most fundamentally motivated by the desire to fill the gap thus opened between the infant and the maternal body, but a body itself already fantasmatically displaced in relation to the real:

> the real object, milk, was the object of the function, which is virtually preordained to the world of satisfaction. Such is the real object which has been lost, but the breast – become the fantasmatic breast – is, for its part, the object of the sexual drive. Thus the sexual object is not identical to the object of the function, but is displaced in relation to it; they are in a relation of essential *contiguity* which leads us to slide almost indifferently from one to the other, from the milk to the breast as its symbol.[14]

An important qualification must now be made. From the above schematic account it might seem we could posit a simple parallelism: on the one hand *need*, directed towards an object; on the other hand *desire*, directed towards a fantasy object. Fantasy, however, 'is not the object of desire but its setting . . . the subject does not pursue the object or its sign: he [*sic*] appears caught up himself in the sequence of images'.[15] In this perspective, then, the fact that the infant may be observed making sucking motions even after its hunger has been satiated is not to be construed as the outward manifestation of the intentional aim of a desiring subject towards a fantasy object; rather, what we are witnessing is the display of auto-erotic pleasure in the *movement* itself, to which we must assume an accompanying fantasy not of *ingestion* (functional), but of *incorporation* (libidinal). The fantasy-precipitating sequence *having/losing* the object, then, also institutes *auto-eroticism* (it is a mistake to consider auto-

eroticism a 'stage of development' *prior* to object choice): 'The "origin" of auto-eroticism would therefore be the moment when sexuality, disengaged from any natural object, moves into the field of fantasy and *by that very fact* becomes sexuality'[16] (my emphasis). Even at the most primal moment, 'satisfaction' (the lost object) is not a unitary experience; in so far as it survives, it does so as a constellation of visual, tactile, kinaesthetic, auditory, olfactory, and so on, mnemic-traces; it is such a fantasy *configuration* which is indelibly inscribed as an ever-present principle of organisation in the psychic life of the subject:

> The signs accompanying satisfaction (the breast accompanying the offering of nursing milk) will henceforth take on the value of a fixed arrangement, and it is that arrangement, a *fantasy* as yet limited to several barely elaborated elements, that will be repeated on the occasion of a subsequent appearance of need, . . . with the appearance of an internal excitation, the fantastic arrangement – of *several representative elements linked together in a short scene*, an extremely rudimentary scene, ultimately composed of partial (or 'component') objects and not whole objects: for example, a breast, a mouth, a movement of a mouth seizing a breast – will be revived.[17] (my emphasis)

'Incorporation' rather than 'ingestion' – the psycho-analytic concept of 'incorporation' implies a range of objects vastly more extensive than food, as for example in Melanie Klein's description of the fantasy world of the infant, in which the parental imagos fragment into relatively autonomous 'part-objects', body parts which the child may destroy, repair, identify with, combine, and of course *incorporate*; moreover, the mouth is not the only organ of fantasy incorporation (for example, it would be particularly pertinent here to recall Lacan's discussions of the *eye* as an incorporative organ).[18] The fantasy then, in our 'original' example, albeit metonymically linked to the ingestion of milk and the image of the breast, is not to be *reduced* to such terms, for they will themselves be subject to further substitutions of a metaphorical, as well as metonymical, order. In the above scenario of emergent sexuality, with its emphasis on the *fixation* of

'signifier' to 'satisfaction' we may see exemplified the Lacanian maxim, 'Desire is the alienation of the instinct in a signifier'. It is this *privileged* signifier which stops, 'the otherwise endless sliding of the signification'; it is that which Laplanche and Leclaire, in a much discussed paper,[19] call the 'elementary signifier' of the unconscious, and which in Freud would be one of the senses we may give to 'ideational representative' of the instinct. As I have observed, although the position of 'representative of the instinct' is a permanent one, more than one signifier may be elected to the same post, and these in turn may elect delegates from amongst their derivatives and semblances – a process which will continue throughout the life of the subject as a process of *elaboration*. For example, in Laplanche and Leclaire's paper, 'The Unconscious: A Psychoanalytic Study', we read of a child, during the time he is beginning to speak, experiencing thirst on a beach and addressing a demand to the woman who is caring for him. Become adult, and now in analysis, amongst the elementary particles of one of his dreams are, 'the memory of a gesture engraved like an image' (cupped hands), and, 'the formula "I'm thirsty"'. The gesture here ('enactive') belongs to the kinaesthetic and visual; moreover, the 'verbal' expression is not verbal in the linguistic (lexical, syntactical) sense – the child in question here is French, and at a stage of linguistic development when the use of 'shifters' is not yet fully mastered; the initial sound of *'J'ai soif'* (I'm thirsty), the terminal sound of *'moi-je'* (me-I), and the ultimate syllable of *plage* (beach) become condensed, collapsed together, to result in a dense phonic image – *'zhe'* – inseparable from a meaning purely personal to the child.

We may reasonably suppose that it is this type of process that is at work behind the production of the phenomenon Barthes names *punctum*; just as the phonic fragment *'zhe'* belongs both to, in Saussure's expression, 'the common storehouse of language', and at the same time to a universe of meaning which is purely private to the patient Philippe, so the *punctum* appears at one and the same time in a public and a private context. In some remarks on Freud's insistence on 'the independence and the cohesion' of the conscious and unconscious systems, Laplanche remarks:

it is important to note at what level the passage from one system to another operates: it cannot be the global passage of the same structure from one mode of organisation to another, similar to the oscillatory effect at work in the perception of an equivocal image. What passes from one *Gestalt* to another is always *an isolated equivocal element.*[20] (my emphasis)

He finds a more appropriate analogy in,

those puzzle drawings in which a certain perceptual attitude suddenly makes Napoleon's hat appear in the branches of the tree that shades a family picnic,

observing,

if this hat is able to appear, it is because it can be related to an entirely different 'anecdote', which is not at all present in the rest of the drawing: the 'Napoleonic legend'.

It is precisely such an 'intertextual' mutual imbrication of 'anecdotes', pinned together by a fragment, which allows Barthes to see his own family history in that group portrait from another time and another culture, and which makes '*je*' more than simply a 'shifter' for Philippe. I say 'allows' Barthes, but he himself insists he has no choice but to feel that *affect* which 'pierces' him; *two* things must be stressed here, not only the *involuntary* nature of the unconscious irruption, but the fact that, like the hat in Laplanche's example, it may also derive from an inscription which may be *trans-individual* in its appeal, rather than, like the *punctum*, exclusively personal – assertions which require some elaboration.

III

In the story which 'begins' (in the arbitrary *découpage* of narrative convention) with Philippe on the beach, we may see historically later stages in the vicissitudes of the oral drive, 'alienated in a signifier', for a particular individual. The fantasy *complex*

to which the ramifications of this alienation have given rise has left its traces in all aspects of the unconscious organisation of the subject. The unconscious knows no time – psychco-analytic accounts of fantasy present us with a *simultaneous* continuum of degrees of elaboration. 'Topographically', the fantasy may be conscious, pre-conscious, or unconscious. Thus the fantasy, says Freud, is encountered 'at both extremities' of the dream – both in the secondary elaboration of the waking report, and in the most primitive layers of the latent content, where it is linked to the ultimate unconscious desire, the 'capitalist' of the dream. Freud finds the fantasy present in the form of the hysterical symptom, in the delusional fears of paranoics, in 'acting out', and, as is well known, he believed such cultural manifestations as 'art' to represent the highly elaborated, disguised, expressions of unconscious fantasies. In a sense, therefore, 'the' fantasy is only ever encountered in the *wake* of continual exchanges, transformations and transcriptions, of and between signifiers. In its most primitive form the fantasy complex will consist of *thing-presentations*, the register of the imaginary; thus, with Philippe, 'a gesture engraved like an image'. Later may be found fragments attracted into the 'gravitational field' of the primitive fantasy at the moment of acquisition of language; for example, the compound sound, '*zhe*'. Later still, the adult Philippe will produce the dream of a unicorn, whose image is the transformation (according to 'considerations of representability') of derivatives of a complex of *words* – that aspect of the fantasy which is ensnared within the *symbolic*.

In bringing Philippe's story to my consideration of the anecdote told by Barthes, however, I face a difficulty – Barthes's book is *not* a case-history. I shall therefore take the liberty of incorporating the anecdote of the 'ankle-strap' punctum into a convenient fiction to illustrate a point I wish to make here: suppose that a very small child is inquisitively playing with a ring on its mother's finger; in a playful demonstration the mother takes off the ring and slips it onto one of the child's fingers; then she takes it back. Other circumstances being favourable, the mnemic-trace of this event could become structurally reinforced and re-cathected by the previously established trace of the mouth circling the nipple, and the nipple's subsequent withdrawal.

Later in the history of the subject, knowledge of the significance of the giving of the ring in marriage could, by 'deferred action',[21] further reinforce and intensify the cathexis of this image of the 'encircling of a body-part' – producing the sort of affective and semantic consequences Barthes describes. By juxtaposing this diagramatically simple myth of origin with Philippe's story I wish simply to make the point that although the oral drive will have an effect on the unconscious organisation of all subjects alike, the particular *form* of the effect will vary according to individual history; but that, nevertheless, such individual elaborations of representatives of the drives coexist alongside, and may become imbricated within, fantasy scenarios whose *common* outlines may be detected across differences between individual 'versions'.

Freud was so impressed by the ubiquitous *transindividuality* of a certain small number of fantasies – which 'emerge' in the history of the subject, and yet which seem always already to have been in place – that he suggested they might be transmitted by hereditary factors. These are the 'primal fantasies', as he first called them – 'primal scene', 'seduction', 'castration' – all of which devolve upon major enigmas in the life of the child, enigmas concerning origins: origin of the subject, of sexuality, and of sexual difference. As Laplanche and Pontalis have pointed out, however, we do not need to invoke the idea of phylogenetic inheritance to explain the ubiquitousness of the primal fantasies. These fantasies are the precipitate of the early familial complex in which each child finds itself – at once irreducibly unique in its historical, cultural, and biographical detail, and universally shared in that every newcomer to the world is lodged under the same sign of interdiction of incest. (At the risk of stating the obvious, to acknowledge the Oedipal nucleus of the primal fantasies is not thereby to place *all* fantasy scenarios on the Oedipal stage. To acknowledge *this*, though, is not necessarily to embrace the anarchistic voluntarism exemplified by the Deleuze and Guattari of *Anti-Oedipus* – for so long as it makes sense to say we are living in a 'patriarchal society' we may be sure that we remain, at the most fundamental level, locked in the Oedipal matrix.)

It is the privileged 'families' of related signifiers of the desire of the subject which serve as the *points de capiton* (Lacan)

'buttoning down' the otherwise endless dispersions of Derrida's *différance*, Pierce's 'endless semiosis'. In the history of the subject it is precisely this over-all structural *stability* of the fantasy, albeit constantly subject to transformations, which serves to regulate and organise the otherwise formless displacements of desire; as Jean-Michel Ribettes has put it: 'To such potentially anarchic and polymorphous movements of desire, fantasy opposes the constancy of its forms; to the erratic, fantasy opposes the hieratic'.[22] It is because of the *mise-en-scène* of desire, which is fantasy, that dissemination does not 'centrifugally' dissipate itself but rather 'circles back' on itself to repeat – but *differently*; which is to say, to extend my metaphor, that the movement describes not so much a circle, closed, but a *spiral*, perpetually renewing itself by conquering new territory while nevertheless tracing the same *figure* (no grammar of the unconscious, but a rhetoric); thus, for example, Freud speaks of the day-dream as having a 'date stamp' on it; or again, in the field of public human affairs, we may think of the popular newspaper, endlessly repeating itself in the form of 'news', or, scandalous to add, in the realm of politics, those 'real struggles' – conflicts which renew and repeat themselves precisely to the extent that the fantasmatic which informs them remains untouched by them. (My slide, here, from the 'internal' to the 'external' world is deliberate – I shall return to this later.)

I have spoken of the quality of 'arrest' in fantasy, by my own argument this very attribution is itself a form of arrest – the abstraction of a notional 'elementary' form of fantasy from the multifarious ways in which 'it' is actually encountered. In speaking of 'arrest', however, I wish, first, to emphasise just this insistence, in psycho-analytic theory, on the structural constancy of fantasy across a 'spectrum' of forms of elaboration. Moreover, although the fantasy is an imaginary *sequence* in which the subject plays a part, or parts (the precise mode of integration of the subject, as Freud has demonstrated, being variable – the subject may be represented as observer, as actor, even in the very *form* of an utterance), the 'sequence' is characteristically of such brevity that it may be summarised in a short phrase – 'her necklace was shut up in a box'; or again, a classic example, the title of one of Freud's essays, 'A Child is Being Beaten'. It is in

this that I allow myself to identify the sequence which paradoxically takes on the characteristic of the *still*; for there is no doubt that in this band of the 'spectrum' of elaborations – the band, moreover, of greatest affective density – the fantasy may be represented in an image, and what better word for *this* image, this *mise-en-scène*, than *tableau*. May we not say then that the fantasy is a tableau which stands to the otherwise formless indeterminacies, dispersions, displacements of desire of the individual subject, precisely as the tableau of Diderot stands to the endless dispersions and indeterminacies of the meanings of material events, of 'history'? Two contrasting kinds of claim are frequently made in respect of certain images: 'this image captures, in a single visual statement, the essence of an event which would otherwise take many words to describe'; and, 'this image has a significance which transcends its literal content, and which may not be expressed in words'. The first type of claim defines the tableau, the second defines the hieroglyph. The terms 'tableau' and 'hieroglyph', used by Diderot in his discussion of painting and theatre, and by Barthes in respect of theatre and cinema, label concepts which were already long-established in art theory by the time Diderot came to use them in the eighteenth century, and they are still with us today, albeit they are now less formally described. If we are to account for the longevity of these concepts in the history of theories of representation in the West we might usefully consider the possibility that they are the *projection*, into the field of material representational practices, of fundamental psychological processes described in psycho-analysis.

IV

The question now arises of how, in terms of the analogy I am proposing between certain art-historical and psycho-analytical categories, the relations of the various key terms I have mentioned are to be conceived. In, 'Diderot, Brecht, Eisenstein', Barthes effectively *conflates* the concepts 'hieroglyph', 'pregnant moment' (peripateia), and 'tableau'; my argument here must separate them. First, peripateia and tableau must be placed in a

logical hierarchy: the relation of peripateia to tableau is a relation of *text* to *staging*, the peripateia is an instant arrested within, abstracted from, a narrative flow; the tableau is a particular *realisation* of that as yet purely notional instant (the doctrines of *ut pictura poesis* were concerned precisely with detailing recommended 'correct' procedures for such *mise-en-scène*). Further, in belonging to a *common*-ground of meaning, rooted in, in Barthes's words, 'an ethical and political culture', the tableau is clearly situated in the field of what Barthes first calls the 'obvious meaning', and then ten years later, the *'studium'*; the *punctum*, we will remember, is, on the contrary, unpredictable and private; it is that 'very little' in the image which is 'purely image'; as the meaning of the *punctum* takes the form of an affect which cannot be translated into discourse then, equally clearly, the 'hieroglyph' is on the side of the *punctum*. The separation between tableau and hieroglyph which we may see in the history of the concepts, and the oscillation between them in Barthes's paper, maps the distinction we have inherited from Lacan between the registers of the 'symbolic' and the 'imaginary'; to complete the picture we need to take into account that necessary third Lacanian category, the 'real'. As Barthes's account of the punctum is, for my purposes here, incomplete, I have juxtaposed it with the case history of Philippe – a history of 'stages' of transformation of the alienation of the oral drive in a 'succession' of signifiers (with the understanding that 'stage' and 'succession' here in no way imply 'supercession'). Resumed most briefly, and as the story of Philippe illustrates, the fantasy may be considered as 'standing in for' that which is radically unrepresentable: the absence *in* the real, and the absence *of* the real in discourse. The real then, as Ribettes remarks, is one of the 'three dimensions' of fantasy; the imaginary is that dimension which is outside discourse, attached to (but not assimilable to) the pre-Oedipal; the symbolic is the 'later' dimension of combination, syntax, transcription. In a schematically descriptive 'triangle' of fantasy, therefore, the real would be located at one point, and at the other two could be grouped, respectively, the terms: 'imaginary'/'elementary signifier'/'*punctum*'/'hieroglyph'; and, 'symbolic'/'fantasy scenario'/'*studium*'/'tableau'. This is indeed sketchy, and no doubt in the spirit of a structuralism of

which we have grown suspicious, but I believe there is enough accuracy in it to at least serve my purpose here. A major limitation of this schema is its implication of segregation; in fact, the more highly-cathected, most primitive, elements will have the capacity to 'unfold' upon the very scenarios in which they figure, either directly or in a displaced manner: thus the 'piercing' image of the 'ankle-strap' gives way to the short scene, 'her necklace was locked in a box', which in turn figures . . ., we know not. Some clarification of what I have in mind here may be gained by reference to Herman Rapaport's essay, 'Staging: Mont Blanc'.[23]

Rapaport begins his essay, with a reference to Plato's allegory of the cave, the purpose of which is to communicate the doctrine of pure forms. Rapaport remarks:

> But what is most interesting is the way a prop such as the cave image can suddenly turn into a stage, how an image, itself framed, can suddenly stage itself as stage and in that way absent itself or disappear from the viewer's consciousness as image, object, or prop.

Rapaport then moves to the example of the 'Wolf Man' case history, in which Freud, in Rapaport's words:

> documents what happens to a small child who has been exposed on repeated occasions to a picture of a wolf, an image that can be seen with or through like a kind of optic glass and thus can frame what will become a traumatic fantasy, a nightmare about six or seven wolves in a tree.

Having quoted Freud's transcription of his patient's account of the nightmare, Rapaport comments:

> Here the image of the wolf has been phantomized, has faded out, and frames or stages this dream. *Although the wolf image has disappeared in its original form, its effect or impression energizes the dream*, and it is repeated six or seven times within the image's little 'production'. (my emphasis)

With the word 'production' I am returned again to thoughts

about the cinema, and particularly to the relation of film to still
with which I began.

V

When I first read a short essay by Freud called, 'A Special
Type of Choice of Object Made by Men',[24] I was struck by the
similarities between the syndrome of male desire Freud describes
and the pattern of behaviour 'Scottie' (James Stewart) exhibits
in Hitchcock's film, *Vertigo* (1958). The first condition deter-
mining the choice of love-object by the type of man discussed
in Freud's essay is that the woman should be already attached
to some other man – husband, fiancé, or friend; in the film,
Scottie falls in love with the woman he is hired to investigate –
the wife of an old college-friend. The second precondition is
that the woman should be seen to be of bad repute sexually;
'Madeleine' (Kim Novak), the college friend's wife, suffers from
a fixated identification with a forbear whose illicit love affair,
and illegitimate child, brought her to tragic ruin. The type of
man described by Freud is, 'invariably moved to rescue the
object of his love', and prominent amongst the rescue fantasies
of such men is the fantasy of rescue from water; Scottie rescues
Madeleine from San Francisco Bay. Finally, Freud observes,
'The lives of men of this type are characterised by a repetition
of passionate attachments of this sort: . . . each is an exact
replica of the other', and he remarks that it is always the same
physical type which is chosen; following Madeleine's death,
Scottie becomes obsessed by 'Judy' (Kim Novak), a woman who
physically resembles Madeleine and who he sets about
'remaking' into an exact replica of Madeleine. Behind the
pattern of repetitious behaviour he describes, Freud identifies a
primary scenario of male Oedipal desire for the mother – already
attached to the father, her sexual relations with whom bring her
into ill-repute in the eyes of the little rival for her love. The
ubiquitous fantasy of rescue from water represents a conflation
of 'rescue' with 'birth': just as he was, at birth, 'fished from the
waters' and given life, so will he now return this gift to his
mother in a reciprocal act of recovery from water. Finally, the

adult man's love-attachments form an endless series of similar
types for the simple reason that, as mother-surrogates, they can
never match the irreducibly unique qualities of the original.

When I fish Hitchcock's film from the depths of my memory
it surfaces in the form of two images superposed as one: Madel-
eine's face above the shadow of her lifeless body below the
waters of the bay; Judy's face floating through the green-tinged
gloom of the hotel room where she has just emerged from her
final transformation, in the bathroom, into the image of the dead
Madeleine.[25] I can of course recall many other images, actions,
snatches of dialogue, and so on; but the first, composite, image
comes as if unbidden; spreading itself as if to form the very
screen upon which my memory of the *reel*-film (the object of
'criticism' and most film-theory) is projected. Paraphrasing
Rapaport, I might say: 'although the film has disappeared in its
original form, its effect or impression energises the image'; or
beyond, more fundamentally, 'although the fantasy has been
repressed in its original form, the displacement of its cathexis
energises the film'. Away from the cinema now, away from the
insistence of the film's unreeling, this privileged image opens
onto that skeletal narrative I find in both *Vertigo* and in Freud's
paper on men's desire; but a narrative whose substance is unde-
cidedly (n)either text (n)or tableau; and this in turn immediately
dissolves into a myriad other delegates from a history of Western
representations flooded with watery images of women – from
the *Birth of Venus* to the *Death of Ophelia*. For example, in
pursuit of these last two, I am returned to *Vertigo* by way of the
bridge over the bay, in whose shadow Madeleine casts flowers
on the water as she prepares to jump, leaping the gap between
Hitchcock's and Botticelli's/Millais's images of woman/water/
flowers. As I now recall that Botticelli's 'Birth of Venus' depicts
the goddess at the moment of her *landfall* at Paphos, eliding the
circumstances of her birth out at sea from the bloody foam
produced when Saturn casts the genitals of the newly-castrated
Uranus into the ocean, I find that my re-entry into the text of
the film is by a different route – one destined to take me through
a different sequence of images, until I have traversed the text
again, to regain another exit into the intertext, from which I
shall be returned again . . . and again, until the *possible* passages

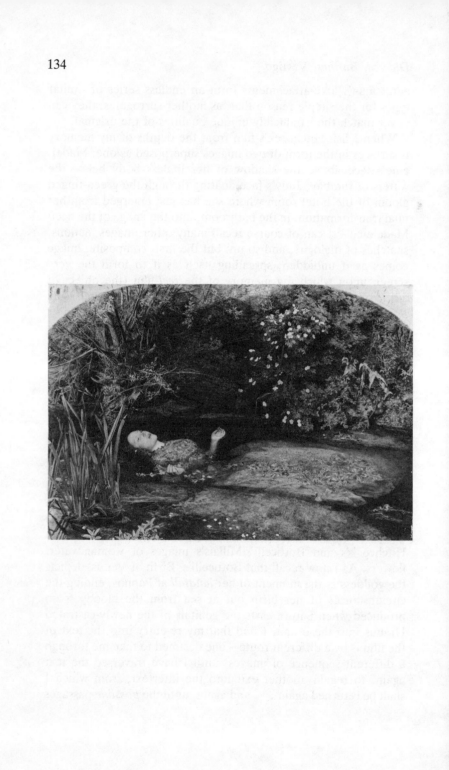

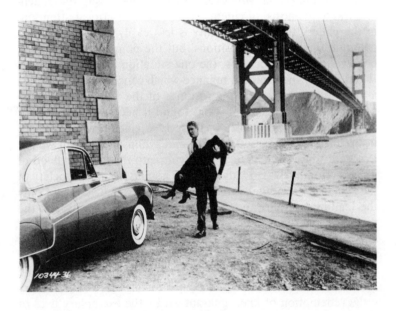

have been exhausted, or until I find that the trajectory of associ-
ations has become attracted into the orbit of some other
semantically/affectively dense textual item, some other fantasy.

In a certain (phenomenological) sense, the cinema is the 'nega-
tive' of the gallery (the museums which now house the paintings
Diderot wrote about; our galleries of contemporary art): in the
cinema we are in darkness; the gallery is light; in the cinema we
are immobile before moving images; in the gallery it is we who
must move; in the cinema we may interrupt the sequence of
images only by leaving; in the gallery we may order the duration
of our attention in whatever sequence we wish; the much-
remarked 'hypnosis' of cinema suppresses our critical attention;
in the gallery the critical faculty is less easily beguiled. I could
continue this list of 'oppositions' but the point is that, as in all
positive/negative processes, the one situation implies the other.
It is precisely their mutual reliance which concerns me here. Just
as Malraux, in assessing the fortunes of the work of art in the
age of mechanical reproduction, found it necessary to speak of
a 'museum without walls', so there is a 'cinema without walls'
in the form of the countless stills and synopses to which we are
exposed; these in their turn dissolving into the broader flood of
images (from 'news' to 'advertising') issuing from our 'society of
the spectacle' – mutually affective *tableaux* which stage not only
the legitimating narratives of human existence but also, in the
process, each other.

I was once in Padua, and took the opportunity to visit the
Scrovegni Chapel to see its famous frescoes by Giotto. In form
the Chapel is a simple box, whose interior faces display the
'grand narrative' of human existence in the fourteenth century
– the redemption of man, guaranteed by the exemplary lives of
the Virgin and Christ. In addition to the narration of the ideal
mother and her ideal son we are shown personifications of the
Vices and the Virtues; although the father does not make a
personal appearance his will is conspicuously seen to be done
throughout, and most vividly in the large final scene of the Last
Judgement, which (Giotto being no Bosch) appears, appropri-
ately, as quite a *domestic* affair. Only a couple of hundred yards
from the Scrovegni Chapel is the Church of the Eremitani, which
in 1944 took a direct hit from allied bombs (thereby losing some

works by Mantegna). In my fantasy, however, it is the Scrovegni
Chapel which explodes, raining its fragments upon the city of
Padua like the scattered contents of a huge Giotto jigsaw puzzle.
The grand narrative of human existence, the meaning of life,
the source of inspiration and legitimation of all social institutions
and individual actions, is not destroyed, but it is now encoun-
tered in a very different way – as representative fragments whose
connections and ultimate meanings must be implied; a material
heterogeneity whose narrative/ideological coherence depends
upon a psychological investment – largely unconscious, and
therefore radically inaccessible to the discourses of an 'ethical
and political culture', except in so far as these discourses them-
selves issue from an unconscious matrix as the heavily elaborated
transcriptions of common fantasy scenarios. In Padua today, as
in all our Western cities, this is precisely the way in which we
encounter the grand legitimating narratives of our existence: on
billboards, in magazines, in family albums, in newspapers, on
picture postcards, and, of course, outside the cinema – from
the metaphorical and metonymical webs of this most general
environment of (mainly photographic) images which *prefigure*
the film, to the particular film-poster and film-still; all of that
which, 'conducts the subject, from street to street, poster to
poster, to finally plunge one into a dark, anonymous, and indif-
ferent cube'.[26] As I have remarked elsewhere:

> the darkness of the cinema has been evinced as a condition
> for an artificial 'regression' of the spectator; film has been
> compared with hypnosis. It is likely, however, that the appar-
> atus which desire has constructed for itself incorporates *all*
> those aspects of contemporary western society for which the
> Situationists chose the name *spectacle*: . . ., desire needs no
> material darkness in which to stage its imaginary satisfactions;
> day-dreams, too, can have the potency of hypnotic
> suggestion.[27]

Discussions of fantasy and cinema have tended to concentrate
on structures 'near the surface' of the film – for example, the
obviously Oedipal scenarios of 'family dramas'. I have suggested
how an elaborate film narrative (here, *Vertigo*) may figure an

Oedipal scene in a more displaced form (Scottie's behaviour). I
have further suggested that, just as the 'manifest narrative' of
the film in my example opens onto ('stages', 'frames') an Oedipal
scenario, so *this* narrative, in its turn, unfolds upon an *image*
(which may well be *extra*-cinematic), of hieroglyphic affect,
which is nothing but a point of condensation of the laconic tales
which *it* figures ('a woman is in the water', 'I am rescuing the
woman', etc.). These, in *their* turn, open onto all those represen-
tations which are (male?) fantasies of birth. In all this perpetual
motion there is no rest, no arrival at a point of *origin*. Nor,
clearly, is there any point at which we may be sure we have left
the domain of the 'political' (Oedipal structures as relations of
authority) for some other. In a sense, psycho-analysis comes into
existence with the recognition that what we call 'material reality',
the 'real world', is not all that is real for us. Unconscious wishes,
and the unconscious fantasies they engender, are as immutable
a force in our lives as any material circumstance. Freud's obser-
vation that unconscious fantasy structures exert as actual a force
on the life of the subject as do, for example, socio-economic
structures, is signified in his use of the expression *psychical
reality*. Psychical reality is not to be equated with the contingent
and ephemeral phenomena of 'mental life' in general. On the
contrary, what marks it is its stability, its coherence, the
constancy of its *effects* upon perceptions and actions of the
subject. Severe cases of 'mental disturbance' are only the most
dramatically obvious manifestations of the *fact* of psychical
reality. Although, almost a century after the birth of psycho-
analysis, it still suits many to draw a line of absolute division
and exclusion between such 'abnormal' behaviour and their own
'normality', psycho-analysis recognises no such possible state of
unambiguous and self-possessed lucidity in which the external
world is seen for, and known as, simply what it *is*.

Common fantasy structures contribute to the construction of
'reality' in the realm of representations. There is no question of
'freeing' representations ('reality') from the determinations of
fantasy. There is, however, a considerable benefit to be achieved
from an *awareness* of the agency of unconscious fantasy in
representations: the representations of women by men; the
representations of blacks by whites; the representations of

'homosexuals' by 'heterosexuals'; and so on. The purpose of my remarks has been to argue that the systematic development of such an awareness in the field of theories of representations has been impeded by too restricted a framing of notions of the 'specificity' of objects of study ('painting', 'photography', 'film').

In approaching the phenomenologically-given field of representations theoretically, we have tended to divide it empirically, (and according to an implicit sociologism); beyond a certain limit, however, attention to the 'specificity' of a representational practice – grounded most usually in its material substrate and material mode of production – becomes unhelpful (as, for example, when 'specificity' is fetishised for professional convenience – to conserve the putative sanctity of the 'discipline', or to respect the reality of academic institutions and markets). Certainly, we need a social history of the news photograph, a semiotics of the cinema, a political economy of advertising, and so on; but we should avoid the risk of 'failing to see the wood for the trees' – we need an ecology as well as a botany. 'Ecologically' speaking, we need to take account of the *total* environment of the 'society of the spectacle' – at least if it is a theory of ideology which is at issue; in order to achieve this we must deconstruct not only the supposed absolute difference between 'fine art' and 'mass media' – with its implication of what Benjamin so accurately, and so long ago, identified as, 'this fetishistic, fundamentally anti-technical notion of *Art*' – but also the differences between such almost equally hallowed and uninterrogated academic categories as 'art history', 'photography theory' and 'film studies'. I recommend this, not in the interests of some spurious argument that the objects of these categories – paintings, photographs, films – are somehow 'the same', but rather in order that we may begin to construe their differences *differently*.

The End of Art Theory

'The means must be asked what the end is' – Brecht

I. A Short History of Common Sense in Art

The crisis in criticism

When I returned to London in 1977, after a year spent living in
New York, I was asked to speak at the Institute of Contemporary
Arts (ICA) in the context of a three-day conference on the 'State
of British Art';[1] I was told that the conference was to be a
response to the *crisis* in British Art. As my own particular brief
was simply to talk about 'Images of People', I felt able to accept
the invitation even though I knew nothing about the purported
'crisis'. I never did learn what the 'crisis in British Art' was; nor,
I suspect, did anyone else. In retrospect, some ten years on, I
now see the ICA event, the brainchild of three British art critics,
as a textbook example of what psycho-analysis terms *projection*:
the crisis sensed by these critics was not in 'art' but in *criticism
itself*. In the previous year, the first edition of Raymond Willi-
ams's *Keywords* had been published; Williams opens his account
of the word 'criticism' by remarking that the sense of the word
in relation to art and literature, 'depends upon assumptions that

may now be breaking down'. Writing at the beginning of the 1980s, and retrospectively surveying the 'theory' explosion of the 1970s, Elizabeth Bruss observes, 'an increase of theoretical activity . . . arises whenever the function of criticism itself is in doubt'.[2]

Implicit in Bruss's observation is the model of a hierarchy of metalanguages, according to which criticism may become contained within the overview of theory, much as the artwork is encompassed by the overview of criticism. As I will have cause to observe again later, such a model has itself been dismantled in recent theory; nevertheless, there is a contingent, empirical, truth in it. 'Theory' and 'criticism', to which we should perhaps add 'reviewing', are all practices of writing; in institutional terms, 'theory' tends to issue from a different site from that of criticism and reviewing: academic institutions and journals in the former instance, art magazines and the press in the latter. The spectrum of discourses, then, runs from scholarly research to consumer information. I refer to a 'spectrum' of discourses, because, although I distinguish between theory and criticism, it will be obvious that theory is (generally) a critical practice, and criticism (necessarily) involves theoretical presuppositions. I shall have more to say later about that portion of the spectrum where theory and criticism most clearly run together. For the moment, however, I wish to speak in terms of the more separated bands of this continuum; in these terms, for my purpose here, what distinguishes 'theory' from criticism and reviewing is that theory is openly and self-consciously theoretical, whereas criticism conceals, or is blind to, its own theoretical basis. The most commonly encountered art criticism characteristically presents itself as operating with, and within, 'common sense' (rather than what it tends to disparage as 'intellectualisations'), whereas theory, as I have written elsewhere, 'sets out to question the underlying assumptions of common sense in order to replace them, where necessary, with better-founded, or more comprehensive explanations'. For theory, 'common sense' cannot be contrasted with 'intellectualisations' because common sense is itself made up of congealed residues of the intellectualisations of past ages. Art practices are themselves, of course, just as subject to tacit presuppositions as are theory and criticism; a

history of art could be written as a graph plotted against the axes of theoretical self-awareness and theoretical oblivion; that more than one line would need to be plotted is clearly indicated to us now, in the 1980s, where there has never been a greater gap between those who practice theory and those who believe themselves innocent of theory. At the present time, the most favoured way of securing the end of theory is by denying that it ever began. Criticism and reviewing, as most commonly practiced, are the major form of this denial.

At its simplest, the common sense picture of the act of criticism shows a critic in confrontation, or communion, with an artwork; the critic is seen as expressing his or her thoughts or feelings about the work, and a judgement of the value of the work, to an audience assumed to be the same audience as for the artwork under review. In the common sense view the artwork has itself originated in the thoughts and feelings of the artist (which may or may not include value judgements about the world in which she or he lives), and is itself an attempt to 'communicate' to this same audience. There is a timelessly natural appearance to this scene: the artist creating, by force of his or her very nature; the critic naturally assuming the judgement seat, by force of a special 'sensibility'; the audience, naturally, *attentive* to both. Apart from such contingent details as the way the participants are dressed, this scene is essentially as it always has been, and always will be. I am reminded of that television cartoon 'sit-com' series, *The Flintstones*, which depicts domestic life in the Stone Age: the central character, Fred Flintstone, a worker in the local stone quarry, is seen going through the everyday ups and downs of life with his wife and teenage daughter (the latter shown perpetually chatting on the stonephone). In another series by the same company (*Hanna Barbera*) this same white middle-American nuclear family is projected into the future as the *Jetsons*: Fred leaves for work in a flying saucer, argues with wife and daughter over who should press the button to start the robot which clears the table and washes up, and so on. Common sense, and the criticism which inhabits it, not dissimilarly tends to construct a history and teleology of art by projecting the dominant contemporary notions of art into the past and the future. It is such an attitude which gives us those

coffee-table books, and 'survey' lecture courses, with such titles as, '*Art: from the Stone-Age to Picasso*'. In such 'history of art', however, it is precisely *history* which is missing – as even a cursorary account of the evolution of the very *term* 'art', itself, will demonstrate.

The word 'art'

In classical antiquity, the word 'art' (Greek, *tekhnē*; Latin, *ars*) was the name given to any activity governed by rules; art was that which could be *taught*, and as such did not include activities governed by instinct or intuition. So, for example, music and poetry were not at first numbered amongst the arts as they were considered the products of divine inspiration, beyond mortal accountability. With, however, the elaboration of a mathematics of pitch and harmony (Pythagorus), and of a poetics (Aristotle), music and poetry took their place amongst the 'arts' – alongside, for example, logic and shoemaking. The only generally-held principle of differentiation between the various skilled activities constituting 'arts' in the ancient world was whether the art in question was considered primarily a manual or an intellectual form of work. This implicitly class-based division of the arts survived into the Middle Ages in the distinction between 'mechanical arts' and 'liberal arts', the latter now specified in terms of the 'trivium' (grammar, logic, rhetoric), and 'quadrivium' (arithmetic, astronomy, geometry, music). These 'liberal arts' formed part of the medieval university curriculum; the teaching of 'painting' and 'sculpture' was undertaken in the artisans' guilds ('sculpture' had, then, no distinct existence outside of the general field of responsibilities of the *mason*, while a painter's responsibilities ranged from the decoration of furniture to advice to women on the application of cosmetics). When, in the early Renaissance, painting became elevated to the rank of 'liberal art', it was as a result of the argument that painting had ceased to be simply a manual skill and had become, *de facto*, a *learnèd* occupation: in order to construct scenes true to perspective, nature and history, the painter must command geometry,

anatomy and literature. It was, however, to take almost another century before sculpture was to be similarly elevated in status.

The emergence, in the latter half of the seventeenth century, of what we would today call 'experimental science' created a further division of the field of 'arts' – with a result roughly corresponding to the modern distribution of 'arts', 'crafts' and 'sciences'. The problem of the *purpose* of such things as music and decorative art, which had vexed Plato in the *Republic*, resurfaced in the form of the question of what, if anything, the liberal arts which were not (experimental) sciences had in common. An answer which gained broad assent was provided by the Abbé Charles Batteaux in his book, *Les beaux arts réduits à un même principe* (1747). Batteaux listed seven 'fine arts' (echoing the late-antique number of seven 'liberal arts'): architecture, dance, music, oratory, painting, poetry and sculpture. The 'single principle' to which these arts could be 'reduced' was that of the selective imitation of nature to provide that which is *beautiful*. Batteaux's appelation 'fine arts' has survived into the present, as has his definition (albeit with some qualifications). Of the seven *beaux arts* on his original list, two – oratory and poetry – very soon became grouped separately as *belles lettres*; in the nineteenth century dance and music seceded to leave only the three 'visual' arts – architecture, painting and sculpture – to enjoy the title *beaux arts* (the *Académies des Beaux Arts* taught only these three subjects). Towards the end of the nineteenth century these three became simply *Art* – a restricted, capitalised, use of the term hitherto unknown in English (today, of course, membership of this class has become even more exclusive, as it is now common to speak of 'Art and Architecture' – many schools are so named). It is this *Art* which the Greater Oxford Dictionary defines as, 'the skilful production of the beautiful *visible* forms', a definition which has a selective relation to the theories which precede and inform it, and to which I shall now (re)turn.

Realism, formalism, expressionism

Prior to the promotion of painting to the status of a 'liberal art' there was no 'theory of art' in the modern sense of an 'explana-

tory scheme of ideas' – for example, an interrogation of the purpose of art, and the values it embodies or serves, developed as a self-consciously independent discipline. Philosophical discussions of such topics as 'beauty' and 'representation', begun in antiquity, were not undertaken with a view to elucidating art – the visual arts served merely as a convenient source of examples. In the Medieval period, discussion of pictures and statues was predominently theological, doctrinal; otherwise, there was a rich workshop literature concerned only with ways and means, never with questions of ends. None of this, of course, should be any occasion for surprise, for, as already observed, there was as yet no independent conceptual category to serve as the *object* of theory – no 'visual art' seen as fundamentally distinct from a host of other skilled trades. Classical antiquity *had* produced many treatises on poetry and rhetoric; in the absence of a classical theory of painting it was to these that humanist scholars turned when, in the mid-sixteenth century, painting first became defined as a *theoretical*, as well as a practical, discipline. Inverting a formula from Horace's *Ars Poetica*, *ut pictura poesis*, 'as is painting, so is poetry', the humanists rooted painting in the representation of the text; from Aristotle's *Poetics* they took the dictum that the highest calling of any art is the depiction of human action in its most exemplary forms: 'young men should be taught to look, not at the works of Pauson, but at those of Polygnotus, or any other painter or sculptor who expresses moral ideas', for, 'Polygnotus depicted men as nobler than they are, Pauson was less noble'.[3]

The programme of so-called 'history painting', which humanist scholarship inaugurated, was able to be assimilated to the extensive philosophical discussion – since Plato and Aristotle – of *mimesis*, 'imitation', or 'representation'. By the eighteenth century, such history painting – art on the side of *mimesis* – had become firmly established as an 'official' form, an art in the service of the state. This was most conspicuously the case in France, where the status of history painting had been secured with Louis XIV's recognition of the *Académie* in 1663, and with the appointment of Le Brun to the position of 'First Painter' to the King. The *Académie* had formed in 1648, under the leadership of Le Brun, as a secessionist group of history painters

seeking independence from the then virtually all-powerful painter's guild, the *Maîtrise*. The *Maîtrise* represented the artisanal tradition; as Norman Bryson writes:

> From its inception, the Académie divided French painting into two provinces, that of *homo significans*, and that of *homo faber*. The final ascendency of the Académie over the Maîtrise marks the institutionalised sanction of those who painted by text over those who painted without it.[4]

Far from waning in influence during the temporary suppression of the *Académie* in the revolutionary period, history painting continued even to illustrate the same classical texts, but in the service, now, of new masters – Republican antiquity being seen as replete with exemplary actions widely deserving of imitation in art and life (that of Junius Brutus, for example, who had his two sons put to death for conspiring to restore the monarchy in Rome). On his accession to the imperial throne in 1804, Napoleon immediately launched schemes for the state control of the arts; in a most extraordinary transformation from Jacobin revolutionary to Napoleonic courtier, the history painter David became appointed *Premier Peintre* to the throne.

If we disregard the dominant contemporary tendency to interpret the history of art as a succession of styles (begun with Winckelmann, but now derived primarily from the work, early in this century, of Wölfflin, and Worringer), we can see an underlying theoretical attitude, recommending a combination of selective imitation and exhortation, running like an unbroken thread from Aristotle's preference that men be depicted as 'nobler than they are', through all subsequent idealisations of monarchical, ecclesiastical, state and revolutionary figures and projects. In this, at least, a line of eminent ghosts – from Aristotle, through Diderot – stands behind Zhdanov: 'Socialist realism, . . . requires the artist to present reality *in its revolutionary course of development, in a true and historically concrete manner*'[5] (my emphasis). There is a residual Zhdanovism in a certain 'left' approach to art in the West to this day ('positive images of'); it might claim to be the sole descendent of true Aristotelianism in the arts were it not

for the fact that the very stance to which it is today customarily opposed – Formalism – is itself of Aristotelian descent.

Plato had a low opinion of painting: paintings imitate objects; objects imitate ideal forms; therefore, paintings are twice removed from true knowledge. Aristotle dispensed with the transcendentalism of Platonic forms – form inheres *only* in substance. The painter therefore may be said to abstract the inherent perfection of form from imperfect objects. It is this strand of Aristotelian thought which effectively 'split off' in the eighteenth century to result, eventually, in the tendency we know today as 'formalism'. This development out of Aristotle was routed through Plotinus's concentration, in late antiquity, on the problem of 'beauty'. Plotinus's 'neo-Platonism' effectively reversed the Platonic condemnation of art as the 'imitation of imitation'; the arts are, 'holders of beauty, and (they) add where nature is lacking'. It is essentially this early idea of selective imitation in the interests of the production of *beauty* which, some seventeen centuries later, gains wide diffusion with the success of the book by Batteaux I have already mentioned, and the incorporation of some of Batteaux's formulations into the *Encyclopédie ou Dictionnaire Raisonné des Sciences, des Arts, et des Métiers* (1751). Even while shifting the project of painting from the exclusive ground of what today we would call 'textuality', Batteaux preserved the humanist equation between painting and poetry. In the *Laocöon* (1766) Lessing attempted to separate the projects of these two *beaux arts* in emphasising that painting depicted a simultaneity of events in *space*, while poetry showed a succession of events in *time* (a distinction nevertheless recognised and accommodated in the doctrines of *ut pictura poesis* in the concept of *peripateia*). It was Lessing who termed architecture, painting and sculpture *die bildenden Künste* – 'the figurative arts' – declaring that while poetry can speak both of the visible and the invisible, painting can express only what is visible; it is in so doing that it obeys the precepts of beauty, painting being best suited to the depiction of 'beautiful shapes in beautiful attitudes'. From Lessing, the line towards modern formalism runs through the philosophical idealism of, most notably, Kant; it enters the present century via the writings of Bell and Fry, and culminates in Clement Greenberg's 'high modernism'. I shall

return to this particular theoretical tradition later; for the moment, I wish to move quickly on to identify a further 'splitting' of this line. To the two basic attitudes towards art, rooted in antiquity, so far mentioned – the view of art as 'imitation', and the view of art as 'form' – the late eighteenth century begins to add a third: the view of art as *expression*.

Seventeenth-century history painters were much concerned with the problem of expression, Le Brun wrote a treatise on it – *Méthode pour apprendre à dessiner les passions proposées dans une conférence sur l'expression générale et particulière* (1698) – a synthesis of his teachings at the Academy. Le Brun is concerned with the problem of showing, in an image, those internal states of protagonists in a drama that the poet is able easily to describe in words. By the end of the eighteenth century, however, 'expression', in connection with visual art, had come to mean quite another thing. A text from the first century AD attributed to the Greek 'Longinus', lost then rediscovered and published in the sixteenth century, exerted an increasing influence across the seventeenth and eighteenth centuries. The text, 'On the Sublime', seeks to identify the source of a quality which only great works of literature possess; of five features 'Longinus' names as contributing to the quality of 'the sublime' one is 'vehement emotion': 'nothing makes so much for grandeur as genuine emotion in the right place'. The resurrection of Longinus and the notion of 'the sublime' was central to a widespread reaction to Enlightenment naturalism and rationalism which had begun, even in the middle of the eighteenth century, preparing the way for Romanticism in the passage into the nineteenth century when, for the first time, as Monroe Beardsley puts it: 'Artistic production comes to be conceived as essentially an act of self-expression; and the critic, as the century moves on, feels a growing concern with the artist's sincerity, with the details of his biography, with his inner spiritual life'.[6] The concept of art as expression is given its twentieth century form most notably in the writings of Benedetto Croce, whose most influential teaching – derived from Kant, and now an unquestionable received wisdom of common sense – is that 'science' is the expression of concepts, while 'art' is the expression of *feelings*.

Rationality and response

As the above remarks begin to suggest, the basic configuration of ideas and institutions which circumscribe our view of *'Art'* today was first assembled in the eighteenth century. Although what we now retroactively identify as 'problems of aesthetics' are discussed in philosophy before the Enlightenment, it is only in 1735 that Baumgarten coins the term 'aesthetics' to identify an *independent* branch of philosophical inquiry. The 'history of art' in the modern sense does not emerge until Winckelmann breaks with the anecdotal 'lives of the artists' format in a book on ancient art published in 1764, whose title introduces the expression 'history of art'. 'Art criticism' also, in the form we know it today, is similarly a product of the eighteenth century. Previously, critical judgements of works of art were mainly concerned with assessing whether or not the rules which were held to govern the making of the work in question had been sufficiently well observed, and whether sufficient skill had been displayed in their observation. The Academy (there were over 100 academies in Europe by the end of the eighteenth century) was the institutional expression of the desire to assemble rules and criteria of judgement into a coherent *teaching* – a system, moreover, which could be imposed beyond the Academy through direct and indirect control of patronage. The French Academy, again, exemplifies the most fully achieved realisation of this desire. The power of the *Académie* under the *Ancien Régime* derived from its incorporation within a broader programme of political consolidation which began with Louis XIV's resolve to rule alone, but its history also runs concurrently with the struggle of the French bourgeoisie for its own birth as the dominant class, and it is not too fanciful to see the impetus of modern criticism in the general assertion of the rights of 'good argument' and individual entrepreneurship against the dictates of sovereign law. The Academy, by emphasising rule and reason as the foundation of art, itself inadvertently encouraged the conviction that any lay person was qualified to arrive at a valid judgement of an artwork through applying everyday morality and rationality. Moshe Barasch finds the prototype of this modern lay critic in Pietro Aretino, a sixteenth-century satirist

who was, 'probably the first layman-critic who judged a work of
art just because it appealed to him and evoked his response,
without caring for either the correctness of the representation or
the profundity of thought suggested by it'.[7] However, although,
'the beginnings of an art criticism based on an educated layman's
taste', may indeed pre-date the Enlightenment, it was not until
the eighteenth century that the ideological and institutional inno-
vations take place – including, most importantly, egalitarianism
and journalism – which will allow the eventual emergence of
'critics' as a professional class.

I have remarked that modern criticism arises with the Enlight-
enment ambition to pit a commonwealth of reason against the
arbitrary despotism of mere aristocratic opinion. In France,
where the political defeat of absolutism was most emphatic, it
was *drama* which became the primary artistic means of focusing
the emerging bourgeois ideologies. Diderot was late in turning
his interest from the stage towards painting and when he did so
it was the painted dramas of Greuze he championed ('history
painting' become bourgeois morality play) against the courtly
decorations of Boucher (history painting become, at least in the
eyes of Diderot, mere stucco). Drama, painting, politics, – all
were to be called as equal subjects before the bench of reason;
there was as yet no question of dealing with them as befitted
their 'individual condition'; ethics, not aesthetics, was the master
discourse in the interrogation of the arts; Diderot writes: 'Two
qualities essential for the artist: morality and perspective'. 'Is it
true?', 'Is it spiritually inspiring?', 'Is it socially useful?', are the
questions to be asked of art, and they may be put, and decided,
by any virtuous, literate (and propertied) citizen.

The idea that 'good common sense' is the fundamentally most
important quality in an art critic was effectively overturned by
the wave of irrationalism which swept in the Romantic move-
ment. By the end of the eighteenth century, under the influence
of, most notably, Rousseau, the metaphor of organic growth
had replaced more mechanical, rational, images of the processes
governing art: ignorant of, or indifferent to, rules and reasons,
the artist creates by blind necessity, like Nature itself. Such a
view was given added intellectual authority by Kant; against the
then prevailing Enlightenment view (derived from Locke) that

true knowledge is only gained empirically, via the senses, Kant
asserted that knowledge is essentially innate – arising from within
the individual, rather than derived from without; for Kant,
Genius is the name given to the 'innate productive capacity', a
gift of nature, which produces art 'from within'. In a well-known
statement of 1800, Wordsworth writes: 'all good poetry is the
spontaneous overflow of powerful feelings'. It is at this time
that the analogy between painting and literature, which had
dominated thinking about the 'visual arts' since the mid-sixteenth
century, gave way to the analogy between painting and music,
as in Pater's celebrated dictum, 'all art aspires to the condition
of music' (from this new metaphor is able to be derived not only
Romanticism, and subsequent expressionist theories, but also
Formalism – according to whether 'music' is taken to stand for
emotional outpouring or pure non-referentiality). The critic now
also, for the first time, becomes an expressionist; Baudelaire,
for example, has no time for that criticism, which, 'on the pretext
of explaining everything, has neither love nor hate, and volun-
tarily strips itself of every shred of temperament'. The removal
of the judgement seat of criticism, and the spring of art
production, from the terrain of reasoned consensus to that of
individual intuition, although it may appear as a radical
upheaval, was in fact a symptom of the consolidation of bour-
geois confidence in its own political and ideological hegemony.
The picture of the critic as a 'cultivated' person of 'sensibility' is
the picture of someone who is bourgeois *to the core*; it is this
core of sensibility which, made to resonate in contact with the
art object, will vibrate in perfect sympathy with other similar
sensibilities, similarly exposed to the same object. Much as, in
George Orwell's description, the British upper middle classes,
'communicate like bats, by means of high-pitched squeaks inaud-
ible to the rest of us', the critic who relies on his or her 'response'
will be sure to be understood by those of their own kind, and
without need of reasoned justification. As Raymond Williams
comments, 'the notion that response was judgement depended,
of course, on the social confidence of a class and later a
profession'.[8]
 The contemporary practice of writing 'personal response'
reports on exhibitions by contemporary artists – 'reviewing' –

was again, not established until the middle of the eighteenth
century. The 'review' emerges as a direct consequence of
changing socioeconomic circumstances in, primarily, the second
half of the eighteenth century: the rapid growth of periodical
literature, and changes in the form of art patronage. The funda-
mental importance of the practice of 'collecting' in the determi-
nation of art institutions cannot be overestimated – the art
market, the museum (the modern form of which, again, emerges
in the eighteenth century), criticism, art history, have all argu-
ably developed in response to it. The practice goes back to
antiquity; the eighteenth century is nevertheless a period of tran-
sition from a situation in which antiquarians passively 'serviced'
the taste of their (mainly aristocratic) patrons towards that
contemporary situation in which 'dealers' extensively *create* the
taste of their (mainly *nouveaux riches*, and corporate) clients.
The practice of reviewing is part of the new pattern of market
forces created in capitalism's progressive transformation of use-
value into exchange-value, and part of the process of audience-
reorientation of art from an hereditary élite of the powerful
towards a 'general public'. This is not necessarily to overestimate
the economic influence of the review; writing in 1824, Stendhal
observes:

> A personable young artist can easily manage, between exhi-
> bitions, to establish relations with the editor of a journal.
> When next he exhibits his work, never mind how poor its
> quality . . . he will find his pictures emphatically noticed, and
> praised as little masterpieces. But nobody will buy them.[9]

There is, however, a shift of emphasis taking place in this
moment of emergent Romanticism which, some 20 years later,
and now fully consolidated, will make mere economic consider-
ations seem, if not actually irrelevent, at least no longer primary.
Baudelaire, writing in 1846:

> What is the good? – A vast and terrible question-mark which
> seizes the critic by the throat from his very first step in the
> first chapter that he sits down to write.
> At once the artist reproaches the critic with being unable to

teach anything to the bourgeois, who wants neither to paint nor to write verses – nor even to art itself, since it is from the womb of art that criticism was born. And yet how many artists today owe to the critics alone their sad little fame! It is there perhaps where the real reproach lies.[10]

With Romanticism, the anguish and turmoil which are the assumed creative lot of the artist now accompany the toils of the critic; but more to my point here, mere monetary reward is no longer the primary issue – it is not fortune that the Romantic artist seeks, it is *fame*.

Imagination and hypnosis

The way the term 'masterpiece' is used by Stendhal, in the passage quoted above, is itself indicative of a fundamental historical transformation in the concepts of art and the artist. In the Middle Ages, the 'masterpiece' was simply the item of work executed by an apprentice to prove he had adequately learned his craft (albeit accession to 'mastership' brought with it financial, and other, class privileges); in the modern sense of the word, however, something more than manual skill is connoted; this expanded sense first begins to emerge as a consequence of the transition of the artist's role 'from *homo faber* to *homo signifi-cans*' initiated in the mid-sixteenth century. Certainly, it is still common today for visual art to be valued for the trace of the *hand*. There are various reasons for this; one, following on the response of Morris and Ruskin to industrialisation, is nostalgia for a pre-industrial 'golden age' – the trace of the hand, absent from most objects around us today, becomes the trace of a lost, utopian, 'organic society' (as Raymond Williams has remarked, the one thing we can be sure of about the 'organic society' is that it is *behind* us). Another reason is in our market economy system of values which fetishises that which is 'unique' – that which permits the sense of *absolute* individual ownership. Yet another is to be located in a 'logocentric' philosophical tradition which privileges the authorial signature as guarantee of *pres-*

ence.[11] The modern valorisation of the hand-crafted object is
thus variously 'overdetermined', and it would be profoundly a-
historical to claim this current penchant as continuous with the
medieval attitude. In the latter, considerations of craftmanship
are inseparable from, and circumscribed by, considerations of
use, the *significance* of which is established *externally* to the
object (as for example, in religious ritual, or courtly pageant);
in the modern attitude, significance is held to be inscribed *within*
the work, and its very right to be called a work of 'art', rather
than of 'craft', is determined by reference to its (supposedly
inherent) semiotic and/or affective status. Thus Gombrich
locates a historically 'most decisive phase' of development of the
idea of art in, 'the assimilation of the visual arts to their "sister
arts", architecture, poetry, music, and the dance'. In this devel-
opment, 'art lovers . . . came to seek in art the same kind of
imaginative experience they had found in literature and maybe
in music'. He concludes, 'Thus it was not so much the work of
the human hand which became an object of admiration, but any
token of the creativity of the human mind'.[12]

In the Middle Ages, to speak of the 'creativity' of the artist
would have been to risk burning as an heretic – there was only
one *Creator*; nor is the idea of the artist's 'creativity', at the time
it emerges, quite the same as the notion most widely held today.
The story of the evolution of perfection in art told by Vasari in
his *Lives of Painters, Sculptors and Architects* (1550 and 1568)
is a story of the progressive perfection of *representation* in which
art is seen as an activity of problem-solving indistinguishable in
kind from that of science. Vasari writes: 'Greatness of art in one
is born of diligence, in another of study, in this one of imitation,
in that other of knowledge of the sciences'; Venturi comments,
'too many origins, and precisely that which was wanting was the
only authentic one – creative imagination'.[13] What is modern in
Venturi's (1936) opinion is the yoking of 'creativity' to a very
particular understanding of 'imagination'. Venturi's particular
aesthetics derives most directly from Croce, probably the single
most influential modern aesthetician, but the origins of this idea
of 'creative imagination' are earlier – they date from the nine-
teenth century. Today, the idea that 'creative imagination' is the
'only authentic origin' of art may seem so unquestionably self-

evident that we forget that it is, historically, a quite recent assertion, and we also forget the circumstances in which it emerged. In the nineteenth century this notion of art served a *revolutionary* Romanticism, politically opposed to the narrow profit-seeking utilitarianism which industrial capitalism was seeking to impose in all aspects of society (just as 'post-industrial' capitalism seeks to impose it today). Raymond Williams recommends that, in considering Romanticism, we remember that, 'Wordsworth wrote political pamphlets, that Blake was a friend of Tom Paine and was tried for sedition, that Coleridge wrote political journalism and social philosophy, that Shelley . . .',[14] and so on.

If today, the politics of Romanticism *has* been 'forgotten' (repressed) it is at least partly due to the fact that Romantic aesthetics facilitates, if not induces, such amnesia. In practice the Romantics did not separate aesthetics from ethics, but in theory such a separation was strongly implied. Schelling had early criticised mimetic theories of art in proposing that art, far from being concerned with reality, aspires to truths 'higher' than reality – a theme developed by others to result in a theory of artistic production as necessarily autonomous, free of all demands external to itself – in the words of Goethe (albeit he was speaking of *music*), 'a little world of its own, . . . which must be judged by its own laws'. Kant's distinction between 'phenomena' and 'noumena', provided the conceptual space for a notion of *intuition* as the means to forms of knowledge more 'profound' than those derived from observation. Thus, for Wordsworth, the object of poetry is, 'truth, not individual and local, but general and operative, not standing upon external testimony, but carried alive into the heart by passion'. The vehicle for the communication of such 'general' truths was the *symbol*.

Goethe had made a distinction between *allegory* and *symbol* which has behind it a very long history.[15] The 'symbol' is an essentially extra-discursive form, albeit it may appear clothed in the substance of language, whose effect is to abolish the separation of subject and object, establishing an instantaneous and complete communication on the basis of *rapport* rather than cognition. Such an idea leads to an emphasis on the *intrinsic* form of the art object itself, and the relation of the viewer to

the form, rather than on the relations between object, viewer, and the world in which both are situated (a denial of difference, in a shift from a triadic to a dyadic relation, in which those who read psycho-analytic theory may see something of a concomitant emotional regression). As Terry Eagleton writes,

> The symbol fused together motion and stillness, turbulent content and organic form, mind and world. Its material body was the medium of an absolute spiritual truth, one perceived by direct intuition rather than by any laborious process of critical analysis. In this sense the symbol brought such truths to bear on the mind in a way which brooked no question: either you saw it or you didn't. It was the keystone of an irrationalism, a forestalling of reasoned critical inquiry, which has been rampant in literary theory ever since.[16]

And we may of course add, in art theory too: it is this same Romantic formalism which, in Clement Greenberg's high modernism, was destined to become the official aesthetics of the Western world in the middle of the twentieth century; and it is precisely the same mystical doctrine of the 'symbol' which after Modernism's demise in the late 1960s, is born again today in the resurrected body of 'new' expressionist painting. It is the idea of the 'symbol' which is most responsible for today's dogmas of artistic 'expression' and critical 'response'. The basic configuration of past intellectualisations which today masquerade as spontaneous 'response' (Pascal asked, 'who knows but that second nature is not merely first habit?') I have identified as 'realism', 'formalism', and 'expression theory'; these are the three theoretical tributaries which feed the mainstream of contemporary 'common sense' in art and art criticism. Today they are rarely encountered in isolation from one another, nor are they peculiar to the 'visual' arts; for example as Catherine Belsey has observed,[17] the prevailing common sense view of literature today has its origins in the position Ruskin developed on painting. Ruskin's view of visual art represented a synthesis of the relatively new Romantic expression theories with the traditional theories of art as *mimesis* to which Romanticism had been opposed. In the mimetic tradition, art is supposed to

represent reality; in Romantic thought, art is supposed to express personal feelings; the confluence of these two views gives us a view of art as 'reality refracted through a sensibility' – 'expressive realism'. Some variety of 'expressive realist' position still informs much left-humanist art theory and practice in the West, and it is nowhere stronger than when it is legitimating documentary photography – Donald McCullin is the 'expressive realist' artist, *par excellence*, of our day. However, the dominant common sense view of art in the West is perhaps best characterised as 'expressive formalism'. Lessing, as I have remarked, saw the essence of visual art as consisting of, 'beautiful shapes in beautiful attitudes'; add Romanticism to this and we have the dominant common-sense understanding – seemingly shared by most art journalists – that artists 'express themselves' by means of beautiful shapes and colours. Through the magic of the 'symbol', the theory has now become generalised to the point that 'beautiful shapes and colours' can be claimed to 'express' anything whatsoever – 'higher realities', the 'human essence', more or less whatever the critic or artist chooses. What was truly *critical* in the old debates has today been lost from sight. What began as an emphasis on imagination – a creative faculty which seeks to *transgress* the given orders of representation – by degrees became a form of self-hypnosis in the service of the *status quo*. 'Criticism', no longer concerned with what is *critical* in society, is now the form of the incantation through which hypnosis is induced.

Common sense and (the) concrete

It is significant that the allocation of a distinct 'period' to Romanticism continues to present problems to orthodox art history and criticism. 'We don't know who discovered water', someone remarked, 'but we're sure it wasn't a fish'; if, in the view of a certain history and criticism, the boundaries of Romanticism seem to expand and contract, advance and recede, it is because this view is *from within* Romanticism. As it cannot survive outside of this ideological environment, orthodox history, theory and criticism, therefore, must believe that there is no outside,

no boundaries, no limits to the freedoms it so fiercely defends: the freedom of the artist to create without preconception, the freedom of the critic to respond without prejudice. But critical judgement, as Barthes has remarked:

> is always determined by the whole of which it is a part, and the very absence of a system – especially when it becomes a profession of faith – stems from a very definite system . . . it is when man proclaims his primal liberty that his subordination is least disputable.[18]

The putative 'freedom' of the artist is no more or less constrained than that of the critic. Contrary to the bland dogmas of our 'new', dissent-free, Romanticism, the artist does not simply 'create' – innocently, spontaneously, *naturally* – like a flowering shrub which blossoms because it can do no other. The artist first of all inherits a role handed down by a particular history, through particular institutions, and whether he or she chooses to work within or without the given history and institutions, for or against them, the relationship *to* them, is inescapable.

Institutional legitimation imposes a grid of the permissible upon the field of the possible. Obviously, a complex of considerations determine what is permissible in an institution – legal, economic, political, and so on. All such given determinants and constraints will, however, be submitted to the articulation of the 'master discourse' of the institution in question. The master discourse organises the field of the generally permissible in terms of what, in its terms, is *thinkable*. The discourse of the institution is, therefore, more fundamental to the identity of that institution than, say, physical plant or organisational hierarchies; indeed in many cases – the Catholic Church is a good example – the latter are the direct expression of the former. More surely than buildings and chains of command, the master discourse is always already *in place* to receive its novices; by its means the functionaries of an institution, regardless of rank, are inducted into the common system of beliefs and values which, by taking lodging in their own mouth, will identify them as *belonging*. The discourse allows the fiercest debates (as proof that it is open and spontaneous) but cannot recognise dissent – in the dispute over

the number of angels who may gather on the head of a pin the *existence* of angels cannot be brought into doubt; in the art world also, to question the existence of certain ideological 'angels' is to commit self-exile, to disappear over the discursive horizon.

The master discourse which is the common sense of '*Art*' is in the thrall of an antique, 'nominalist' view of language – believing that because there is a singular word, 'art', then there must be some singular *thing*, some 'essence', which the word names. History (to say nothing of modern linguistics) is the enemy of this illusion; real history therefore – mutable, heterogeneous, indeterminate – is kept prisoner in its own dungeons while a more coherent imposter (a more plausible narrative) takes public command, and dispenses judgements. Our art museums are most often machines for the suppression of history,

> substituting for concrete historical locations the fictive back-drops of an autonomous history of art or an unquestioned, and perhaps inexpressible, standard of 'aesthetic excellence'. Where historically remote work is being displayed, instead of the massive historical work of recovery necessary to re-insert the 'dead' signs in the complex moments within which they once resonated with meaning, we are all too frequently offered the 'scholarship' of the family tree and pedigree, the spectacle of the cemetery with its monuments and relics.[19]

The contents of this graveyard is the canon of established 'masterpieces'; to be admitted to it is to be consigned to perpetual exhumation, to be denied entry is to be condemned to perpetual oblivion. The canon is what gets written about, collected, and taught; it is self-perpetuating, self-justifying, and arbitrary; it is the gold standard against which the values of new aesthetic currencies are measured. The canon is the discourse made flesh; the discourse is the spirit of the canon. To refuse the discourse, the words of communion with the canon, in speaking of art or in making it, is to court the benign violence of institutional excommunication:

> Regional dialects of the discourse, so to speak, are acknowl-edged and sometimes tolerated, but you must not sound as

though you are speaking another language altogether. To do so is to realise in the sharpest possible way that critical discourse is power. To be on the inside of the discourse itself is to be blind to this power, for what is more natural and non-dominative than to speak one's own language?[20]

Seen from the centre of the discourse, the horizons of the discourse are quite simply the boundaries of art itself (as Wittgenstein said, 'the limits of my language are the limits of my world'). From the horizon however, the view is of another world, one which includes elements of the previous one, but is no longer contained by them. From the centre, of course, this new position is literally *eccentric*; there are moments, however, when historical circumstances favour heretics, and when the 'crazies' suddenly make sense.

In the late 1960s, various forms of social revolt were endemic in France and Italy, and there were widespread protests in Europe and the US against the Vietnam war. A wave of political and cultural radicalism arose in 'higher education', where, as Elizabeth Bruss has written: 'the tacit interests and assumptions that had always governed classroom procedures and curricula were suddenly exposed to view'. At this cultural moment, she observes:

> the defense of art as a superior reality had lost its former social meaning as an attack upon utilitarian values and had become instead a plea for quietism and social withdrawal – by implication tolerant of any world, no matter how ugly or unjust, so long as it allowed some small protected space where art could function.[21]

When the shock wave of the French May events of 1968 hit the British educational institutions it rocked even the normally quietistic art schools (where 'non-conformism' is traditionally confined to the invention of new styles of dress). In the late 1960s, art students militated for the democratisation of decision-making processes in general, and for changes in curricula and syllabuses in particular, with the over-all aim of opening the art academic course to the wider contemporary world around it.

('He was educated as an artist', the Formalist Viktor Shklovsky remarked of a friend, 'which is to say he wasn't really *educated* at all'.) In *Le Gai Savoir*, Godard's 1968 film about education (which particularly addresses the questions, 'what, and how, do we learn from images?'), one of the characters remarks, 'Self-evident truths belong to bourgeois philosophy'. In the late 1960s, the self-evidently eternal verities of *Art*, inherited from the Enlightenment and Romanticism, a 'Philosophy of the Life Room', were rigorously interrogated. For a moment the grip of art academic restrictive practices relaxed. The advance into the 1970s, however, was an advance into economic recession, rising unemployment, educational cutbacks and increasingly authoritarian 'neo-conservative' politics. By 1980, the 'life room', which the late 1960s and the early 1970s had turned into a debating chamber, was once again the silent habitat of stiffly naked ladies and mouldering piles of fruit; what I had felt moved to describe in the 1970s as, 'the anachronistic daubing of woven fabrics with coloured mud, the chipping apart of rocks and the sticking together of pipes – all in the name of timeless aesthetic values',[22] was once again the unquestioned and unquestionable norm. The debates themselves, however, were not silenced, they continued in the margins of the art institutions and, in exile from the increasingly conservative 'art magazines', they took up residence in other journals (particularly, the newly-emerging reviews of 'cultural theory'). Political dissent was not the only French import of the late 1960s and the 1970s, there was also a massive influx of theory. Introduced into Britain by *New Left Review*, and then developed in a variety of other journals, most notably (in terms of my interests here) *Screen*, French Marxism, semiotics and psycho-analysis became the radical alternatives to the discourse of *Art* in general, and the empirical-intuitive Anglo-Saxon critical tradition in particular. With the new theory came a rejection of the established 'high art' hierarchies, with film and photography tending to take precedence over literature and painting, and with all forms of 'art' being viewed as part of a broader picture of representational practices in contemporary society. It became impossible to think 'art theory' in isolation from 'theory of ideology' – particularly under the massive theoretical and political impact of feminism. As Laura Mulvey has

remarked of this period, 'The "great tradition" of British culture
. . . was rejected as complacently chauvinistic in both the
national and sexual senses of the word'.[23] No mere 'crisis in
British art' then, in the 1970s, but a crisis in the very *culture* in
whose name criticism pronounced its judgements. Viewed in the
overlapping illuminations of Marxism, semiotics, psycho-analysis
and feminism, orthodox criticism was safe neither in its empiri-
cism nor its intuitionism, neither in its liberal humanism nor
in its phallocentrism; it was, however, perfectly secure in its
newspapers and magazines, its galleries and museums, its art
schools and art history departments – mere intellectual and moral
bankruptcy was not to deprive it of its institutional holdings. In
1968, *New Left Review* had published a translation of Lacan's
celebrated 'mirror-phase' article; in 1971, *New Left Books*
published a translation of Althusser's equally influential 'Ideo-
logical State Apparatuses' essay. Shortly after, writing about
British historiography, one of the *New Left Review* editorial
board observed:

> British historians have largely remained impervious to the
> solutions put forward by Marxism, psychoanalysis, and
> classical sociology. Or else they have only glimpsed them
> through the blurred light of caricature and vulgarisation . . .
> The result is as weird as if a Newtonian physicist were to come
> across Einstein, admit that relativity was probably a factor of
> some importance, and then to attempt to carry on as before,
> under the impression that the occasional acknowledgement
> would absolve him from the necessity of further thought about
> it.[24]

I feel this same sense of the 'weird', which Gareth Stedman
Jones's analogy so perfectly characterises, when I contemplate
the 'art scene' of the 1980s. It has undergone a sea change and
yet it has not changed at all. It loudly and proudly proclaims its
new-found 'postmodernism', and yet the period which separates
it from modernism, the late 1960s and 1970s, the period which
dismantled modernist art and criticism totally, is a period in
which, as it is generally stated, 'nothing happened'. Conservative
criticism has again displayed its favoured way of dealing with

ideas which threaten it: when the ideas are new, they are contemptuously dismissed as 'fashionable' and/or 'obscure', when they are no longer new they are loftily dismissed as *passé*; in the space between, the texts are looted of their *terminology*, which is then used to vacuously ornament the pages of conservative writings, in demonstration that the new material has, anyhow, now been 'assimilated': pages are now peppered with such terms as 'signifier', 'desire', 'drive', 'deconstruction', and so on – a roll-call of the arrested, terminological prisoners given meaningless labour in intellectual deserts. The greatest act of appropriation, however, has been the reduction of a complex intuition of the 'end of an era', with all the possibilities that should offer for 'thinking the unthinkable', to an art market gimmick – I refer to the trivialisation of the idea of the 'postmodern'.

II Criticism and Voluntarism in the Age of Postmodernity

Enlightenment, surveillance, simulacra

In an art world ever eager to decant its old ideological wine into new terminological bottles, there has been much critical discussion of, and greater uncritical use of, the idea of a 'postmodern' aesthetics. The wider current debates around the term 'postmodern', however, range beyond questions of aesthetics, they derive from apprehensions of a fundamental shift, if not a mutation, in (North-Western) history, culture and politics in general. As Frederic Jameson puts it:

> this problem is at one and the same time an aesthetic and a political one. The various positions which can logically be taken on it, whatever terms they are couched in, can always be shown to articulate visions of history, in which the evaluation of the social moment in which we live today is the object of an essentially political affirmation or repudation.[25]

We should bear in mind then, first, that the 'postmodern' is not so much a 'concept' as it is a *problematic*, a complex of

heterogeneous but interrelated questions which will not be silenced by any spuriously *unitary* answer; secondly, as is clearly inscribed in the very term 'postmodern', any position defining itself as such is, *by* definition, a position on the modern – a postmodern vision cannot be a solely prospective one, it is necessarily also retrospective; thirdly, but most fundamentally, the 'political' and the 'aesthetic' are the inseparable, simultaneously present, faces of the currency of the postmodern problematic. Turning first to the political, for my particular purposes here (which can only be to sketch a small number of the features I find most salient) I ask to be excused a slide from the 'political' in a strict sense, to a broader nexus of political/philosophical/cultural considerations. In these terms, the period of modernity may be seen as beginning with the Enlightenment belief in the infinitely perfectible progress of social and political institutions through the power of *reason* (philosophy); its emblematic historical moment is nevertheless fully *active* – the French Revolution; in which the arbitrary absolutism of aristocratic and ecclesiastical authority was to be replaced 'at a stroke' by the just rule of democratic rationality. The 'faith in reason' was the result of a consolidation and generalisation, in the eighteenth century, of the scenario of the progressive solution of problems in experimental science which had emerged in the seventeenth century. As Habermas (after Weber) notes, the eighteenth century identified three autonomous spheres of reason – science, morality and art – as engendering discrete bodies of discourse, which could then be separately institutionalised:

Each domain of culture could be made to correspond to cultural professions in which problems could be dealt with as the concern of special experts. This professionalised treatment of the cultural tradition brings to the fore the intrinsic structures of each of the three dimensions of culture. There appear the structures of cognitive-instrumental, of moral-practical and of aesthetic-expressive rationality, each of these under the control of specialists.[26]

The reservoirs of knowledge thus accumulated through specialisation were to bring into bloom a paradise-on-earth of rational

social organisations; eight-tenths of the way into the twentieth century, however, such optimism has been revealed as misplaced – the Enlightenment vision of a rational ordering of the social totality did not foresee its consequences in twentieth-century *totalitarianism* – Hitler, Stalin. In an important sense, then, a postmodern sociopolitical perspective is one in which the programme of the Enlightenment – the 'liberation of Man' [*sic*] through scientific invention and 'scientific social management' – is seen to have at best failed, or at worst to have been the *cause* of the ills from which the twentieth century suffers.

The Enlightenment project of replacing arbitrary authority with the rule of beneficent reason has, in contemporary Western democracies, and in harness with capitalism, secured individual freedoms only in the context of imposed norms of behaviour and aspirations which together form a universe ordered to fulfill, not human desires, but the needs of an increasingly autonomous principle of *production* – the maximisation of 'gross national product'. In the West – due in significant part to the erosion of state autonomy consequent upon the growth of multinational corporations – the democratic process has effectively been reduced to the opportunity of the individual to vote, every few years, on the issue of whether the state should stand on one, or the other, of its party-political feet – a change of posture leading to little internal readjustment, and no change of direction. In recent years, the equally economic–production centred programmes of Marxist parties – the traditional recourse of those, in the West, in opposition to the capitalist state – have themselves been seen as failing to meet the most urgent aspirations of substantial sections of the population; not only as a short-term exigency, while 'preparing for power', but as a perpetually inbuilt necessity of their own Enlightenment-rooted totalising logics. The events of May 1968, in France, saw the emergence of forms of Left oppositional politics which had little to do with Western Marxist parties either in their organisation or their affiliation – being both radically democratic, and independant of the labour movement. In the years since 1968 we have seen the consolidation and proliferation of such 'micro-political' movements: women, blacks, gays; ecology, anti-nuclear, anti-psychiatry; and so on. Thus the reductionist projects of totalis-

ation and normalisation in Western 'democracies', whether they issue from the state or its traditional opponents, are being opposed by the democratic (re)assertion of a *plurality* of interests. It might be objected that there is nothing new here – the reconciliation of the often conflicting interests of social factions and fractions within the over-all project of the state has been *the* perennial problem of democracy. Against this it may be asserted that what *is* new, and what now counts as a 'postmodern' political perspective, is the refusal of *any* oppositional philosophy or strategy of the *totality*. Women, for example, have for some time been no longer prepared to subordinate their immediate demands to the cause of some supposed 'ineluctable advance of the proletariat', whose eventual and inevitable triumph is purported to be the only certain guarantee that those demands will be met. (Such a refusal may derive both from historical observation of the failures of socialist revolutions to dissolve patriarchal social formations, and from Marxist analyses of contemporary Western societies, in which the industrial working class is seen as now displaced from its once privileged strategic relation to power by other groups not defined in terms of social class – for example, the emergent information technocracy and bureaucracy.) As we are reminded seemingly every day, a negative aspect of the general phenomenon of political, 'interest-group', splintering is terrorism. As Baudrillard observes, in the media-generated babble of information, disinformation, suspicion and counter-suspicion, acts of terrorism often appear as detached from any *particular* cause:

> Is any given bombing in Italy the work of leftist extremists, or of extreme right-wing provocation, or staged by centrists to bring every terrorist extreme into disrepute and to shore up its own failing power, or again is it a police-inspired scenario in order to appeal to public security? All of this is equally true, and the search for proof, indeed the objectivity of the fact does not check this vertigo of interpretation.[27]

What is certain is that the state will respond with an increasingly vigilant surveillance of its own population, thus adding a further increment in a process of totalisation which threatens, according

to a logic of 'the inevitability of gradualism', to shade into totali-
tarianism almost without our having noticed it. Nor is this
particular aspect of the process of totalisation a contingent
response to the phenomenon of terrorism – it is, as Foucault has
related, a structural aspect of modern Western societies.

In *Discipline and Punish*, Michel Foucault describes how the
Enlightenment turned in horror from the punishment systems of
the *Ancien Régime* – based on public torture and execution, and
in which incarceration played a relatively unimportant role – to
evolve a system of punishment in which the centre-piece is the
prison, thus shifting emphasis from punishment of the body to
reform of the mind. Foucault shows, first, that punishment under
the *Ancien Régime* was not irrational barbarism, as the Enlight-
enment viewed it, but was itself, in terms of its own internal
logic, perfectly rational. Secondly, he shows that, far from
resulting in the 'reform' of miscreants, returning them to society,
the prison brings into being a whole new recidivist 'criminal
class'; but moreover, it gives birth to a 'technology of power'
based on *surveillance* which is then disseminated to all sectors
of society, imposing 'normality' from school, to office and
factory, to hospitals, and so on. Foucault writes:

> The judges of normality are present everywhere. We are in the
> society of the teacher-judge, the doctor-judge, the educator-
> judge, the 'social worker'-judge; it is on them that the
> universal reign of the normative is based; and each individual,
> wherever he may find himself, subjects to it his body, his
> gestures, his behaviour, his aptitudes, his achievement.[28]

Foucault refers to modern society as a 'Panopticon society' –
after Bentham's 'Panopticon' prison, in which a single guard is
able to watch *all* prisoners, while the prisoners know only that
they are being watched but never *when*. Readers of Foucault
were quick to interpret this metaphor in terms of contemporary
information technologies. Thus Mark Poster responds:

> The techniques of discipline no longer need rely on methods
> of regulating bodies in space as Foucault thinks. In the elec-
> tronic age, spatial limitations are bypassed as restraints on

the controlling hierarchies. All that is needed are traces of behaviour; credit card activity, traffic tickets, telephone bills, loan applications, Welfare files, fingerprints, income transactions, library records, and so on. On the basis of these traces, a computer can gather information that yields a surprisingly full picture of an individual's life. As a consequence, Panopticon monitoring extends not simply to massed groups but to the isolated individual.[29]

In the above passage Poster, in effect, gives a picture of a new subject for the new society of information technology – a subject (like the subject known to psycho-analysis) radically 'decentred', a subject formed 'in the wake of the signifier' – in this case, the traces of its work, leisure, and consumer activities scattered in a random pattern across the fields of contemporary life in the West. The subject thus constituted is invisible and (potentially) radically inaccessible, it inhabits the micro-circuitry of the ever-growing community of data banks. To this scattered and invisible field of the subject-as-data (that which is sucked from, or shed by, the subject in its paths through contemporary history) society adds the scattered but visible field of *spectacle* (those products of the media and advertising industry which are sucked into the subject; that into which the subject projects itself in a countless series of identifications). The existential subject lives out its experience between these two 'layers' of the phenomenological subject extended in information technology and the media. From this perspective emerges a more fully 'postmodernist' view in which the present period of Western history is seen not simply as a stage, albeit perhaps terminal, in the *evolution* of Enlightenment-inspired social formations, but rather as a total transfiguration of these formations as the result of a (technologically facilitated) mutation in the form of capitalism itself. As Jameson has observed, we are witnessing,

a prodigious expansion of late capitalism, which now, in the form of what has variously been called the 'culture industry' or the 'consciousness industry', penetrates one of the two surviving pre-capitalist enclaves of Nature within the system –

namely the Unconscious. (The other one is the pre-capitalist culture of the Third World.)[30]

In this period of what Jameson calls 'late capitalism' (after Ernest Mandel's description of the three-stages of capitalism: market capitalism; monopoly capitalism; and *Spätkapitalismus* – multinational, 'late', capitalism) it is the nature of *exchange* which has most fundamentally mutated.

Marx identified three stages of evolution leading to the primacy of exchange-value: a time up to, and including, the Middle Ages, when only production which was surplus to real needs was exchanged; the time of emergent capitalism, when *all* material production enters into commerce; and, with nineteenth-century industrial capitalism, a time of 'universal venality', when 'everything, moral or physical, . . . is brought to the market to be assessed at its truest value'. A primary source of the postmodern sensibility is the apprehension that the 'commodity society' we still inhabited in the 1950s has now metamorphosed into what Guy Debord has called the 'society of the spectacle', in which, as Debord puts it: 'The image has become the final form of commodity reification, . . . the spectacle is *capital* to such a degree of accumulation that it becomes an image'.[31] The universal principle of the Western political economy of the sign is now the effortless symbolic transmutation of all things into all other things through the intermediary of money. Such mobility of symbolic value is achieved through a form of society unprecedented in history, a form which may be viewed as replicating, at the level of the social and material, the radical disjunction of signifier and referent we find at the level of language – for this is not simply a society of the image, it is a society in which the image has effectively *replaced* that which it purportedly represents. In a (Platonic) word, upon which Jean Baudrillard has elaborated, we are a society of the *simulacrum*.

The simulacrum is a 'copy' of which there is no original. The commodity, in its potentially infinite series, is only the most palpable form of the simulacrum; the can on the supermarket shelf, certainly, but also the supermarket itself – each 'new' branch identical to the others – and the job at the check-out desk too (the fact that one person, branch, or can, may tempor-

arily precede the others does not make it the original, merely the first). Such systems of simulacra live in the embrace of other such systems. Through the 'media', objective reality has become a membrane of simulacra stretched over the real; in it we glimpse our reflected, media-inflected, desires and fears. Our eyes and ears, extended in the camera and the microphone, probe dangers to which our bodies are not, at that moment, exposed – an impregnable clairvoyeurism which blinds us to our own precarious social realities by making them appear external to themselves: Baudrillard writes, with an aside which invokes Foucault.

> Disneyland is there to conceal the fact that it is the 'real' country, all of 'real' America, which *is* Disneyland (just as prisons are there to conceal the fact that it is the social in its entirety, in its banal omnipresence, which is carceral).[32]

In the society of the simulacrum there is an incessant sliding of the spectacle over the real in which the referent – re-run, rewound, scrutinised in freeze-frame, run fast-forward – is eaten *live* by the signifier. In this imagistic irreality, print/imprint, positive/negative, image/reality, pose as oppositions only to dissimulate that they may exchange places at will. Baudrillard writes,

> *Watergate is not a scandal*, . . . capital, which is immoral and unscrupulous, can only function behind a moral superstructure and whoever regenerates this public morality (by indignation, denunciation, etc.) spontaneously furthers the order of capital, as did the *Washington Post* journalists.[33]

The illusion of difference where none exists, the identity of a thing with what it had projected/rejected as its opposite (in what Derrida has termed the 'logic of the supplement' – I shall discuss this later), is nowhere more apparent than in the regimes of simulacra which make up the 'art world'; nowhere more clear than in those incestuously intimate dances in which critical discourse, money, and image continuously exchange masks.

The market for fashion

As already observed, with the triumph of exchange-value over
use-value any object can become the equivalent of any other;
with the triumph of 'universal venality' any act, any statement,
any belief, can be emptied of signification to become a token in
a universalised system of monetary values where money itself is
the sole signified. A photograph of a painting by Giorgio de
Chirico appears one morning on the front page of a daily news-
paper.[34] Below the image, a spokesman for the museum which
is about to exchange over a million pounds for the painting, is
quoted as saying that de Chirico's 'juxtaposition of a torso and
a bunch of bananas' is, 'one of the most bizarre and compelling
inventions in the history of art', which, 'has given this picture
something of the hold on the imagination of a wide public that
is possessed by the Mona Lisa or Rodin's Thinker'. Surely the
fact that this is a 'surrealist' painting has determined the first
part of this statement (by way of Lautréamont's 'encounter of
an umbrella and a sewing machine'), as it has also determined
the recourse to an 'aesthetics of shock' in the second part. The
fact that the statement is not only mechanically formulaic but
patently exaggerated signifies only that the *content* of what is
said does not matter, only the form counts; something connoting
learning and authority – something to invoke the legitimation of
the 'great story' of *Art* – is to be intoned over this exchange of
a very large sum of money for an image. The photograph of the
painting printed in the newspaper will be seen by many more
people than will see the painting, an image which will also be
reproduced in books and on postcards (all this contributing to
what Malraux liked to call the 'museum without walls'). Every-
thing here is *said* as if a privileged 'real' – de Chirico's painting
– stood behind these myriad representations, verbal and visual,
to give them their ultimate meaning and truth; but this manner
of speaking only barely conceals the fact that, in the systems of
exchange in which the painting is a token, the painting is no
more the 'real', and no more the final resting place of meaning,
than is the interview, the photograph, the front-page news, the
postcard in the museum shop, the million-pound cheque. They
are all part of, 'this pandemonium of Capital . . . the intense

chaos of signs blinking within and without us, overwhelming our senses and critical faculties, . . . signs as empty as they are strident'.[35] The skin shed by the hand of de Chirico is now just another film in a succession/circulation without end and, now, *without beginning* – 'a real without origin or reality' (Baudrillard). The only principle of coherence ordering this otherwise vacuous milling of meanings is psycho-economic: the interdependent logics of fetishism and exchange, whose dual fascinations will, on the one hand, bring in the same crowds to see this image of a million pounds as gather around the Gioconda and the 'Treasures of Tutankhamun', and on the other, are singularly consistent with this *particular* image, which anxiously offers the consolation of a multiplicity of 'bananas' to this 'female' form's amputated melancholy.

The intermediary of money guarantees the abolition of difference and the creation of equivalence, much as, in horror films, Dracula's kiss converts the contradictory social heterogeneity of the living into the single-minded unity of the undead. Dracula's victims lose their identity, along with their blood, in exchange for parity with their victimiser, an analogous transfusion of contents and status is performed at the art auction: the painting is drained of its symbolic value, which passes to its purchaser in the form of prestige, in exchange for investment value. Part of the symbolic value of the painting, of course, inheres in the (magical) belief that its essential substance is congealed 'creativity' – this too (by the same magic of communion) becomes the *property* of the purchaser. Hence the catalogue to an exhibition at the Museum of Contemporary Art, Los Angeles, 1983: *The First Show: Painting and Sculpture from Eight Collections 1940–1980*. In place of the customary names of artists, the cover carries only the names of the collectors; the greater part of the catalogue is devoted to interviews with them; the essays in the catalogue are about the collectors and their place in the history of the art of collecting. In short, the discursive forms of dominant, 'common sense', art criticism are transferred, unmodified, from 'art and artists' to 'collections and collectors'. For example: 'Rowan's is a cultivated, sensuous taste that first found expression in his renowned collection of colour-field paintings'; or, again, 'The collection of Count and Countess Giuseppe Panza

di Biumo is a brilliant creative endeavour unlike any we have seen in this century. Guided by his own innate and dramatic grasp of the beauties of architectural space', and so on. I read all this in Los Angeles, but am now writing in London and am aware of an opinion here which would attach no more significance to this show than that of a mere quirk of the Californian Grotesque, the product of a singularly unmixed economy which dictates that Museum and University must flatter private wealth or perish; in Europe, the state cocoons those it charges with the preservation of eternal verities and values from such undignified soliciting. This, of course, is untrue – here in Thatcher's Britain it becomes patently less true by the minute – but this is not the point. Suppose it were true that the Museum were really a seat of 'independent' and 'disinterested' aesthetic judgement – the sort of judgement invoked to legitimate the exchange of a million for the de Chirico. It is worth quoting Baudrillard here at length:

> One might believe that, by removing the works from this private parallel market to 'nationalise' them, the museum returns them to a sort of collective ownership and so to their 'authentic' aesthetic function. In fact, the museum acts as a *guarantee* for the aristocratic exchange. It is a double guarantee:
> – just as a gold bank, the public backing of the Bank of France, is necessary in order that the circulation of capital and private speculation be organised, so the fixed reserve of the museum is necessary for the functioning of the sign exchange of paintings. Museums play the role of banks in the political economy of paintings:
> – not content to act as an organic guarantee of speculation in art, the museum acts as an agency guaranteeing the universality of painting.[36]

Baudrillard adds, 'Objects other than painting, of course, could be analysed in the same terms: for example knowledge'.

And so it is that the institutionally dominant form of art history in the modern period has been a history of, and for, the salesroom; its efforts have been primarily directed towards perfecting the determination of attribution and provenance, a self-imposed

restriction of vision which can have no other explanation than
the need of a financially hyperinflated art market – essentially
arbitrary, and therefore inherently unstable – for the spuriously
stabilising 'objectivity' that only art historical 'science' could
bring to it.

It is thus that art history, criticism, the market, and the
museum, mutually circulate their meanings: a fashionably
nostalgic de Chirico revival amongst young painters in Italy,
selected for capitalisation and promotion by art dealers, results
in the upward valuation of works by de Chirico, a major exhi-
bition of his work, and the million-pound price tag, which in
turn underwrites the spiraling prices of his young 'followers'. All
meanings here contribute to, and are swallowed up in, the roar
of *fashion*; the heady alternation/alteration which converts
'different' into 'same'; a dizzy whirl whose very velocity, like a
gyrating toy, guarantees its stability; a vortex of effects which
sucks a vacuum into its own core, such that it no longer makes
sense to posit the market – the economy – as 'origin'. The
'centre', prime cause (like power itself, in Foucault's descrip-
tion), is now everywhere and nowhere. In contemporary capi-
talism, in the society of the simulacrum, the market is 'behind'
nothing, it is *in* everything. It is thus that in a society where the
commodification of art has progressed apace with the aestheticis-
ation of the commodity, there has evolved a universal rhetoric
of the aesthetic in which commerce and inspiration, profit and
poetry, may rapturously entwine. Compare, for instance, the
following two passages (they are by no means exceptional, they
are typical), the first is from *Vogue* magazine:

As the sun descends the butterfly bright colours which flourish
at high noon give way to the moth shades. The tones are
pale, delicate. These are the classic Mayfair colours. White,
naturally, takes pride of place, but evening white lightly
touched with silver or sometimes gold. Mayfair colours are
almond, pink and green, dove greys and blue with the
occasional appearance of what can only be described as peach.
Jewellery is kept to a minimum, just simple pearls and
diamonds. Not necessarily real, it is the non-colour that is
important. The look is essentially luxurious, very much for the

pampered lady dressed for a romantic evening with every element pale and perfect.

The following is from an art review column of *The Guardian* newspaper:

> In his new show a whole new range of cheeky pinks, violets, silvery greens are put through their paces alongside the more familiar Alan Green colours, a red that hovers on the edge of becoming maroon and that silent deep-sea blue, 'the night made visible'.
>
> In previous exhibitions the colour has completely covered the canvas but here the artist is seen experimenting with various framing mechanisms that not only anchor the main colour on the wall but also set up a whole new series of internal relationships.
>
> A grey is surrounded by a violet, and although there is much more of the grey it is the violet that seems to have infiltrated the spirit of the picture. Red-Pink is almost square. The inside is reasonably sedate, a deep poppy crimson. But the frame is an outrageous pink which seems determined to upset the red's decorum. It fails but only just.

As the art world sways increasingly to the rhythm of fashion (the most conspicuously *visible* flutter of the pulse of capitalism) so the discourses of fashion and art journalism have flowed into an easy confluence such that they are now often indistinguishable in 'tone'. Frederick Jameson has spoken of a process of the commodification of the narrative in which,

> the best-seller has tended to produce a quasi-material feeling tone which floats above the narrative but is only intermittently realised by it: the sense of destiny in family novels, for instance, or the 'epic' rhythms of the earth or the great movements of 'history' in the various sagas.

Such 'feeling tones', says Jameson,

> can be seen as so many commodities towards whose consump-

tion the narratives are little more than means, their essential materiality then being confirmed and embodied in the movie music that accompanies their screen versions.[37]

In *Système de la Mode*, Barthes identified, in fashion writing, a 'written garment', (*vêtement écrit*) radically distanced from the description of actual clothing in that it has no other purpose than to be consumed at the level of *myth*; similarly, the genre of art criticism exemplified above manufactures a mythified 'written painting' – reproducing its absent 'original' (we are back with the simulacrum) as a 'feeling tone'; this, also, has its material, musical, counterpart in those television art programmes in which creators are seen frowning through dense layers of Bach as they fiercely scumble paint onto canvas, the morning's art review perhaps mumbling through their minds and made material in their hands, the word made paint.

The crisis of legitimation

I have already quoted Habermas on the fragmenting of discourses in the eighteenth century which led to our present separation of 'art' and 'politics' as discrete domains of experience. Habermas is not a cultural postmodernist, he believes that the Enlightenment project may be realised, albeit in a corrected form, and he, moreover, sees the new communication technologies as unprecedented means to attaining a harmoniously integrated society, one in which the previous separation of realms of expertise, and the separation of 'experts' from 'public', will be dissolved. Lyotard, a political and cultural post-modernist, is highly critical of this scenario, in which he sees all the provenly dangerous French Enlightenment and German Idealist fantasies of a managed totality – dangerous in that the utopian dream of an 'organic society' has proved to take historical form only as a totalitarian nightmare of 'consensus' under force. On questions of *aesthetics*, Habermas and Lyotard are both modernists – albeit again they differ in their view of the role of modernist art. Habermas's view of the role of modernist art is best summarised in a tale related by Peter Weiss, which Habermas retells with

approval.[38] The story concerns a group of 'politically motivated, knowledge-hungry workers in 1937 Berlin', young people who, 'through an evening high-school education acquired the intellectual means to fathom the general and social history of European art'. From, 'the resilient edifice of this objective mind, embodied in the works of art', they gathered, 'chips of stone' [*sic*], which they then 'reassembled in the context of their own milieu'. In 1937 such deference to established culture had already been 'overtaken on the left' by such movements as *Proletkult* and *Arbeiterfotografie*; today, Habermas would sound simply irrelevantly schoolmasterish to young left workers more inclined to play rock than gather it.

As I have already remarked, the programme of 'high modernism' in Art – as, for example, set out in Clement Greenberg's criticism – is a culmination of the Enlightenment project of organising knowledge into independent areas of self-reflexive expertise (Greenberg makes his own debt to the Enlightenment specific: 'I conceive of Kant as the first real modernist'). As I have put it previously,[39] Greenberg defined modernism as, 'the historical tendency of an art practice towards complete self-referential autonomy, to be achieved by scrupulous attention to all that is *specific* to that practice: its own traditions and materials, its own *difference* from other art practices', to which we should add that he further viewed modernist art as the vessel, and the bastion, of 'superior culture'. Lyotard, like Greenberg, is a Kantian in his interpretation of the role of modernist art; it is our means to an intuition of the *sublime*, which for Lyotard means 'the unrepresentable' – 'that which does not allow itself to be made present'. I have already given responses to such an aesthetics of the ineffable, both from a sociopolitical and a psycho-analytical point of view.[40] I shall not repeat my remarks here except to add that Lyotard's modernism is further compromised from a historical point of view in its nostalgia for an impossible vanguardism, long overtaken by events. Lyotard's position is, as Jameson observes, 'the celebration of modernism as its first ideologues projected it – a constant and ever more dynamic revolution in the languages, forms, and tastes of art', yet which are today simply, 'assimilated to the commercial revolutions in fashion and commodity styling we have since come to

grasp as an immanent rhythm of capitalism itself'.[41] We may in fact make more progress in formulating a post-modern problematic for art through attention, not to what Lyotard says about 'art', as such, but rather to what he says about (scientific) *knowledge* (a reasonable shift of attention as, as already remarked, art since the Enlightenment has been conceived of as embodying a *type* of knowledge).

In *The Postmodern Condition* Lyotard identifies two major 'narratives of the legitimation of knowledge' which once justified scientific research. In one, the narrative of *emancipation*, the extension of a universal scientific suffrage to all members of society (through, primarily, early schooling in science) is to lead to a society freed from need or injustice, as a result of the duality of rationality of demands and the (scientifically secured) satisfaction of such demands at all points within the social formation. In the narrative of emancipation, the subject of science is *the people*. Thus, if I am an individual researcher, I may justify my experiments by recourse to a narrative in which my work is *on behalf of* the people (no matter that the research is commissioned by the state, the state is the representative of the will of the people).

In the second major narrative of legitimation, the subject of science is not the people, but *philosophy*. Here, knowledge is sought *for its own sake*; philosophy is, in effect, sceptical that the desire of the people is necessarily benign. Science 'for its own sake' (conducted nevertheless in accordance with a sovereign ethic) will achieve, by purely 'internal' speculative means, that unity of knowledge of nature which can only benefit humanity in general. Thus, in terms of this narrative, my work as an individual researcher is to contribute a further 'piece' to knowledge conceived of as a sort of jigsaw puzzle which may be surveyed from the superior vantage point of the *university* as a potential totality in process towards completion.

A *crisis of legitimation* in science occurred with the dissolution of the positivist dream of a unified totality of knowledge built on *observation*, with the recognition that, in the words of Heisenberg, 'Natural science does not simply explain and describe nature, . . . it describes nature as exposed to our method of questioning'.[42] There is thus no longer any singular 'reality' to

provide the common ground upon which all scientifically rational demands of the people, or all instances of 'pure research' *en route* to a 'unified knowledge', can stand. Both major narratives of legitimation therefore enter a terminal crisis. Lyotard's response to this crisis of legitimation is through linguistics, particularly through an assimilation of the scientific theory to Austin's notion of the 'performative' utterance. The performative is an enunciation – for example, 'keep off the grass', or 'I thee wed' – which has *in itself* no descriptive function (albeit it may be, in Austin's expression 'void for lack of reference' – for example a 'keep off the grass' sign where there is no grass). The performative is rather an incitement, inducement, or commitment, to an *action* (or, as in such utterances as, 'I thee wed', its meaning is in the very *act* of its utterance). Thus, as Jameson puts it, the justification of scientific work now becomes, 'not to produce an adequate model or replication of some outside reality, but rather simply to produce *more* work, . . . to make you have "new ideas"'. In the absence of the 'master narratives of legitimation', scientific research is now characterised as, 'so many smaller narratives or stories to be worked out . . . small narrative units at work everywhere *locally* in the present social system'.[43] (We may note the formal similarity of this post-modern picture of scientific activity to the post-modern pattern of political activity).

If we return now to the question of the legitimation of art, we can see narratives of legitimation at work which are broadly analogous to those which once were operative in science: 'art for the people', and, 'art for art's sake'. Jameson suggests an analogous 'crisis of legitimation' of art in the nineteenth-century 'crisis of representation' which led from realism to modernism. I find this unsatisfactory, unlike science, art (here, painting) did not lose its confidence in the existence of a singular reality, merely its confidence in its ability to represent that reality with the speed and comprehensiveness of the new photographic technologies – hence the painter Paul Delaroche's celebrated exclamation at the first exhibition of the Daguerrotype, 'From today, painting is dead'. The subsequent work of, for example, Cézanne and the Cubists, was justified by such critics as Bell and Fry precisely in that, they asserted, such paintings offered access to

a more singularly essential, 'noumenal', *superior*, reality. In the first half of this century, the two master narratives of legitimation survived to serve, respectively, in the West, high modernism, and in the East, Socialist Realism. Western Modernism in the visual arts went into crisis with the dawning realisation, in the 1960s, that its formal experiments were exhausted and that its political utopianism had become vacuous. The 'campus revolts', and other political events of the 1960s, assisted in precipitating the terminal crisis of 'art for art's sake'; for a short time into the 1970s the alternative master narrative of 'art for the people' enjoyed a vogue amongst those who had helped get rid of modernism, but it was undermined in history and in theory (I shall return to this later), and it collapsed.

With the 'delegitimation' of the master narratives of *Art*, art also is now in the position of operating with 'local' narratives – narratives which can no longer be assumed as always-already in place, but which must be continually *in process* of writing and revision. It is no accident therefore that we have, since the end of the 1960s, seen an increasing number of 'artist-theoreticians', a development which is neither historically unprecedented nor institutionally inconsistent. To summarise what I have already said at some length: art in general, in the modern sense, begins in the mid sixteenth century with the recognition of painting as a *theoretical*, as well as a utilitarian, practice – a recognition consolidated in the ensuing programme of *ut pictura poesis*; the eighteenth century sees the foundation of a modernist 'specificity', a 'purely visual' art relieved of a narrative function (Lessing), but in the name of a superior theoretical knowledge (Kant), and under the guarantee of the 'grand legitimating narrative' of the Enlightenment (henceforward, painting is destined no longer to contain narratives, but only at the cost of becoming contained *by* a narrative of a 'higher' order). The eighteenth century also sees the provision of the necessary 'external' material conditions and discursive institutions for the support of the putative 'autonomy' of the aesthetic: the institution of 'aesthetics' and 'art history' as independent disciplines; the growth of the Academy, notably differing from the former artisans' guilds in that it inducts its candidates into philosophical, as well as technical, discourses; the expansion of the institution of

the public exhibition (exemplified by the *Salon*), the growth of periodical literature, and the emergence of 'critics' as an independent professional class. It is this legacy of the Enlightenment which we have inherited in the form of our present art institutional complex, a variety of sites – studios, galleries, magazines, academic journals, art schools, university art departments, museums, and so on – which are linked by the discourses common to them, and which in turn they replenish and recirculate according to the terms of their particular practices (painting, criticism, dealing, conservation, teaching, and so on). Within this over-all discursive formation the 'discourse in dominance' is itself a legacy, a survival of past intellectualisations now sedimented into the 'common sense' of *Art*. I have identified the primary strata of this amalgam as 'realist', 'expressionist' and 'formalist' theories, bonded together through the ideological primacy of the 'symbol'. In addition to the 'discourse in dominance' there are 'discourses in dissidence'; these, already in the minority, are further reduced in their institutional effectivity in that they are commonly defined only in their opposition to the status quo (beyond this they most often appear as heterogeneous, often mutually hostile, 'left factions').

Discourse and discursive formation

It is because my purpose in this essay has been to examine art criticism and theory that my attention has been directed to the register of *discourse*. This is not to deny the determinations of the economic, the political, or any other analytically isolable realm of the social formations within which art institutions and practices are articulated. It is, however, most emphatically to deny that discourse is merely the means of 'expression' of pre-existent entities – individuals, social classes, political or artistic practices, 'history', the *zeitgeist*, 'structure', or whatever else – conceived as independently constituted *outside* of discourse. It is to stress that discourse is itself a determinate and determining form of social practice; discourse does not *express* the meanings of a pre-existent social order, it *constructs* those meanings and that order. I have noted that the recognition of the art institution

as a *discursive* institution is consistent with an influential post-modernist perspective, most notably that of Lyotard, which foregrounds the agency and efficacy of the *legitimating narratives* in the construction of *practices* within the social formation. I believe that such a recognition is of crucial strategic importance to any 'dissident' art programme. Some recent experiences, particularly in the US, have led me to believe that, in spite of the theoretical work of the 1970s, an implicit 'reflection' or 'expression' theory of discourse still prevails on the 'left' of art theory and criticism; I therefore feel I should resume a position on discourse derived from a collage of some of the work of the past decade before proceeding with the articulation of this position within a post-modernist art problematic.

I have, so far, spoken of the 'discourses' of the art institutions, and of these institutions as 'discursive formations', without giving any particular definition of the *word* 'discourse'. I should now explain more precisely what I intend in using this word rather than some other, such as 'speech', 'writing', or 'ideas'. In the first decade of the twentieth century, modern linguistics was able to emerge from nineteenth-century philology by means of the distinction Saussure made between *parole*, individual acts of speaking, and *langue*, the system of elements and combinatory rules of a language which all speakers of a language hold in common. *Langue*, the abstract underlying system of language, thus became the object of systematic study, while *parole* was left outside of such study, as a supposedly freely-willed act of personal expression. Saussure himself had observed, in passing, that not all of speech consisted of spontaneous invention; he gave the name 'fixed syntagms' to those locutions we commonly call *clichés* – 'how do you do', 'have a nice day', and so on. Writing in the 1940s Louis Hjelmslev, in developing Saussure's linguistics, found it necessary to interpose a third category, 'usage', between *langue* (the abstract system) and *parole* (an individual's use of that system): 'usage' was to be described through analyses of the actual linguistic practices extant in a given society at a given time. Modern linguistics had begun with a model of language use in which a sender 'communicates' with a receiver; the task of linguistics was to describe the system internal to language itself which permits such communication.

In more recent years, Michel Pêcheux has been notable for his attempt to elaborate a linguistics capable of taking into account the fact that, first, 'sender' and 'receiver' are not the fully self-possessed subjects presupposed by Saussure, but are in fact 'split' between conscious and unconscious, as described in psychoanalysis; and secondly, that language is most intimately bound up with 'context' in general and social institutions in particular. Here, 'one must leave behind the notion of *langue*, to which each speaker bears a similar relation, and consider discursive formations, specific areas of communicability that set in place both sender and receiver and which determine the appropriateness of messages'.[44] This is to say that, whereas structural linguistics, guided by Saussure's notion of *langue*, seeks to identify universal principles of linguistic production at a high level of generalisation and abstraction, discourse analysis operates at a very different level of considerations, being concerned with particular formations of language-in-*use* which emerge in a society, at a particular historical conjuncture, on the *basis* of *langue*. Discourse analysis is therefore a tool of institutional, ideological, investigation, in a way that theoretical linguistics cannot be. In the words of Pêcheux and his collaborator Catherine Fuchs, discourse analysis is, 'the theory of the historical determination of semantic processes'.

No doubt in part because of the technical difficulties of its formal linguistic framework, the work of Pêcheux is less well known than that of Michel Foucault. Foucault's work is in no way simply assimilable to that of Pêcheux, but nevertheless there is much that is similar in the over-all intent of the two projects. Just as, in Pêcheux's work, the expression 'discursive formation' takes over from *langue*, so, in Foucault, it takes over from 'thought' or 'ideas'. Foucault is basically concerned with the question, 'where do ideas come from?'. Histories of ideas, under the sway of Renaissance humanism and its Enlightenment development, have been written as histories of progress and continuity. Foucault describes the cost of such spurious continuities; for Foucault, the history of ideas is one of profound discontinuities in which 'ideas' never form or function in isolation from institutions and relations of *power*. Discourses in power establish their own continuity and legitimacy of lineage only by the

(violent if need be) suppression of those discourses which oppose them. By 'discourse' here is meant a series of utterances, Foucault calls them 'statements', produced under definite social and historical conditions: the science of physics; 'concerned' social documentary photography; interior design magazines; psychiatry; art criticism – the list is potentially endless. The questions Foucault would bring are: 'why have these discourses been produced and not others?'; 'what are the necessary conditions of their existence?'; 'how are they pre-constructed as the survival of previous discourses?'; and so on. Towards the close of the *Archeology of Knowledge*, Foucault envisages the possibility of an 'archeology' of painting which would try to recapture the 'murmur' of the painter's intentions, the implicit philosophy which informed the painter's view of the world; an 'archeology' which would trace the extent to which the opinions, scientific knowledge, ethical systems, and so on, of the period in which the painter lived, appear in the painter's work, transcribed now, not in the form of words, but as images. This 'archeology' would attempt to reconstitute the latent discourse of the painter:

It would not set out to show that the painting is a certain way of 'meaning' or 'saying' that is peculiar in that it dispenses with words. It would try to show that, at least in one of its dimensions, it is discursive practice which is embodied in techniques and effects.[45]

Elsewhere in *The Archeology of Knowledge* Foucault writes: 'The archeological description of discourses seeks to discover the whole domain of institutions, economic processes and social relations on which a discursive formulation can be articulated'.[45] As formal discourse analysis soon discovered, any single institution is itself the site of a plurality of discourses which, moreover, are often mutually contradictory; it is thus that, as Colin MacCabe writes:

The substitution of the notion of discursive formation for discourse emphasises that there can be no simple one to one homology between institution and discourse – there can be no

method of counting the number of discourses or ideologies within a given social formation. The analysis will always depend on the political and ideological struggles imbricated with the different discursive formations.[47]

In the interests of brevity, and in order to proceed with my specific project here, I made a provisional distinction between 'discourses in dominance' and 'discourses in dissidence'; in so doing I posited a unified dominant 'common-sense' of *Art*, opposed by disunited 'dissident' factions. It may be objected that art history, theory, and criticism *in general* proceed by mutual contestation, if not denunciation and recrimination. The overwhelming majority of such litigations before history however are fought *on behalf of the same ideological beneficiary* – as Bourdieu has remarked, 'nothing better conceals the objective collusion which is the matrix of specifically artistic value than the conflicts through which it operates'.[48] For example, critical argument over whether this or that work is a masterpiece or not, can only benefit the status quo if it fails to problematise the categories 'work' and 'masterpiece'.

Let us suppose, however, that we are able (as most of us believe we are) to distinguish between discourses which are not simply different shoots from the same theoretical root, but are mutually opposed 'root and branch'. On what basis do we judge in favour of one or the other? Apart from the 'grand narratives', it is most usual to find that the appeal of both parties to the dispute is to such things as 'experience' or 'reality' – factors external to the discourse, which each sees as supporting its own position. In such a case we have encountered a common root in the 'argument from epistemology', and it is at this point that we must stress the obvious fact that 'theory' is itself a form of discourse.

In the introduction to *Mode of Production and Social Formation*, Hindess and Hirst write:

Throughout this text we refer to theory as theoretical *discourse*. Why do we use this term? Theoretical discourse we shall define as the construction of problems for analysis and solutions to them by means of concepts. Concepts are

deployed in ordered successions to produce these effects. This order is the order created *by the practice of theoretical work itself*: it is guaranteed by no necessary 'logic' or 'dialectic' nor by any necessary mechanism of correspondence with the real itself. Theoretical work procedes by constant problematis-ations and reconstructions. Theories can only exist as *discourses* – as concepts in definite orders of succession producing definite effects (posing, criticising, solving prob-lems) – as a result of that order. Classically, in epistemologies, theories have an appropriate form of order in which their relation to the real is revealed. They appropriate, correspond to or are falsified by the real. The limits of nature set their limits. Theory ultimately represents and is limited by the order of the real itself. In empiricist epistemologies, for example, theories take the form of categories translatable into definite observation statements. Our conception of discourse cannot be so limited. This is not to deny 'reality' exists, is ordered, or to assert that it is infinite and unknowable – all of these are sceptical or critical positions within epistemological discourse. We reject the category of reality-in-general as epistemological; it is the couple of knowledge-in-general . . . The reason why discourse is interminable is because the forms of closure of discourse promised in epistemological criteria of validity do not work. They are silent before the continued discourse of theories which they can never correspond to or appropriate.[49]

We may note that Hindess and Hirst's view of the status of theory is perfectly compatible with that of Lyotard, and is a response to the same observation of the crisis of legitimation in science. A consequence of the rejection of epistemology is that we replace the question, 'is this discourse true?', with the ques-tion 'what is the truth effect of this discourse?' This is more than a semantic quiddity; as Hindess and Hirst continue:

If independently existing real objects are thought to exist in the form of actual or potential objects of discourses, then any theoretical discourse may be measured against what is thought to be known of those objects. For example, . . . 'bourgeois'

historians and social scientists have been criticised for their failure to recognise objects specified in Marxist discourse.

Here, however,

> far from constituting a theoretical critique of the concepts and arguments of the discourse in question, this mode of analysis merely measures the substantive distance between the objects specified in one discourse and those specified in another.[50]

Thus, for example, 'sexism' is not some *thing* which had independent existence prior to its 'discovery' by women; 'sexism' is a *discursive construct* of feminist discourse, a construct whose specifiable *effects* are aimed at changing the structure of real social relations within the various practices – social, political, economic, and so on – with which the discourse is imbricated. The knowledges created and mobilised by the term are thus *strategic*, not ontological, and cannot be specified in advance of particular material contexts and conjunctures. For example, as Elizabeth Cowie writes:

> An image of a woman and child can be attacked for reproducing notions of femininity wholly defined by motherhood . . . the 'natural' career of children. On the other hand it can be argued that the same image instead presents a positive image of women – affirming their roles as mothers in a society which treats as second citizens those who are involved in the care of children.[51]

Outsiderism and subversion

I have already observed, in talking about the common sense of *Art*, that we are still extensively in the thrall of a Romantic discursive formation. In a long essay on Romanticism, Sayre and Löwy have stressed that, *'far from being a purely nineteenth-century phenomenon, Romanticism is an essential component of modern culture'*;[52] they are at pains to emphasise the complexity of the Romantic movement, but they nevertheless identify a

'unifying element' in, *'opposition to capitalism in the name of pre-capitalist values'*.[53] If we take them at their word here in their identification of Romanticism with the *modern*, as I believe we must, then we may see the current confusions in art around the idea of the *post*modern as the perturbations attending a historical passage *out of Romanticism* (nothing more contradictory than Romantic postmodernism); we may then, further, define a postmodernist left aesthetics as 'opposition to capitalism in the name of . . .' *not*, presumably, pre-capitalist values (as these are known to us only in the form of a Romantic fiction), but then what? This, precisely, is what is currently *in question*; we may, however, make some progress towards a solution by means of a preliminary 'ground-clearing' in which we set aside those left art positions which seem most imbued with the survivals of Romanticism. For my purposes here, I wish simply to consider the second term in the expression 'discursive institution'. Specifically, I want to look at the traces of two Romantic preconceptions – the autonomously expressive individual (culmination of humanism), and 'the people' (projection of the dream of a pre-capitalist 'organic society') – as they have coagulated in the form of subject positions for work 'inside the art institution but independent of it', 'inside the institution but working to subvert it', and 'outside the institution'.

The arguments which make up the various 'anti-humanist' left critiques of the Romantic liberal humanist idea of the 'autonomous' artist are widely available and need no further rehearsal here (I am thinking primarily of the arguments from Marxian socioeconomics, and from Freudian/Lacanian psycho-analysis). I shall therefore pass over this particular Romantic formation, picking it up only at a convenient point of transition to the second position on/in the institution mentioned above: I have heard many artists say, 'My only relation is with my work'; by which I assume they mean this is the only thing *they* value. This may be, but it is beside the point in the context of any consideration of the *historical* entity *'Art'*. Regardless of the personal feeling of the artist, it just happens to be a fact that the art which gets *seen* (in galleries or museums, in magazines or books), the art which becomes counted *as* 'Art', has been subjected to processes of selection and legitimation which are beyond the

control of the artist (albeit some artists are infinitely more attuned to these processes, and skillful at negotiating them, than others). Thus Pierre Bourdieu writes:

> who is the true producer of the value of the work – the painter or the dealer, the writer or the publisher, the playwright or the theatre manager? The ideology of creation, which makes the author the first and last source of the value of his work, conceals the fact that the cultural businessman (art dealer, publisher, etc.) is at one and the same time the person who exploits the labour of the 'creator' by trading in the 'sacred' and the person who, by putting it on the market, by exhibiting, publishing, or staging it, *consecrates* a product which he has 'discovered' and which would otherwise remain a mere natural resource. *The art trader is not just the agent who gives the work a commercial value by bringing it into the market.*[54] (my emphasis)

Bourdieu consequently makes a necessary distinction between 'cultural value' and 'economic value'.

Many artists have expressed hostility to the 'commodification' of their work by making work intended to attack the very system it ostensibly feeds (like the cartoon cat who substitutes a stick of dynamite for the sausage on the bulldog's plate). Bourdieu speaks of such work, mentioning for example Manzoni's tins of 'artist's shit', and comments:

> Paradoxically, nothing more clearly reveals the logic of the functioning of the artistic field than the fate of these apparently radical attempts at subversion. Because they expose the art of artistic creation to a mockery already annexed to the artistic tradition by Duchamp, they are immediately converted into artistic 'acts', recorded as such and thus consecrated and celebrated by the makers of taste. *Art cannot reveal the truth about art without snatching it away again by turning the revelation into an artistic event.*[55] (my emphasis)

The 'paradox' here identified by Bourdieu is given an extra, ironic, twist when those doing the 'consecration and celebration'

are themselves 'radical' art critics; such critics are apt to praise work which 'resists commodification', but in so doing they are anachronistically locked into the logic of a cash, rather than a credit, economy – according to the inexorable logic of *contemporary* capitalism, the cultural value critics accord to such work *will* be transmuted into economic value (no matter that the work 'does not sell' – at the very least, lecture fees and airplane tickets will be generated, and if enough critical writing is produced to make the work 'historically important', a National Endowment for the Arts grant may be forthcoming, or even a museum acquisition); in short, only work which remains *invisible* may remain untouched by money. (The pious show of repudiation of money *as such*, rather than of the inequitable distribution of the wealth it represents, is surely the least convincing guise in which moralism masquerades as morality.) Again, on those rare occasions when the 'subversive' work actually provokes a public scandal, and/or a legal action, the institution under 'attack' only benefits – for the art world thrives on scandal, and the market needs occasionally to convince its bourgeois clients that art is *dangerous*, therefore *exciting*. Such processes contribute to what Bourdieu calls the *accumulation of symbolic capital*: '"Symbolic capital" is to be understood as economic or political capital that is disavowed, mis-recognised and thereby recognised, hence legitimate, a "credit" which, under certain conditions, and always in the long run, guarantees "economic" profits'.[56]

Apart from the recently popular left critical position which tolerates the art object and the gallery only on condition that the former be seen to attempt to do away with the latter, there are other available 'left positions'. The extreme left position on the object and the gallery is summarily to pronounce both as dissolved. Various articulations of this position have been inherited from the aesthetic debates in the Soviet Union in the immediate post-revolutionary period: a situation is sought in which visual art will, in the street and in the workplace, give expression to 'the people' – either directly (the Soviet *Proletkult* position), or through the intermediary of trained artists (the *Lef* 'art at the social command' position). Contemporary exemplifications of these scenarios might be: in the former instance, the spray-can graffiti on New York subway trains; in the latter, the

incorporation of artists into Trade Union work as designers of publicity material, and/or the exhibition of artworks in factory canteens, union halls, and so on. The first, obvious, thing we should note about such a general programme for art in contemporary Western society is that this society is neither post-revolutionary nor pre-revolutionary. In the case of subway-car art, a very small group of young Spanish-Americans were selected for promotion in the gallery-system (thus instantly excluding the rest as 'inferior artists', 'failures') while an advertising programme was simultaneously mounted *inside* the subway-cars in which prominent black athletes, civic leaders, and other 'personalities', condemned the 'defacing' of public property. The publishing industry in general (and Norman Mailer in particular) made profits from selling photographs of the 'subway-art'; a number of, mainly white, artists – who had nothing whatsoever to do with the original, popular, 'movement' – launched careers with a fashionable, *faux-naïf*, 'graffiti-art'. Finally, we might note that the content of the original, 'authentic', popular art was the *signature*, as it were, 'in lights' – a poignantly understandable response to the grinding anonymity of institutionalised poverty, but in no way indicative of the existence of a spontaneous popular ideology *exterior* to the ethos of such culture-industry products as the TV show *Fame*. As for union work, most of the artists I know who have been involved in union work *as* artists have complained that their work has been subjected to (conservative) political and aesthetic censorship, and/or that shop-floor workers were simply indifferent to the 'art' shown to them – even where it directly represented 'real struggles' in which they themselves might become involved (for example, industrial injuries compensation cases).

I would emphatically stress that I do not intend my negative remarks to dismiss *in principle* any such initiatives as discussed above – the viability of such initiatives can only be determined *in context*. I merely wish to point out that there is little empirical support for the ultra-leftist critical position which advocates 'working outside the (art) institution' as, *a priori* the privileged, indeed the *only*, politically progressive strategy. Such a critical position must be set aside as 'voluntarism' (defined by Lenin as a political strategy based on an idealised picture of the material

conditions of struggle, rather than on an analysis of those
conditions) for, quite simply, there *is* no 'outside' to institutions
in contemporary Western society; they fit together like the pieces
of a jigsaw puzzle – to leave one institutional site is simply to
enter another, which will have its *own* specific conditions and
determinations. The artist who works for a trade union *as* an
'artist' has not moved into any 'outside' (Romantic 'outsider*ism*'
is at the core of this voluntarism), he or she has simply exchanged
the problematic of one institution for that of another; in so doing
he or she risks abandoning a struggle to which they could bring
some experience and expertise, for one to which they are
novices. Moreover, more fundamentally, they remain firmly
inside the dominant *discourses*. The major weakness of the 'art
outside the institution' position is the completely empiricist and
untheorised concept of 'institution' with which it operates: at its
most reductive, 'institution' is equated with 'real estate' and
'market' – take the work out of the gallery and onto the street,
refuse to sell it as a commodity, and the prison of 'institutions'
is magically escaped. A number of sociological descriptions of
the art institution are available and I shall not attempt to
summarise them here, except to remark again that, even
described empirically, the 'art institution' is a complex hetero-
geneity – art magazines, the art market, university departments,
museums and so on – which offers no *singularity* which may be
confronted from an unproblematical 'outside'. More theoreti-
cally, as I have already stressed, it is essential that we recognise
the art institution as a *discursive institution*. The left in particular
must recognise that in addition to such questions as, 'How can
artists directly assist ongoing workers' struggles?', there is
another question to be asked: 'What is the nature of political
struggle specific to the art institution itself?'. The left must
further recognise that more is involved in answering *this* question
than the ultimately merely *gestural* response of 'subversion'. As
Gramsci urged, the task of the left is less to reflect on the existing
culture than it is to respond to the 'possibility and necessity of
creating a new culture'. Rather than play Samson between the
pillars of the museum, – which is, anyhow, futile – we should
recognise that the museum is no more 'irretrievably bourgeois'
than is, for example, the movie theatre, or the class-room – all

such spaces are sites of perpetual contestation over 'what goes on' in them, what gets shown, what gets discussed, what issues get raised and taken out of the museum into the surrounding social institutions: in short, what *truths* are (re)generated as prisms of perception and frameworks of action.

The outside as supplement

The voluntarist attitudes of 'individualism' and 'outsiderism' rest on a common assumed *binarism* in which an 'inside' (of the subject, of the institution) is simply opposed to an 'outside'. It is precisely such ordering principles which post-structuralist theories in general have tended to subvert. Such a tendency is, however, most *closely* associated with the work of Jacques Derrida. In his critique of 'logocentrism', Derrida 'deconstructs' the supposed opposition between speech and writing in which the latter is considered a dependent and inessential addition to the former. In his discussion of this purported hierarchy, a legacy of classical antiquity, Derrida examines the work of Rousseau, who writes: 'Languages are made to be spoken, writing serves only as a supplement to speech'. The hierarchy assumed here is more than simply a logical one, it is ethically charged: speech, if in good faith, may be trusted; but writing can never be free of the doubt that the text may have been misinterpreted, or wrongly ascribed. Rousseau therefore speaks of *ce dangereux supplément*,[57] in the course of what Derrida calls a 'logic of the supplement' running throughout Rousseau's writing. Thus, for example, just as Rousseau condemns writing for 'usurping' and 'corrupting' speech, he similarly condemns masturbation – that which, 'cheats Nature' – for usurping and corrupting 'normal' sexuality. These abnormal and unnatural 'supplements' however, Derrida argues, prove on examination to contain all that most essentially defines that to which they are presumed to be opposed: the meanings attendant upon a speech act are generated by essentially the same underlying systems of *differences* as generate the meanings of written texts, and in neither case is there any possible final closure of meaning upon a point of certainty, such closure is rather endlessly *deferred*; again, the

very fact that masturbation may serve *in place of* interpersonal sexual activity should alert us to the likelihood that it is not after all 'external' to 'natural' sexuality; and in fact the overwhelming predominance of the *imaginary* object, and the radical impossibility of possessing it (the perpetual incapacity of 'satisfaction' to exhaust desire), is common to both. Derridean 'deconstruction' therefore attacks the coherence of discourses and institutions at the level of the very 'logics of exclusion' through which they define and establish themselves. As the juxtaposition of the previous examples – language and sexuality – may suggest, a deconstructionist reading of psycho-analysis will be one which sees, in Freud's work, deconstruction *avant la lettre*. As Jonathan Culler puts it:

> Freud begins with a series of hierarchical oppositions: normal/ pathological, sanity/insanity, real/imaginary, experience/ dream, conscious/unconscious, life/death. In each case the first term has been conceived as prior, a plenitude of which the second is a negation or complication. Situated on the margin of the first term, the second term designates an undesirable, dispensable deviation. Freud's investigations deconstruct these oppositions by identifying what is at stake in our desire to repress the second term and showing that in fact each first term can be seen as a special case of the fundamentals designated by the second term, which in this process is transformed. Understanding of the marginal or deviant term becomes a condition of understanding the supposedly prior term. The most general operations of the psyche are discovered, for example, through investigations of pathological cases. *The logic of dreams and fantasies proves central to an account of the forces at work in all our experience . . .* These deconstructive reversals, which give pride of place to what had been thought marginal, are responsible for much of the revolutionary impact of Freudian theory.[58] (my emphasis)

I have taken the example of Freud here, as work anticipating deconstruction (Marx could also serve in this capacity)[59] because very many critics and artists who are in one way or another 'on the Left' are hostile to psycho-analysis and are therefore

theoretically disadvantaged by a further 'inside/outside' dualism, that of a Cartesian world order. Gilbert Ryle describes this world (the world of common sense) in *The Concept of Mind*, in it:

> A person . . . lives through two collateral histories, one consisting of what happens in and to his body, the other consisting of what happens in and to his mind. The first is public, the second private. The events in the first history are events in the physical world, those in the second are events in the mental world.[60]

For the majority of the art left, *History* is the first history; the second history, such as it is, is (somehow) the precipitate of the first. (This view is 'materialism' any other is 'idealism' – the first judgemental stop on a terminological slippery slope which runs precipitiously via 'subjectivism' onto the rocks of 'bourgeois individualism'.) As Ryle observes, in the terms of what he calls the 'official theory', 'the transactions between the episodes of the private history and the public history remain mysterious, since by definition they can only belong to neither series'.[61] Consequently, there has been a tendency on the Left, since Marx, (a Left too often fatally inclined to mistake mere *positivism* for 'materialism'), to assimilate the concept of 'false consciousness' (*ideology*) to the category of, simply, *error* (an assimilation encouraged by the fact that the very little that Marx and Engels said about 'false consciousness' was never, anyhow, very clear). The result has been a tradition of Left art practice as *propaganda* – a strategy of confronting the 'public' with the *facts* (most often with a mixture of moral accusation and exhortation). But what if a correlation between 'knowledge of the facts' and 'correct' action – indeed *any* action – cannot be assumed; what if a *non*-correlation can practically be guaranteed? The Left has no answer here except a voluntaristic self-assertion which belongs to the same structure of *disavowal* ('I know very well, but nevertheless . . .') upon which the strategy of propaganda has foundered.

The word 'disavowal', here, comes from Freud, who first uses it in his discussion of (sexual) *fetishism*. Marx, in his discussion of *commodity fetishism*, finds he must similarly have recourse

to a language of animistic magic and mysticism: a table, for example,

> so soon as it steps forth as a commodity, . . . is changed into something transcendent. It not only stands with its feet on the ground, but, in relation to all other commodities, it stands on its head, and evolves out of its wooden brain grotesque ideas, far more wonderful that 'table-turning' ever was.[62]

Marx explains that in order to grasp the nature of the commodity, in which, 'a definite social relation between men, . . . assumes, in their eyes, the fantastic form of a relation between things', he must take his analogy – fetishism – from, 'the mist-enveloped regions of the religious world'. It is in its potential to dispel such mists that psycho-analytic theory is essential to Left cultural analysis, for in so doing it lays bare the shifting labyrinths of 'psychic reality' which occupy that place of 'transaction between mental and physical', which the 'official theory' assumes to be occupied merely by a (more or less clean) *window*. Althusser saw most clearly not only the vital necessity for an adequate theory of ideology, but also that this theory must draw upon psycho-analysis; he remarks that in Marx and Engels's *The German Ideology*, from which their most frequently cited remarks on ideology are derived, the formulation of ideology is positivistic: 'Ideology is conceived as a pure illusion, a pure dream . . . All its reality is external to it'; and he observes, 'Ideology is thus thought as an imaginary construction whose status is exactly like the theoretical status of the dream among writers before Freud'.[63] Psycho-analytic theory is necessary because ideology is not a matter of 'false consciousness', it is not a matter of consciousness at all, it is profoundly *unconscious*.

In an Althusserian scenario, the art institution is one amongst the 'Ideological State Apparatuses' whose function is to secure the reproduction of ideology. This function is clearly inscribed across the history of art; equally clearly, art cannot be *reduced* to this function, cannot be specified *exclusively* in terms of ideology. Speaking of the social marginality of literary humanist discourse, Terry Eagleton observes that it:

was certainly a peripheral phenomenon within late capitalism, but this, precisely, was its ordained place. Its role was to *be* marginal: to figure as that 'excess', that supplement to social reality which in Derridean style both revealed and concealed a lack, at once appending itself to an apparently replete social order and unmasking an absence at its heart where the stirrings of repressed desire could be faintly detected. *This, surely, is the true locus of 'high culture' in late monopoly capitalism: neither decorative irrelevance nor indispensable ideology, neither structural nor superfluous, but a properly marginal presence, marking the border where that society both encounters and exiles its own disabling absences.*[64] (my emphasis)

Art is not simply a *part* of ideology in general, the ideological is always, whether explicitly or implicitly, *at issue* in art – a fact most clearly displayed in the relation of art production to political authority and social reproduction (history offers a spectrum of such relations, from the unreflecting total subservience of the medieval artisan to ecclesiastical and aristocratic authority, to the highly self-conscious opposition to industrial capitalism of the Romantics).

The collision, or collusion, of the Law and Desire is to be found in all parts of the social formation, as within the subject itself. Art is perhaps today unique among representational institutions, however, in that it may now have no function *other* than to represent such encounters.

'The end of art' theory

I began my remarks on the postmodern with Jameson's observation that any such reflection entails a 'political affirmation or repudiation' of the social formations we now inhabit. It might seem that this observation itself entails a return to moral and political certainties (from where else may 'affirmation or repudiation' be derived?) which have themselves been repudiated in postmodernism. In a recent conversation about postmodernism, published in a left cultural journal, one of the participants says: 'I have found this personally very "liberating", . . . to get the

weight of moral and political certainty or necessity off my mind, but also ultimately very depressing to be left in the restless flux of rhetoric without a rudder'.[65] What needs to be said here is that moral certainty and political necessity is not, of itself, dissolved in the 'restless flux' of postmodernism's 'anything goes'. We should first remember that the 'postmodern' is a 'first-world' problematic – thus, for example, the moral certainty and political necessity that black South Africans should democratically participate in the government of their own society, will not be swept away by any amount of breathlessly fashionable gush about postmodernism; but neither, closer to home, has the tacit institutionalised racism of British society ceased to be any less certainly a moral evil. The end of 'grand narratives' does not mean the end of either morality or *memory*. For example, to speak personally, the fact that I do not see in contemporary events the portents of the imminent collapse of capitalism and the guarantee of the inevitable triumph of the proletariat does not mean that I have forgotten the experiences of my working-class childhood, it does not erase my sense of what social injustice is, and it does not change my social and political allegiances. *Of course* memory cannot be conclusively disentangled from fantasy; *of course* my strongly-*felt* moral sensibility has roots in irrationality and internalised policemen whose influence over my actions is far from completely benign; *of course* allegiances may be betrayed as easily as affirmed, and ideology and political affiliations cannot simply be 'read off' from social class. *Of course* moralities and histories are 'relative', but this does not mean they do not *exist* – at the very least as components of that 'psychic reality' which is the ground of my actions. The question for art (and) theory, as for politics (as always) is, 'how is all this – which devolves upon a "subjective" point of view – to be articulated in a way which is intersubjectively valid and productive; how is it to be (re)constructed in (re)presentation?'. It is as an answer to *this* question that the 'grand narratives' seem no longer credible.

What have expired are the absolute guarantees issued by overriding metaphysical systems. 'Certainties and necessities' are now seen as inescapably *positional*, derived from, and applied within, complex networks of mainly local and contingent conditions; it is thus that Lyotard sees the great legitimating narratives, 'good

for all time', as having given way to a proliferation of smaller narratives, 'good for the moment', or at best, 'for the forseeable future'. Nothing can be guaranteed by history (desired goals must be worked for, not waited for), nor can any action be measured against norms and criteria given in advance, they are rather *born* in the conflicts of authority and desire, (we now ask not, 'is this correct?', but rather, 'what is this trying to do?'). In all this there is no longer any 'outside' in which to work, or from which to speak. Too many of our 'progressive' critics are nevertheless failing to draw the obvious conclusion – as Jameson has put it:

> The cultural critic and moralist . . . along with all the rest of us, is now so deeply immersed in postmodernist space, so deeply suffused and infected by its new cultural categories, that the luxury of the old-fashioned ideological critique, the indignant moral denunciation of the other, becomes unavailable.[66]

This consequence of the transition to postmodern culture has been confirmed in the contemporaneous and analogous transition to post-structuralist theory. The passage to post-structuralist criticism is a movement, as Barthes put it, 'From Work to Text': from a view of criticism as an operation performed by a self-possessed subject upon a discrete and distanced object, to a view of criticism as an act of *reading*, imbricating, implicating, a divided and unstable subject in the multiple instabilities of a text which continually opens onto other texts. Barthes writes:

> it is part of the theory of the text to plunge any enuciation, including its own, into crisis. The theory of the text is directly critical of any metalanguage: revising the discourse of scientificity, it demands a mutation in science itself, since the human sciences have hitherto never called into question their own language, which they have considered as a mere instrument.[67]

Subsequent calling into question of critical languages has been conducted with a necessarily restless, if not reckless, disregard for disciplinary boundaries. Previously separated streams of

discourse have burst their banks, defamiliarising the features of academic-institutional landscapes which had seemed immutable. But a (post-modernist) *mutation* in the 'science' of criticism (theory) calls for more, it calls for a radical interrogation of the whole discursive structure of the *institution of criticism itself*.

I have spoken of the deligitimation of the 'master narratives' of art – the heroic teleologies of 'art for the people' and 'art for art's sake', with all their attendant 'parallel' and 'sub' plots (most prominently, 'the greatest story ever told', humanism's 'Ascent of Man' [*sic*]). This deligitimation has, of course, been achieved only 'in theory'. Jameson accurately observes that if the master narratives have now 'disappeared' it is because they have 'gone underground' to contribute to what he calls the 'political unconscious'. Their everyday manifestations are in every aspect of the institution, every instance of what Benjamin termed the 'apparatus'. In viewing the institution in its discursive aspect we should not confine the concept of discursivity merely to language itself. For example – to speak of the academy – the architecture of the lecture theatre, the arrangement of chairs in a class-room, are also 'statements' in a discursive formation. Foucault cites, as an example of the discursive 'statement', the empty space which forms the margin on the page of an official report – made wide in order to receive the comments of a superior. In the contemporary art institution, all works are made with, in effect, a 'margin' which awaits the inscription of the master narrative, or the critical judgement, (most often they amount to the same thing). More, the art 'most likely to succeed' today is that which is in essence *nothing but* a blank slate upon which the critical discourse may be inscribed (to a great extent, the distaste of critics for conceptualism, and its derived forms, has been a distaste for the spoiled page). Of course, the very opposition 'critic'/'artist' is itself *the* major statement in the art-critical discursive institution. In this relation, the subjective site 'artist' is that of 'the visual', a site of silence and intuition, of transcendent Spirit, but also the place of the supplicant before History; the subjective site 'critic' is that of 'the verbal', a site of speech and intellect, of transcendent Reason, and the judgement seat of History. In recent years an increasing number of 'artists' have been prepared to transgress this hallowed line of *apartheid* in

the racial system of representational practices; they have met very few critics coming in the opposite direction. There is of course absolutely no reason why a critic *should* make art (we do not *have* to go along with Benjamin here), but neither is there any reason for critics to continue to complain that 'we do not have the art we need'. Today, any critic making this complaint should 'put up or shut up'; no special technical skills are *necessary* in order to make art today (the time is long past when a lengthy apprenticeship in painting and drawing from the figure, and a study of anatomy, was an unavoidable precondition of art production); there, therefore, remains only the argument that the artist is 'a special sort of person', a major component of the dominant mythology, but hardly a notion to be subscribed to by critics devoted to the critique of such ideologies. The critic may of course plead that he or she is 'too busy' to devote time to the *practice* of art; in this case we may ask what is most important, to make 'the art we need', or to complain that we do not have it?

Foucault described a certain picture of the left intellectual who, 'spoke and was acknowledged to have the right of speaking . . . as a representative of the Universal . . . the consciousness/conscience of everyone';[68] he argued (following Gramsci) that, for some time now, intellectuals have in fact tended to play another role – no longer purveyors of the general, the 'good for all time', they now engage the particular conditions of their everyday professional and social lives. No longer 'universal' intellectuals, they have become 'specific' intellectuals. This, today, is the modest condition of the intellectual in the art institution – whether they be styled 'artist', 'critic', 'theoretician', 'historian', 'curator', or whatever. To accept this condition is to work not for 'posterity', 'the people', 'truth', not even for that hardy perennial chimera 'the general public'; it is to work, rather, on those particular projects which seem *critical* at a particular historical conjuncture (feminist art, criticism and theory offers the best recent example, here); such projects are *held in common* by a 'constituency' which may, or may not, be large; there are a potential multiplicity of projects corresponding to a plurality of constituencies; constituencies are not necessarily mutually exclusive, they may overlap; nor is there any one way of defining

a constituency (it might be entirely a hypothetical *projection*, not empirically known – for example, the readership of a particular journal).

A postmodern art problematic is one which puts on the agenda the imbrication of the aesthetic and the political, but *now*, as Foucault has put it:

> the problem isn't so much to define a political 'position' (which brings us back to making a move on a pre-constituted chess-board) but to imagine and bring into existence new schemes of politicisation. To the great new techniques of power (which correspond to multinational economies or to Bureaucratic states) must be opposed new forms of politicisation.[69]

Some years ago, commenting on this passage, I wrote:

> 'new forms of politicisation' within the institutions of art (and) photography must begin with the recognition that meaning is perpetually displaced from the *image* to the discursive formations which cross and contain it; that there can be no question of either 'progressive' contents or forms *in themselves*, nor any ideally 'effective' synthesis of the two; that there can be no *genre* of 'political' art (and) photography *given in advance* of the specific historical/institutional/discursive conjuncture; that there can be neither 'art for all' nor 'art for all time'. These and other unrequited spectres of the left art imaginary are to be exorcised; the problem *here* is not to answer the old questions, it is to identify the new ones.[70]

The identification of new questions, the generation of new work, is precisely the function Lyotard allocates to theory. When this function is undertaken as 'criticism' (when theory is brought into relation with a given text) then the first requirement is that it should establish a 'meshing' of the respective 'language games' (of criticism, of the artwork) such that what results is *collectively productive*. Far too often, however, 'criticism' takes the form merely of the incantation/imposition of a 'master narrative' over the work in question, whose own terms are not engaged. There then results that unlitagable injustice that Lyotard has termed

the *différand* ('A case of *différand* between two parties takes place when a 'regulation' of the conflict which opposes them is done in the idiom of one of the parties while the injustice suffered by the other is not signified in that idiom').[71]

The *différand* orders the *end* of art theory – here, the *goal* of one theory is the *death* of the other. It is dissolved only with the recognition of no other order but that of *difference*. Difference is today denied not only in the petrified 'common sense' which dominates the art institution (for all its pious pretence of pluralism), it is also negated in the sovereign metalanguages of the 'theory' which has come more recently to oppose such art ideologies. Both, in their very different ways, have engendered forms of unlitigable terrorism – institutional in the former case, intellectual in the latter. To make this observation is in no way to eliminate the crucially significant difference between common sense criticism and 'theory'. The former is an inert residue – habits of mind formed in the repetition of figures from forgotten intellectual systems; as a result of the latter, however, we now look out upon a totally transformed intellectual landscape. As already noted, our contemporary category, 'art', came into existence in the mid sixteenth century with the separation of *homo significans* from *homo faber* (a foregrounding of the semiotic, rather than the artisanal, aspect of art), and the recognition of art as a *theoretical practice*. This theoretical status of art was confirmed and consolidated in the discursive-institutional constructions of the eighteenth century (the academy, art history, criticism, and so on) to form the foundations of the modern art institution. The apparent 'emergence' of theory in the art world of the late 1960s (which so scandalised the self-appointed guardians of art's intellectual innocence) was therefore simply a *resurgence* of that which had been repressed in the ideologies of (a degraded) late-Romanticism. The waning of these ideologies (those composing what I have called the 'common sense' of *Art*) was symptomatically expressed in the mid-1970s as a 'crisis in criticism'. Response to this crisis has been various: predominantly, there has been *no* response other than the automatic repetition of that vapid critical 'art-speak' which seems now to be an essential lubricant to the flow of money in the art market; amongst the critical opponents of such

hack journalism (admittedly far worse a problem in Britain than anywhere else) are to be found, mainly, proponents of a regressive-Utopian Romantic anti-capitalism in which art is seen as a potential pinnacle of purity in a sea of venality; it is from this position that we hear, for example, the strident moral denunciation of the present – the call to reconstruct an earlier, more spiritual, age.

The category of the 'postmodern' is our first glimpse of the historical emergence of a field of *post*-Romantic aesthetics. The cultural theory of the 1970s – drawing predominantly on feminism, Marxism, psycho-analysis and semiotics – demonstrated the impossibility of the modernist ideal of art as a sphere of 'higher' values, independent of history, social forms, and the unconscious; this same theory has undermined the modernist dogma that 'visual art' is a mode of symbolisation independent of other symbolic systems – most notably, language; modernist pretensions to artistic independence have been further subverted by the demonstration of the necessarily 'intertextual' nature of the production of meaning; we can no longer unproblematically assume that '*Art*' is somehow 'outside' of the complex of other representational practices and institutions with which it is contemporary – particularly, today, those which constitute what we so problematically call the 'mass-media'.

A consequence of these developments is that the study of 'visual art' – for so long confined within artificially narrow intellectual and institutional limits – now ranges across the broader spectrum of what I have called elsewhere the 'integrated specular regime' of our 'mass-media' society. 'Art theory', understood as those interdependent forms of art history, aesthetics, and criticism which began in the Enlightenment and culminated in the recent period of 'high modernism', is now at an end. In our present so-called 'postmodern' era the *end* of art theory *now* is identical with the objectives of *theories of representations* in general: a critical understanding of the modes and means of symbolic articulation of our *critical* forms of sociality and subjectivity.

Notes and References

Modernism in the *Work* of Art

1. Expanded version of a paper given at the 1976 Edinburgh Festival 'Avant-garde Event'.

2. Jan Mukarovsky, 'L'Art comme fait sémiologique', *Actes du huitième congres internationale de philosophie à Prague 2–7 Septembre 1934*, Prague 1936.

3–11. Clement Greenberg, 'Avant-Garde and Kitsch', in *Art and Culture*, Beacon Press, 1961, pp. 3–21.

12. Alexis de Tocqueville, *Democracy in America*, vol. 2, Vintage, 1945, p. 54.

13. Clement Greenberg, 'Avant-Garde and Kitsch' in *Art and Culture*, Beacon Press, 1961, pp. 3–21.

14. Raymond Williams, *Culture and Society 1780–1950*, Pelican, 1961.

15. A collation of its 'physical accomplishments and expenditures' estimates its total cost as $35 million. Included in its production: 2,566 murals; 180,099 easel paintings; and designs for about 2 million posters (35,000 of which were produced). (On a separate budget, the WPA building programme built thousands of art galleries.)

16. Holger Cahill, 'American Resources in the Arts', in *Art for the Millions*, ed. Francis V. O'Connor, New York Graphic Society, 1975, pp. 36–7.

17. Stuart Davis, 'Abstract Painting Today' in *Art for the Millions*, ibid., p. 126.

18. Robert Cantwell, quoted by William Stott, *Documentary Expression and Thirties America*, OUP, 1973, p. 113.

19. Cf. Walter Benjamin, 'The Author as Producer', in *Understanding Brecht*, New Left Books, 1973, pp. 85–103.

20. Alexei Gan, 'Constructivism', in Camilla Gray, *The Great Experiment: Russian Art 1863–1922*, Thames & Hudson, 1962, p. 285.

21. Vladimir Mayakovsky, *I Myself*, quoted in Richard Sherwood, 'Documents from *Lef*', *Screen*, vol. 12, no. 4, 1971–2, p. 29.

22. El Lissitsky, 'The Book from the Visual Point of View – the Visual Book', in *The Art of Book Printing*, Moscow, 1962, p. 163.

23. See *Soviet Advertising Poster 1917–1932*, Moscow, 1972.

24. 'We are Searching' (Editorial, *Novy Lef*, nos. 11, 12, 1927), *Screen*, vol. 12, no. 4, 1971–2, p. 67.

25. Ralph Graham, 'The Poster in Chicago', in *Art for the Millions*, p. 181.

26. Alexis de Tocqueville, *Democracy in America*, vol. 2, Vintage, 1945, p. 54.

27. The leading work was done by the *Berliner Illustrierte*, whose half-million circulation was matched by its imitator the *Münchner Illustrierte Presse* (1923). Other publications included the Communist *Arbeiter Illustrierte Zeitung (AIZ)* (1921), and the National Socialist *Der Illustrierte Beobachter*. (*Life* appeared in 1936, *Look* in 1937, *Picture Post* in 1938.)

28. See Tim N. Gidal, *Modern Photojournalism: Origin and Evolution, 1910–1933*, Collier, 1973.

29. Laszlo Moholy-Nagy, *Painting, Photography, Film*, Massachusetts Institute of Technology, 1973, p. 28.

30. Dziga Vertov, 'Film Directors, A Revolution', *Lef*, vol. 3, in *Screen*, vol. 15, no. 2, 1944, p. 52.

31. Lev Kuleshov, 'The Principles of Montage', in *Kuleshov on Film*, University of California, 1974, p. 192.

32. Raoul Hausmann, 'Peinture Nouvelle et Photomontage', in *Courrier Dada*, Le Terrain Vague, 1958, p. 47.

33. El Lissitsky, in *Merz*, no. 4, 1923, quoted in Szymon Bojko (see below), p. 16.

34. Szymon Bojko, *New Graphic Design in Revolutionary Russia*, Praeger, 1972, p. 27.

35. William Stott, *Documentary Expression and Thirties America*, O.U.P., 1973, p. 212.

36. Raoul Hausmann, 'Peinture Nouvelle et Photomontage', in *Courrier Dada*, Le Terrain Vague, 1958, pp. 48–9.

37. Louris Aragon, 'John Heartfield et la beauté révolutionnaire', in *Les Collages*, Princeton University Press, 1965, p. 82.

38. Donald Drew Egbert, *Socialism and American Art*, Princeton, 1967, p. 116.

39. Clement Greenberg, 'Avant-Garde and Kitsch', in *Art and Culture*, Beacon Press, 1961, pp. 3–21.

40. Roger Fry, quoted in Lionello Venturi, *History of Art Criticism*, Dutton, New York, 1964, p. 308.

41. Clive Bell, *Art*, Capricorn, New York, 1958, pp. 28–9.

42. Clement Greenberg, 'Modernist Painting', *Arts Year Book*, 4, 1961, pp. 103–8.

43. Tzvetan Todorov, 'Some approaches to Russian Formalism', *20th Century Studies*, December 1972, p. 10.

44. Clement Greenberg, 'Modernist Painting', *Arts Year Book*, 4, 1961, pp. 103–8.

45. Ibid. ('Flatness' is of course also an attribute of film and photography.)

46. Viktor Shklovsky, quoted by Frederic Jameson in *The Prison-House of Language*, Princeton University Press, 1972, p. 53.

47. Viktor Shklovsky, *Sentimental Journey*, Cornell University Press, 1970, p. 233.

48. Boris Eichenbaum, 'The Theory of the "Formal Method"', in *Russian Formalist Criticism*, University of Nebraska, Lincoln, 1965, p. 112.

49. Roman Jakobson, quoted by Ben Brewster in 'From Shklovsky to Brecht: A Reply', *Screen*, vol. 15, no. 2, 1974, p. 87.

50. Roman Jakobson, 'Linguistics and Poetics', *The Structuralists*, ed. De George and De George, Doubleday, 1972, pp. 85–6.

51. Clement Greenberg, 'Modernist Painting', *Arts Year Book*, 4, 1961, p. 103.

52. Roman Jakobson, quoted by Ben Brewster in 'From Shklovsky to Brecht: A Reply', *Screen*, vol. 15, no. 2, 1974, p. 86.

53. Roland Barthes, 'Diderot, Brecht, Eisenstein', *Screen*, vol. 15, no. 2, 1974, p. 33.

54. See Roland Barthes, 'Myth Today', *Mythologies*, Paladin, 1973, pp. 109–59.

55. Louis Althusser, 'Ideology and the State', *Lenin and Philosophy*, New Left Books, 1971, p. 160.

56. Cf. Jacques Lacan, 'The Mirror-phase as formative of the Function of the I', *New Left Review*, no. 51, Sept–Oct, 1968, pp. 71–7.

57. Louis Althusser, 'Ideology and the State', *Lenin and Philosophy*, New Left Books, 1971, p. 155.

58. Jean Roussel, 'Introduction to Jacques Lacan', *New Left Review*, no. 51, Sept–Oct, 1968, p. 69.

59. Cf. Umberto Eco, 'Articulations of Cinematic Code', *Cinemantics I*, January 1970.

60. Roland Barthes, 'Diderot, Brecht, Eisenstein', *Screen*, vol. 15, no. 2, 1974, p. 36.

61. See Henri Cartier-Bresson, 'The Decisive Moment', *Photographers on Photography*, Prentice Hall, 1966.

62. Roland Barthes, 'Rhetoric of the Image', *Working Papers in Cultural Studies*, Spring 1971.

63. Cf. Stephen Heath, 'Lessons from Brecht', *Screen*, vol. 15, no. 2, 1974, p. 106 ff.

64. Laura Mulvey, 'Visual Pleasure and Narrative Cinema', *Screen*, vol. 16, no. 3, 1975.

65. Julia Kristeva, 'The System and the Speaking Subject', *Times Literary Supplement*, 12 October 1973.

66. Clement Greenberg, 'The Late Thirties in New York', *Arts Year Book*, 4, 1961, p. 30.

67. Donald Drew Egbert, *Socialism and American Art*, Princeton, 1967, pp. 134–5.

68. Cf. Umberto Eco, *A Theory of Semiotics*, Indiana, 1976, pp. 286–98.

69. Clement Greenberg, 'The Late Thirties in New York', *Arts Year Book*, 4, 1961, p. 101.

70. Ibid., p. 116.

71. Julia Kristeva, 'The ruin of a poetics', *20th Century Studies*, December 1972, p. 104.

72. Alexis de Tocqueville, *Democracy in America*, vol. 2, Vintage, 1945, p. 61.

73. Clement Greenberg, 'The Late Thirties in New York', *Arts Year Book*, 4, 1961, p. 17.

74. Bertolt Brecht, 'The Popular and the Realistic', *Marxists on Literature*, ed. David Craig, Pelican, 1975, p. 421.

The Absence of Presence: Conceptualism and Postmodernisms

1. E. H. Gombrich, *Symbolic Images*, Phaidon, 1972.

2. Victor Burgin, 'Looking at Photography', in *Thinking Photography*, Macmillan, 1982.

3. Victor Burgin, *Work and Commentary*, Latimer Press, 1973.

4. Victor Burgin, 'Photography, Phantasy, Function', in *Thinking Photography*, op. cit., and, 'Seeing Sense', *Artforum*, February 1980.

5. J. F. Lyotard, *La Condition Postmoderne*, Les Editions de Minuit, 1979.

Seeing Sense

1. See James J. Gibson, 'Constancy and invariance in perception', in Gyorgy Kepes (ed.), *The Nature and Art of Motion*, Studio Vista, 1967.

2. Karl H. Pribram, 'The Neurophysiology of Remembering', *Scientific American*, January 1969.

3. Mardi J. Horowitz, *Image Formation and Cognition*, Meredith, 1970.

4. Brewster Ghiselin, *The Creative Process*, Mentor, 1955, quoted in Dan I. Slobin, *Psycholinguistics*, Scott, Foresman, 1974, p. 101.

5. Sigmund Freud, 'Fragment of an Analysis of a Case of Hysteria', in *Case Histories*, Pelican, 1977.

6. Sigmund Freud, *The Interpretation of Dreams*, Pelican, 1976, p. 383.

7. Sigmund Freud, *A General Introduction to Psychoanalysis*, Pocket Books, 1973, p. 183.

8. Lev Vygotsky, *Thought and Language*, Massachusetts Institute of Technology, 1977, p. 139.

9. Lev Vygotsky, ibid., p. 148.

10. Jean-François Lyotard, *Discours, Figure*, Editions Klincksieck, p. 244.

11. Mardi J. Horowitz, *Image Formation and Cognition*, Meredith, 1970, p. 77.

12. Sigmund Freud, *On Creativity and the Unconscious*, Harper & Row, 1958, p. 47.

13. Sigmund Freud, ibid., p. 48.

14. Sigmund Freud, 'The Ego and the Id', in John Rickman (ed.), *A General Selection from the Works of Sigmund Freud*, Doubleday, 1957, p. 213.

15. Mardi J. Horowitz, *Image Formation and Cognition*, Meredith, 1970, p. 78.

16. Lee Friedlander, *Self Portrait*, Haywire Press, 1970.

17. John Szarkowski, *New Photography U.S.A.*, Universita' Di Parma/Museum of Modern Art, New York, 1971.

18. See Victor Burgin, 'Looking at Photographs', *Tracks*, New York, Fall 1977.

19. Gary Winogrand, Grossmont College Gallery, El Cajon, California, 1976.

20. Roland Barthes, *S/Z*, Jonathan Cape, 1975, p. 10.

21. John Szarkowski, Quintavalle Mussini, *New Photography U.S.A.*, Universita' Di Parma/Museum of Modern Art, New York, 1971, p. 15.

22. Clement Greenberg, 'Modernist Painting', *Arts Year Book*, 4, 1961.

23. Maren Stange, 'Szarkowski at the Modern', in *Photography: Current Perspectives*, Light Impressions, 1978, p. 74.

24. John Szarkowski, *The Photographer's Eye*, Museum of Modern Art, New York, 1966.

25. Clive Bell, *Art*, Capricorn, 1958, p. 29.

26. Maren Stange, 'Szarkowski at the Modern', in *Photography: Current Perspectives*, Light Impressions, 1978, p. 74.

27. Clement Greenberg, 'Four Photographers', *New York Review of Books*, 23 January 1964.
28. John Szarkowski, *The Photographer's Eye*, Museum of Modern Art,
29. E. H. Gombrich, *Symbolic Images*, Phaidon, 1972.

Re-reading *Camera Lucida*

CC	*La Chambre Claire*, Editions du Seuil, 1980
CE	*Critical Essays*, Northwestern, 1972
CL	*Camera Lucida*, Jonathan Cape, 1982
E	*L'Empire des Signes*, Skira, 1970
IMT	*Image-Music-Text*, Fontana, 1977
M	*Mythologies*, Paladin, 1973
RB	*Roland Barthes by Roland Barthes*, Hill & Wang, 1977
S/Z	*S/Z*, Jonathan Cape, 1975
V	Textual Analysis of Poe's 'Valdemar', in R. Young (ed.), *Untying the Text*, Routledge & Kegan Paul, 1981

Diderot, Barthes, *Vertigo*

1. In an abbreviated form, this paper was first given at the symposium, *Film and Photography*, at the University of California, Santa Barbara, May 1984.
2. I am careful to specify psycho-analytic *theory* here, as the history of the *institution* of psycho-analysis, as a professional practice, has tended to elide the socially radical nature of Freud's legacy (see, for example, Russell Jacoby, *The Repression of Psychoanalysis, Otto Fenichel and the Political Freudians*, Basic Books, New York, 1983).
3. To avoid possible misunderstanding at the start, I would stress that *no* implication of a Jungian 'collective unconscious' is intended here. I do, however, assume a collective *preconscious* (in the sense in which the notion is encountered in both Freud and Lacan). I further assume that the 'mechanisms' of the unconscious (primary processes) are held in common (much as all speakers of English hold English syntax in common, albeit syntax belongs to the preconscious); moreover, I assume that certain unconscious contents (for example, fantasy 'scenarios') will be held in common by all individuals in a given society, in a given historical period – albeit the particular forms of representation of these contents will vary according to biographical circumstances (see section III).

4. Roland Barthes, 'The Third Meaning', in *Image-Music-Text*, Fontana, 1977, p. 52.

5. Ibid., p. 69.

6. 'Just as the twenty-four letters of the alphabet are used to form our words and to express our thoughts, so the forms of the human body are used to express the various passions of the soul and to make visible what is in the mind'. Nicolas Poussin to André Félibien, cited in Moshe Barasch, *Theories of Art: From Plato to Winckelmann*, New York University Press, 1985, p. 326.

7. See Rensselaer W. Lee, *Ut pictura poesis: the humanistic theory of painting*, Norton, 1967.

8. For a succinct account of allegory in Renaissance painting, see James Hall, *A History of Ideas and Images in Italian Art*, John Murray, 1983.

9. See, for example, Thornhill's commentary on his *Allegory of the Protestant Succession*, quoted in R. Paulson, *Emblem and Expression: Meaning in English Art of the Eighteenth Century*. By way of correcting my perhaps over-schematic characterisation of the evolution of allegory as 'simple to complex', see also Rubens's late (1638) letter of description of his *The Horrors of War*, quoted in Wolfgang Stechow, *Rubens and the Classical Tradition*, Harvard, 1968, pp. 87–9.

10. *Discours sur la póesie dramatique* (1785), quoted in Jean Claude Bonnet, *Diderot*, Livre de Poche, 1984, pp. 182–3.

11. Quoted in Rudolf Wittkower, 'Hieroglyphics in the Early Renaissance', in *Allegory and the Migration of Symbols*, Westview Press, 1977, p. 116.

12. *Oeuvres Complètes* (22 vols), J. Assézat and M. Tourneaux (eds), vol. III, p. 190, quoted in Norman Bryson, *Word and Image: French Painting of the Ancien Régime*, Cambridge, 1981, p. 179.

13. Roland Barthes, *Camera Lucida*, Hill & Wang, 1981, pp. 43, 53.

14. Jean Laplanche, 'The Order of Life and the Genesis of Human Sexuality', in *Life and Death in Psychoanalysis*, Johns Hopkins, 1976, pp. 19–20.

15. Jean Laplanche and J.-B. Pontalis, 'Fantasy and the Origins of Sexuality', *The International Journal of Psycho-Analysis*, vol. 49, 1968, part 1, p. 17.

16. Ibid., p. 16. (It is this perspective which allows Derrida to locate the error in Rousseau's condemnation of masturbation as a deplorable ancilliary to sexuality; it is in this 'supplement', the grubby margin to the bright page of human affective relations, that sexuality reveals itself most essentially.)

17. Jean Laplanche, 'The Ego and the Vital Order', in, *Life and Death in Psychoanalysis*, Johns Hopkins, 1976, p. 60.

18. Jacques Lacan, 'Of the Gaze as *Objet Petit a*', in *The Four Fundamental Concepts of Psycho-Analysis*, Hogarth, 1977, pp. 67–105.

19. Jean Laplanche and Serge Leclaire, 'The Unconscious: A Psychoanalytic Study', *Yale French Studies*, no. 48, 1972, p. 118.

20. Ibid., p. 135.

21. For an account of this concept see J. Laplanche and J.-B. Pontalis, *The Language of Psycho-Analysis*, Hogarth, 1973, pp. 111–14.

22. Jean-Michel Ribettes, 'La troisième dimension du fantasme', in D. Anzieu *et al.*, *Art et Fantasme*, Champ Vallon, 1984, p. 188.

23. Herman Rapaport, 'Staging: Mont Blanc', in Mark Krupnick (ed.), *Displacement: Derrida and After*, Indiana, 1983, p. 59.

24. *The Standard Edition of the Complete Psychological Works of Sigmund Freud*, (24 vols), Hogarth Press, 1953–74, vol. XI, p. 165.

25. For Hitchcock's own fascinating comments on this scene, 'the scene which moved me most', see *Hitchcock/Truffaut, Edition Definitive*, Ramsay, 1983, pp. 208–9.

26. Roland Barthes, 'En sortant du cinéma', in *Communications*, no. 23, Seuil, 1975.

27. 'Looking at Photographs', in Victor Burgin (ed.), *Thinking Photography*, Macmillan, 1982, p. 153.

The End of Art Theory

1. Papers and responses published in *Studio International*, vol. 194, no. 989, 2, 1978.

2. Elizabeth Bruss, *Beautiful Theories*, Johns Hopkins, 1982, p. 32.

3. Artistotle, *Politics* (1340a 32ff), quoted in Moshe Barasch, *Theories of Art*, New York University, 1985, p. 13.

4. Norman Bryson, *Word and Image, French Painting of the Ancien Régime*, Cambridge University, 1981, p. 30.

5. From the first (1932) charter of the *Association of Soviet Writers* (analogous bodies were subsequently set up by the Communist Party of the Soviet Union for the other arts), in Lee Baxandall (ed.), *Radical Perspectives on the Arts*, Penguin, 1972, p. 241.

6. Monroe C. Beardsley, *Aesthetics from Classical Greece to the Present*, University of Alabama, 1966, p. 247.

7. Moshe Barasch, *Theories of Art*, New York University, 1985, p. 251.

8. Raymond Williams, *Keywords*, Fontana, 1976, p. 74.

9. Quoted in, Lorenz Eitner (ed.), *Neoclassicism and Romanticism 1750–1850, Sources and Documents*, vol. II, Prentice-Hall, 1970, p. 151.

10. Ibid., p. 155.

11. See, Victor Burgin, 'The absence of presence: conceptualism and post-modernisms', in this volume.

12. E. H. Gombrich, 'The Art of Collecting Art', *The New York Review of Books*, vol. XXIX, no. 19, December 1982, pp. 39–42.

13. Lionello Venturi, *History of Art Criticism*, Dutton, 1964, p. 100.

14. Raymond Williams, *Culture and Society, 1780–1950*, Penguin, 1961, p. 48.

15. See Victor Burgin, 'Diderot, Barthes, *Vertigo*', in this volume.

16. Terry Eagleton, *Literary Theory*, Basil Blackwell, 1983, p. 22.

17. Catherine Belsey, *Critical Practice*, Methuen, 1980, pp. 8–10.

18. Roland Barthes, 'Neither-Nor Criticism', in *Mythologies*, Paladin, 1973, p. 82.

19. John Tagg, 'A Socialist Perspective on Photographic Practice', in *Three Perspectives on Photography*, Arts Council of Great Britain, 1979, p. 70.

20. Terry Eagleton, *Literary Theory*, Basil Blackwell, 1983, p. 203.

21. Elizabeth Bruss, *Beautiful Theories*, Johns Hopkins, 1982, p. 18.

22. Victor Burgin, 'Socialist Formalism', *Studio International*, vol. 191, no. 980, March–April, 1976, p. 148.

23. Laura Mulvey, untitled essay in *Magnificent Obsession*, ARC Gallery, Toronto, and Optica Gallery, Montreal, 1985, unpaginated.

24. Gareth Stedman Jones, 'History: the Poverty of Empiricism', in Robin Blackburn (ed.), *Ideology in Social Science*, Fontana, 1972, pp. 96–7.

25. Frederic Jameson, 'The Politics of Theory: Ideological Positions in the Postmodernism Debate', *New German Critique*, no. 33, Fall 1984, p. 53.

26. Jürgen Habermas, 'Modernity – An Incomplete Project', in Hal Foster (ed.), *The Anti-Aesthetic, Essays on Postmodern Culture*, Bay Press, Washington, 1983, p. 9.

27. Jean Baudrillard, 'The Precession of Simulacra', in *Simulations*, Semiotext(e), 1983, p. 31.

28. Michel Foucault, *Discipline and Punish*, Allen Lane, 1977, p. 304.

29. Mark Poster, *Foucault, Marxism and History*, Polity Press, 1984, p. 103.

30. Frederic Jameson, 'Pleasure: a Political Issue', in *Formations of Pleasure*, Routledge & Kegan Paul, 1983, p. 3.

31. Guy Debord, *Society of the Spectacle*, Black and Red, 1983.

32. Jean Baudrillard, 'The Precession of Simulacra', in *Simulations*, Semiotext(e), 1983, p. 25.

33. Ibid., p. 27.

34. *The Guardian*, London and Manchester, Tuesday, 2 April 1985.

35. Jacques Dalaruelle and John McDonald, 'Resistance and Submission', in André Frankovits (ed.), *Seduced and Abandoned: The Baudrillard Scene*, Stonemoss, Australia, 1984, p. 18.

36. Jean Baudrillard, *For a Critique of the Political Economy of the Sign*, Telos, 1981, pp. 121–2.

37. Frederic Jameson, 'Reification and Utopia in Mass Culture', *Social Text*, Winter, 1979, p. 133.

38. Jürgen Habermas, 'Modernity – An Incomplete Project', in Hal

Foster (ed.), *The Anti-Aesthetic, Essays on Postmodern Culture*, Bay Press, Washington, 1983, p. 13.

39. 'The absence of presence', in this volume.

40. See, for example, 'Modernism in the *Work* of Art', and, 'Diderot, Barthes, *Vertigo*', in this volume.

41. Frederic Jameson, 'Foreword' to, Jean-François Lyotard, *The Postmodern Condition: A Report on Knowledge*, Manchester University, 1984, p. xvi.

42. Werner Heisenberg, *Physics and Philosophy*, quoted in Elizabeth Bruss, *Beautiful Theories*, Johns Hopkins, 1982, p. 15.

43. Frederic Jameson, 'Foreword', op. cit.

44. Colin MacCabe, 'On Discourse', in Colin MacCabe (ed.), *The Talking Cure*, Macmillan, 1981, p. 208.

45. Michel Foucault, *The Archeology of Knowledge*, Tavistock, 1974, p. 194.

46. Ibid., pp. 163–5.

47. Colin MacCabe, 'The discursive and the ideological in film. Notes on the conditions of political intervention', in *Screen*, vol. 19, no. 4, winter, 1978–79, p. 31.

48. Pierre Bourdieu, 'The production of belief: contribution to an economy of symbolic goods',in *Media, Culture and Society*, vol. 2, no. 3, July 1980, p. 266.

49. Barry Hindess and Paul Hirst, *Mode of Production and Social Formation*, Macmillan, 1977, pp. 7–8.

50. Ibid., p. 14.

51. Elizabeth Cowie, 'Women, Representation and the Image', *Screen Education*, Summer 1977, no. 23, p. 20.

52. Robert Sayre and Michel Löwy, 'Figures of Romantic Anti-Capitalism', *New German Critique*, no. 32, Spring–Summer, 1984, p. 42.

53. Ibid., p. 46.

54. Pierre Bourdieu, 'The production of belief: contribution to an economy of symbolic goods', in *Media, Culture and Society*, vol. 2, no. 3, July 1980, p. 263.

55. Ibid., p. 266.

56. Ibid., p. 262.

57. See quotation from, *Pléiade*, I, in Jacques Derrida, *Of Grammatology*, Johns Hopkins, 1976, p. 150.

58. Jonathan Culler, *On Deconstruction*, Routledge & Kegan Paul, London, 1983, pp. 160–1.

59. See Michael Ryan, *Marxism and Deconstruction*, Johns Hopkins, 1982.

60. Gilbert Ryle, *The Concept of Mind*, Penguin, 1963, p. 13.

61. Ibid., p. 14.

62. Karl Marx, *Capital*, vol. I, Lawrence & Wishart, London, 1954.

63. Louis Althusser, 'Ideology and Ideological State Apparatuses

(Notes toward an Investigation)', in *Lenin and Philosophy and other Essays*, New Left Books, London, 1971, p. 150.

64. Terry Eagleton, *The Function of Criticism*, Verso, 1984, pp. 91–2.

65. *Camerawork*, no. 32, Summer 1985, p. 16.

66. Frederic Jameson, 'Postmodernism or the Cultural Logic of Late Capitalism', *New Left Review*, 146, July–August 1984, pp. 85–6.

67. Roland Barthes, 'Theory of the Text', in Robert Young (ed.), *Untying the Text*, Routledge & Kegan Paul, 1981, p. 35.

68. Michel Foucault, 'The political function of the intellectual', *Radical Philosophy*, 17, 1977, p. 12.

69. Michel Foucault, 'Interview with Lucette Finas', in *Michel Foucault – Power, Truth, Strategy*, Ferel, 1979, p. 72.

70. Victor Burgin, 'Photography, Phantasy, Function', in Victor Burgin (ed.), *Thinking Photography*, Macmillan, 1982, pp. 215–16.

71. Jean-François Lyotard, 'The *Différand*, the Referent, and the Proper Name', *Diacritics*, Fall 1984, p. 5.

Index